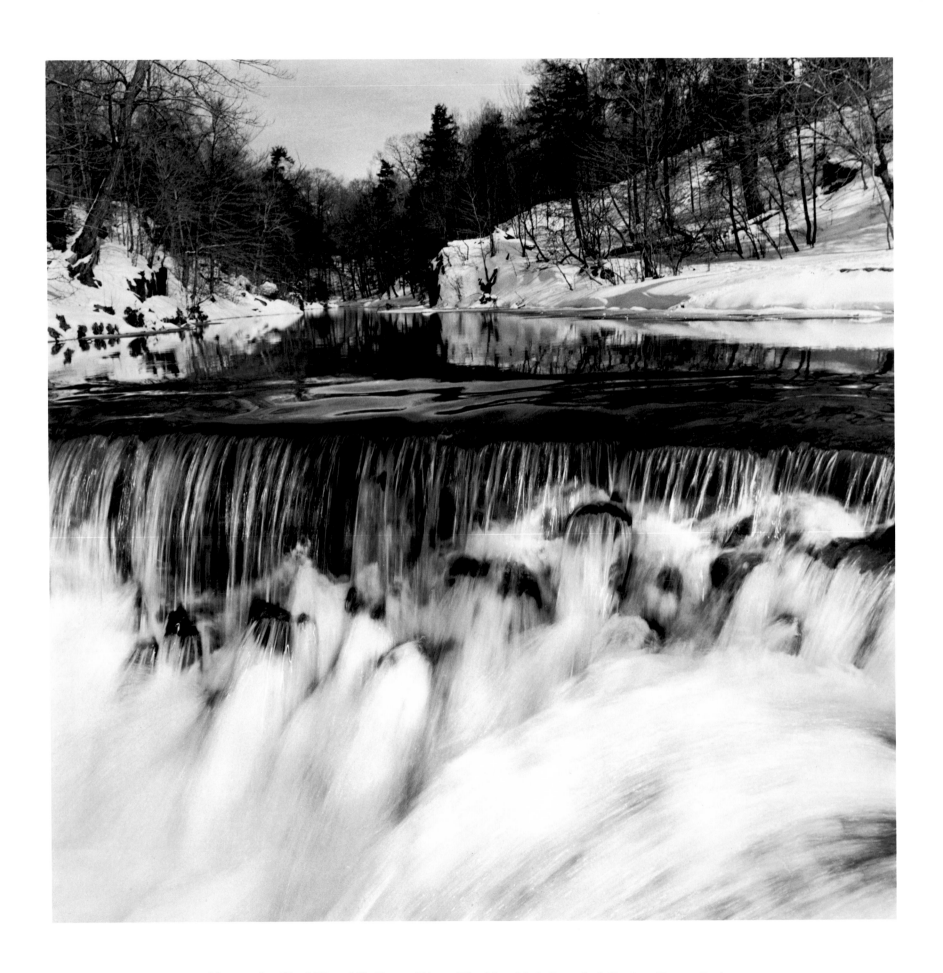

Plate 1. Lorillard Waterfall, Bronx River, The New York Botanical Garden, Bronx Park.

URBAN WILDERNESS

NATURE IN NEW YORK CITY

Text by Jean Gardner

❧

Photographs by Joel Greenberg

❧

Foreword by Bill Moyers

Published by Earth Environmental Group

With funding from the Exxon Corporation

Distributed by Earth Environmental Group,
265 Water Street, New York, N.Y. 10038.

Earth Environmental Group
publishes posters, pamphlets and notecards
on The Parks and Natural Areas in New York City.
A catalogue is available upon request.

Library of Congress Card Catalogue No. 88–072219
ISBN 0–9621060–0–3

Front Cover: Udall's Cove, Udall's Cove and Ravine Park, Queens.
Back Cover: The Pool, Central Park, Manhattan.

❧

URBAN WILDERNESS: NATURE IN NEW YORK CITY
has been published in this First Edition
of 3,000 copies.

CONTENTS

ACKNOWLEDGEMENTS

Urban Wilderness: Nature in New York City is the culmination of a ten-year survey of the geology, vegetation, ecology, and history of the natural sites of New York City. Besides this book, Earth Environmental Group has published posters, guides, notecards, and a film strip that present New York City's diversified natural environment. The kernel of the idea to make easily available popular information on the unique natural ecologies of New York City came from Raymond S. Rubinow, Director Emeritus of the J. M. Kaplan Fund. A pamphlet, funded by the Kaplan Fund, resulted from his interest. It describes three New York City parks with environmental education centers. Donald Kahn of the Public Affairs Department of the Exxon Corporation had the foresight and generosity to provide initial funding for the *Rediscover New York City Project* itself. Ed Markowski, Al Wofford, and Sarah Johnson later continued Exxon's support with the funding of research, archival photographs, and posters that were distributed free to community, school, and other groups. Frank Abbruscato of Exxon not only gave funding for the publication of this book, but also his time and personal support. Exxon's Art Director Elton Robinson gave generous advice on the design of the book. Consolidated Edison Company of New York and Ken Kowald, its Assistant Director of Environmental and Educational Programs, Community Relations, have given encouragement and general financial support for many years. Manufacturers Hanover Trust and Charles McCabe, Joyce Healy, Patsy Warner, Paul Incarnato, Claudia Mengel, and Barbara Paddock generously aided and financially backed the project, particularly research and publishing of survey results in Brooklyn. The President of the J. M. Kaplan Fund, Joan K. Davidson, and its Executive Director, Suzanne Davis, have contributed ideas, guidance, and funds to the survey in Queens and the publishing of a pamphlet on Riverside Park. The Vincent Astor Foundation financed research and publishing of information on the Hemlock Grove in The New York Botanical Garden. The survey was also made possible, in part, with public funds from the New York State Council on the Arts and the National Endowment for the Arts. The National Endowment for the Arts also provided funding from their Visual Arts, Photographic Survey category. We are extremely grateful to all, for the generous support received during the research, the photography, and the publication of this book.

One of the pleasures of doing research on and writing about New York City's natural sites has been getting to know the people whose lives have become interwoven with these areas. These individuals are as much part of the ecology of the natural areas as the vegetation and wildlife are. It is with great gratitude that I express my appreciation and respect for the contributions these people have given to this book and to the pamphlets and posters that made available the earliest research phases.

In The Bronx the late Dr. Theodore Kazimiroff introduced me to The New York Botanical Garden, Pelham Bay Park, and Van Cortlandt Park. The late Cass Gallagher shared her knowledge of Van Cortlandt Park. Dr. Mark J. McDonnell, Terrestrial Ecologist with the Institute of Ecosystem Studies in The New York Botanical Garden, and his assistant, Edward Roy, explained their work and reviewed the text on the Garden Forest. Paul Berizzi, Administrator of Pelham Bay/Van Cortlandt Parks, patiently answered countless questions about his parks and also generously double-checked the relevant text.

In Manhattan Charles McKinney, Director of Riverside Park, brought me a vivid understanding of park restoration. Charles joined me and fellow Board Members of Earth Environmental Group, Hilary Baum, and Richard Stein, to publish a pamphlet on Riverside Park. In Queens, Joan and Hy Rosner, Founders and Honorary Directors of the Queens Alley Pond Environmental Center, introduced me to that park. William Nieter, Vice Chairman of the Alley Pond Center, brought me up-to-date on park restoration projects and reviewed the pertinent text and picture captions.

In Brooklyn John Tanacredi, Chief Officer of Resource Management and Compliance at Gateway National Recreation Area, described the innovative work he is doing at Floyd Bennett

Field and Jamaica Bay. Similarly, Tupper Thomas, Administrator for Prospect Park, explained her unusual approach in restoring that Olmsted and Vaux park. Both John and Tupper also reviewed for factual accuracy the book sections dealing with their respective parks.

The Protectors of Pine Oak Woods on Staten Island provided research materials, tours, and enthusiastic support. Richard Buegler, President of the Protectors, contributed significantly at every phase, from the publishing of the Earth Environmental Group's Clay Pit Pond pamphlet to the reviewing of the final text on Staten Island. Joe Fernicola, a Founder and Honorary Director of the Protectors, took me on many walks through the clay pit-pine barren. Ellen Pratt, Corresponding Secretary for the Protectors, explained that group's recent efforts to establish wetlands as storm sewers and to preserve Kingfisher Pond and the Mount Loretto and Long Pond Area. Marilyn Mammano, City Planning Commissioner for Staten Island, reviewed with me the wetland–storm drainage proposal and Tom Paulo, Administrator of the Greenbelt, summarized management studies and plans for that park.

Many other individuals have contributed to the book, each in their own special ways: Arne Abramowitz, Administrator for Flushing Meadows Corona Park; Clare Beckhardt, Regional Director, New York State Office of Parks, Recreation, and Historic Preservation, New York Region; Peter Berg and Judy Goldhaft of the Planet Drum Foundation; the poet Robert Bly; Adrienne Bresnan, former Director of Planning, New York City Parks and Recreation; Tom Fox, Executive Director, Neighborhood Open Space Coalition; Geologist Sidney Hornstein; Visionary Designer Michael Kalil; Plant Expert Gary Lincoff; Natural Resources Group Director Marc Matsil and field technicians Nancy Barthold, Helen Forglone, and Chris Nadereski; Ecologist Paul Mankiewicz; Proofreader Janet Marks; Seer Kathy Merlin; Councilwoman Ruth Messinger; Gaia Institute Fellow Peter Reynolds; Landscape Architects and Architects Quennell Rothschild Associates; Poet Jim Ryan; Botanist Bill Schiller; storytellers Laura Simms and Gioia Timpanelli; Parks Commissioner Henry Stern; fellow members of The Parks Council Board, in particular, Al Appleton, Arthur Baker, Jeannette Bamford, Peter Rothschild, and Philip Winslow; and Board Members of Earth Environmental Group—Bruce Cratsley, Geoff Gregg, Kathy Madden, Frank Moretti, and Allen Tate. Thanks to the many others who answered my numerous questions.

Special gratitude to Bill Moyers, whose concern for New York City's natural sites has awakened new interest in the city's environment, and to his assistant, Andie Tucher, who has been unfailingly encouraging. Warm thanks, also, to my editor, the late C. Ray Smith, with whom it was a privilege to have worked. I was fortunate to have had his guidance until the final revisions. Special thanks to my daughter, Moira, who spent much of her early years accompanying me to New York City's natural sites; and to Paul Ryan for bringing me the inspiration and support needed to finish the text.

Jean Gardner

❧

I am deeply indebted to the many people who shared of their knowledge, their time and energy, and their good faith. Thank you for your support and for helping to make this book possible.

I would especially like to thank Ansel Adams for his encouragement and inspiration during the early stages of this project. My sincere thanks go to Robert Indiana, who helped me to realize new ways of thinking about landscape photography. Jay Iselin, former president of WNET, shared his interest in conservation and his knowledge of communications. For his enthusiastic and valued suggestions I am grateful. I sincerely thank Mark and Diane Dittrick, writers, editors, and publishing consultants, for their many hours of wise counsel in all phases of this book's development. I am deeply grateful to Wendy Stewart, for her skills in the selection and sequencing of the photographs, her sensitive vision in collaborating on its design, and for her editorial advice. I am sincerely grateful to Bruce Cratsley who edited the photographs early on in the project. I would also like to express my gratitude to Geoff Gregg, for his continued encouragement throughout this project. Special thanks go to Mel Adelglass and Phil Tovlin, who have shared with me their equipment and their extensive knowledge on large format photography. I would also like to thank Carroll MacAdam, who has helped me numerous times with darkroom design and construction. For their support and advice, my thanks to Marvin Wildstein, Anne Edelstein, Michael George, Patrick Pagnano, and David Hall.

I would like to dedicate the photographs in this book to the memory of my father, Hyman Greenberg.

Joel Greenberg

COMMENTS BY
THE PHOTOGRAPHER

by

Joel Greenberg

The photographs in this book are selected from many years photographing New York City's urban wilderness. For over a decade I periodically chased the clouds around New York, hoping to be ahead of them when they arrived. I ventured out into this urban wilderness, loaded down with camera equipment, and accompanied by Baron, my faithful Laborador Retriever. In the cold of winter, and the heat of summer, we went out looking for beautiful landscapes. I recognized early on that these images were very ephemeral, and would only briefly appear before me. Often, I would return to the same spot to photograph again, from a slightly different vantage point, or with a different camera, only to find that the image I was after had vanished with the wind and the clouds. However, I always left with a vision of the amazing tranquility and beauty I found surrounding me.

When I first discovered that New York City had such an incredible landscape, 50,000 acres of green luscious beauty, I was overwhelmed by it. I felt that I was privy to a secret, one that in its small way might improve the quality of life for many people, a secret that would reveal to others the significance of New York's natural environments and the serenity to be found there. I have spent many years photographing the magnificent landscape of Maine, and each time I have returned to New York City I have always been amazed, all over again, at the diversity of natural beauty to be found within its borders.

I drew much of my inspiration during the early stages of this project from the 19th century pioneer photographers of the American West, William Henry Jackson, Carlton Watkins, and Timothy O'Sullivan. These men photographed the Wild West, not only independently, but also as part of the U.S. Geological Surveys. Their images were instrumental in helping to create legislation that laid the foundation for the National Park system that we enjoy today. In the 19th century, few people knew what natural wonders existed throughout this great country. In 1975, when *Urban Wilderness: Nature in New York City* was started, few people realized that New York City had such a magnificent and diverse natural environment. Under the auspices of Earth Environmental Group, working with Jean Gardner, I undertook this photographic survey to try to visually tell the story of New York's natural wonders. Like the 19th century photographers, I worked with medium and large format cameras, mixed my own chemical formulas, developed my own film, and made all the photographic prints that were used in this book.

From its inception this undertaking has been a most inspirational experience, and very much a labor of love. Throughout this project, my wish has been to do more than just document New York City's natural landscape. I have tried, instead, to capture its spirit, and its historical sense of place. It is my hope that these photographs, and this book, will bring many moments of pleasure into your life, just as they have been brought into mine.

FOREWORD

by

Bill Moyers

I took the galleys for this book with me on a visit to Edinburgh, Scotland, a long way from New York. Edinburgh is one of my favorite cities, not only because it is where my wife and I lived while beginning graduate studies thirty years ago, but because it truly is one of Europe's remaining gems of civilization. By civilization I mean the state of human culture where physical, spiritual and human resources converge in a social fabric respectful of individuals. One can stroll Edinburgh's streets without feeling overwhelmed. Progress has not meant a diminution of the human need for space, air and freedom. Commerce flourishes, but it has not swallowed the residential forms of life that make a city more than just a marketplace. Wherever one turns, landmarks of the past blend into the present. One is aware of the continuity of generations, and the social bustle of the moment is tempered by the gifts of nature. Not only by the assets of the Royal Bank of Scotland is the wealth of Edinburgh measured. It also is measured by gardens, parks, trees, meadows, flowers and vistas. This is a modern city, and it chose to become so without sacrificing the natural amenities of life.

Walking the curving and tree-lined streets, sitting in any number of parks within strolling distance of one another, watching the townfolk gather at dusk to dance their old highland flings in a downtown public garden, I thought of the photographs in this book and of what Edinburgh has to teach New York about the harmonies of city and nature.

Edinburgh's marriage of geography and metropolis did not just happen. It was arranged. Back in the 18th century, when the city fathers realized that the existing boundaries could no longer contain the burgeoning population or assure its economic future, they decided to build what became known as New Town, the heart of modern Edinburgh. They wanted the advantages of expansion and the trade and commerce that would follow, but they also wanted Edinburgh to be a civilized place to live. Architects were sought whose imagination would enhance geography and setting. The spaciousness and light that touch the spirit of the visitor and resident alike are there today because of conscious choices made through the years by citizens, public officials, planners and builders who believed a city was a covenant between the people who occupy it and between nature and municipality. Edinburgh shaped its human scale out of regard for the natural environment.

New York City today is just as rich in natural resources as Edinburgh. We do not have the fortunate opportunity of a fresh start, but we still have time to make our own abiding compact with nature. Just look at the photographs in this book. They constitute an inventory of our common wealth—waterfalls, streams, woods, beaches, trees, fauna, marshland, meadows, rock formations, ridges, valleys. These are the handiwork of Providence, worn and encroached upon, to be sure, but still our living ground. They could yet spare us that utterly barren cityscape which is the certain fate of a people who do not treasure the gifts of nature.

This summer, looking down upon Edinburgh from the crest of Arthur's seat—the legendary peak on the edge of the city—I was reminded that the future can unfold as the human mind envisions it: civilization can be willed. Looking at the photographs in this book, I am reminded that New York's future is still up for grabs. One sees the pictures and visits the places where they were taken, and one prays that every reader, inspired by what remains of nature in New York, will be stirred to save and nurture it.

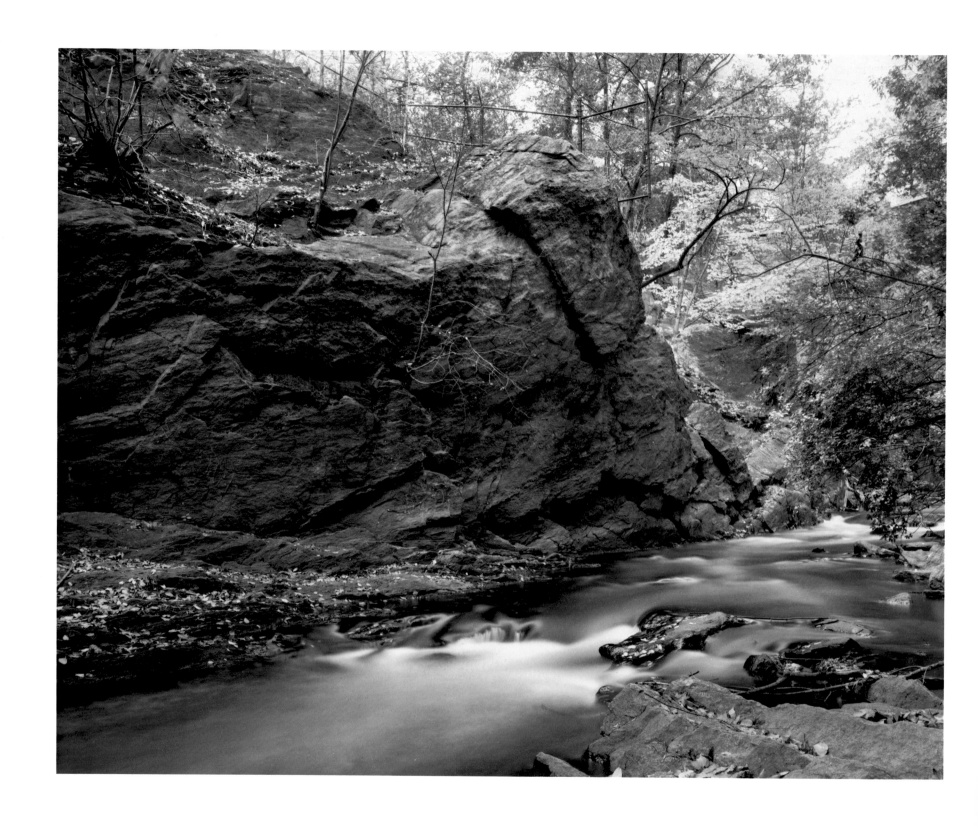

Plate 2. Gorge, Bronx River, The New York Botanical Garden, Bronx Park.

NATURE IN NEW YORK CITY

Revealing the Patterns that Connect

by

Jean Gardner

Mention New York City and most people picture the Statue of Liberty, Times Square, and the Empire State Building. Few see the magnificent natural environment of the city with its swiftly flowing rivers and meandering streams, its extensive falling-leaf forests with stands of evergreen trees, and its expansive tidal and freshwater marshes. Still fewer recognize that within New York City live birds, butterflies, fish, frogs, lizards, snakes, turtles, and many mammals other than humans. A humpback whale and deer have been sighted within the city's limits.

This book describes the rich natural diversity of New York City and reveals the new urban ecosystem that is emerging from current rejuvenation of the city's natural environment. The book's photographs result from a ten-year survey to discover nature where least expected—in the neighborhoods of New York City. During the 19th century, landscape photographs helped make people aware of the spectacular land features of the American West and of the need to preserve them. Now, in the 20th century, the photographs in this book present us with an equally unfamiliar frontier—nature as part of the modern city.

Variety distinguishes New York City's natural environment. Despite a population of over seven million, more than a fourth of New York's acreage remains city-, state-, or federally owned parkland. These almost 50,000 acres offer unexpected opportunities to experience the Earth in the midst of one of the world's most dense concrete-and-asphalt cities. San Francisco boasts the Pacific Ocean with its rugged coastline, a memorable bay, and a native chaparral ecology. Chicago can claim the Chicago River and Lake Michigan with its twenty-three continuous miles of publicly accessible beaches and lake-front parks. But right next to New York's Kennedy Airport lies a 9,000-acre salt marsh with softly swaying, feathery grasses. Near devastated neighborhoods in The Bronx grows a centuries-old forest with a hemlock grove. Chemical refineries in southwest Staten Island stand close to a 75-million-year-old sandy environment of scrub trees and shrubs that fire regenerates.

Tidal marsh, hemlock grove, sandy barren—these sites merely hint at the rich complexity of New York's unexpected native natural environment, which is the most varied found in any American city. Within the city limits exist visible bedrock, valleys, hills, ridges, bluffs, beaches, woods, and meadows. These varied lands are complemented by an extensive water system that flows through, around, over, and under them. Springs, streams, rivers, lakes, inlets, coves, bays, estuaries, a sound, a fjord, and an ocean are all part of New York City. At the same time, the wondrous saltwater and freshwater marshes give the city transitional sites that merge land with water.

Presently, the rapid growth of New York City disturbs these unique land and water systems just as it disrupts the city's architectural environment. Questions about the future of New York's natural sites mirror those about its architecture: Which natural sites and buildings should be preserved? Which restored? Which renovated? Which should be changed completely? What new natural sites and buildings should be added? Proper ecological answers to these questions can result in an interweaving of buildings with the Earth that would no longer destroy species of animals and plants, poison soil and water, pollute the air, and put undue stress on humanity. Such answers can make New York City a more viable habitat for both humanity and the natural systems on which the city depends for survival. This book describes some of those answers.

THE GEOLOGICAL AND BOTANICAL DESIGN

Fire and water laid the city's foundations eons ago. These powerful geological forces initiated the dramatic differences that are characteristic of the city's geography and are evident today in its natural sites. Intense heat produced an extraordinary mountain range 360 million years ago. Today when we encounter upthrusted bedrock in The Bronx, in upper Manhattan, and in central Staten Island, we come into direct contact with the weathered and eroded stumps of these ancient mountains.

Water in the form of a 500-foot-high glacier buried the area that was to become New York City—not once, not twice, but four times. The Wisconsin Glacier, the last of these icy masses, began to push southward from the north pole about 75,000 years ago. A series of southwesterly positioned low hills and shallow depressions, which geologists call a terminal moraine, mark its line of maximum southern advance in Queens, Brooklyn and Staten Island. The outwash of the melting glacier created the flat, sandy, coastal plain that forms southern Queens, most of Brooklyn, and parts of Staten Island.

Boulders help tell the story of the path of that last ice mass. The glacier broke off chunks of bedrock in lands distant from the area that would become New York City. It then pushed and dragged these gigantic rocks across the Earth, bringing them to this region. Marks scratched in city bedrock by the boulders and other glacial debris are still apparent today in New York's natural sites. When the ice melted, it dropped the boulders. Today many of these ancient rocks reside throughout New York City like nomads given a permanent home—silent testaments to the powerful forces of change inherent in the cooling and warming of the Earth.

As the glacier melted within what would become New York City, plant and animal habitats began to develop. Windblown seeds from the southern Appalachians and the extended Atlantic coastal plain landed here and took root. Gradual warming of the climate continually changed these flora, and they in turn affected the animal types that could survive.

Today this vegetation has its own fascinating story to tell. Each borough picks up the storyline and adds new characters, creating a botanical adventure that the curious can explore in detail. Northern plants predominate where the glaciers were, while plants associated with the Middle Atlantic states flourish in areas the glaciers never reached. As a result, the city's natural ecologies include the southernmost grove of hemlock trees near the Atlantic Ocean as well as scrubland similar to New Jersey's sandy pine forests. Other plants that grow in the city include ones native to regions as distant as Mexico or the prairie states. Unclassified plants, endangered plants, and ones so common that they are often overlooked, all live in New York City.

THE HUMAN DESIGN

During the last three hundred years humanity has also dramatically structured the land that New York City now occupies. These changes to the Earth in order to create an urban habitat are equal in magnitude to the earlier geological transformations. The human species has become a natural force as powerful as geological ones. In the 19th century, visionary individuals, such as the editor William Cullen Bryant and the landscape architect Frederick Law Olmsted, argued the need to incorporate open green spaces into rapidly growing New York City. Olmsted predicted the day when Manhattan Island, nearby Long Island, and the surrounding mainland would be completely covered with architecture. Natural sites had to be designated or one day there would be none left.

Olmsted considered green spaces to be an absolute necessity for survival in the modern city. To him, the increasing human interest in nature was "a self-preserving instinct of civilization." He felt that the human species could not sustain its current evolutionary phase without regular contact with nature. He also argued that as towns enlarged and as people developed urban habits, humanity's craving for nature grew. Experiences of nature balanced the stresses of living in cities: "vital exhaustion," "nervous irritation," "constitutional depression," and "tendencies through excessive materialism to loss of faith and lowness of spirit" were lessened when people had regular contact with nature. Urban natural sites gave city dwellers opportunities to enter "into the life and movement of nature," which is "rooted in . . . (the same) intelligence which embodies and upholds . . . man."

Many people have devoted their lives to creating ways for nature to be a vital part of the modern city. Olmsted and his followers imagined nature coexisting with urban architecture in several ways: by keeping urban shorelines and waterways in the public domain, by planting trees along roads that excluded commercial traffic, by using these tree-lined roads or parkways to connect the city's natural sites, and by providing for every human activity possible in three scales of urban open spaces: small,

medium-size, and large. Strolling, children's play, flower displays, teenage athletics, and similar small-scale activities were to take place in neighborhood green spaces; re-creation and contemplation were to be provided for in medium-size "scenic parks"; and experiences of wild nature were to be enjoyed in larger reservations.

To a remarkable degree, this 19th-century vision of urban green spaces continues to shape the policies that create New York City's open space system, just as it sets policies for most American cities, for individual states, and for the nation. In fact, the very perception of nature, unchanged by the human species, as something to be fenced in and visited did not exist two hundred years ago. Nineteenth-century observers of nature, like Olmsted, created that perception and then developed land policies to implement it—land policies that are still influential today. As a result, New York City has natural sites such as Forest Park in Queens and Inwood Hill Park in Manhattan, New York State has preserves such as the Adirondack Forest Preserve and Bear Mountain State Park, and the United States has parks such as Yosemite and the Everglades.

Currently, the Olmstedian vision has new supporters that are, often unknowingly, implementing its still unrealized features. For example, some New Yorkers, like the members of the New York City Chapter of the Audubon Society, are working to keep the 552 miles of coast in The Bronx, Queens, Brooklyn, and Staten Island free of highrises. They argue, as Olmsted did, that all people should have access to the city's rivers and ocean and that the city's inhabitants should not be walled off from these waters by buildings. Olmsted's plan to have tree-lined streets connecting major parks within the city is also being realized in the creation of greenways, such as the forty-mile Greenway in Queens and Brooklyn proposed by the Neighborhood Open Space Coalition. It will link Long Island Sound to the Atlantic Ocean via thirteen parks. In addition, today many groups, like The Parks Council, envision more small neighborhood parks, particularly in underserved areas—a fulfillment of Olmsted's prediction that these small-scale, neighborhood sites would be needed to serve the everyday outdoor needs of humanity.

Regrettably, the 19th-century vision of nature is also responsible in part for the 20th-century deterioration of the urban natural environment. Many of the policies and designs fulfilling that vision needed a level of management and maintenance that today's modern city cannot sustain. The mid-20th-century degradation of parks designed by Olmsted attests to this situation. Nor has nature been able to maintain these parks because Olmsted's designs were not ecologically based. Other parks, not designed by Olmsted, that contained ecologically based natural systems also deteriorated. Little or no knowledge of how ecological systems work often led to the misuse, even to the destruction of their natural ecologies. Cunningham Park with its forest and Pelham Bay Park with its marshes are examples of parks in New York City with ecological systems that deteriorated. Nor is this the extent of the influence on the urban natural environment of 19th-century ideas about nature. Pollution of air, ground water, soil, and rain; loss of plant and animal species; and lack of understanding about appropriate park uses, ecology, and humanity's relation to the Earth—all helped produce a crisis in New York City's natural sites by the mid-20th century.

RECIPROCITY

In response to the deterioration of the urban natural environment, today's visionary efforts to sustain nature in New York City embody a reciprocity between nature and the city. The initiators of these efforts realize that human life depends on maintaining the natural processes of the Earth. Their work strengthens the biological and physical systems within urban natural sites. Their park plans also provide for the physical activities and for the psychological/spiritual relief that 19th-century park advocates knew the modern city must offer its inhabitants.

Recent scientific research in botany, biology, ecology, hydrology, atmospheric chemistry, human psychology, and medicine indicates the complex reciprocity between humanity and natural systems. To understand this give-and-take within New York City, all the features of the city can be described under four headings: earth, air, water, and life forms. Earth includes not only the rocks and soils of the solid parts of the city but also their transformations into buildings, roads, and other human artifacts. Air is the mixture of gases that New Yorkers breathe, from car fumes to ocean breezes. Water comes in many forms in New York City, among them fluoridated tap water, freshwater ponds, and acid rain. Life forms are divided into five kingdoms, two of which belong to vegetation and animals. The other three kingdoms cover such living phenomena as bacteria, amoebas, and fungi. Vegetation in New York City ranges from native plants that are also found as far south as North Carolina to vegetation that lives naturally as far north as New England. In addition, the category of vegetation includes the plants and food brought into the city from all over

the Earth as well as substances like lumber that are made out of vegetation. Animals span the living beings of the city, such as warm-blooded native vertebrates like the bobwhite quail and non-native vertebrates like the human species.

The patterns that connect earth, air, water, and life forms at the mouth of the Hudson River shape the New York City habitat. These patterns are such that earth, air, water, and life forms are all homes for each other. Bacteria live in humans and humans live in air and buildings. Buildings are made out of materials that are derived from vegetation and earth. Vegetation lives in earth or water. Earth and water originate from combinations of fundamental chemical elements—the origin of everything.

Ultimately, because earth, air, water, and life forms are all homes for each other, whatever humanity does to the other residents of its habitat, the human species does to itself. Thousands of years ago, humanity sheltered itself in caves. Millions of years ago its primate ancestors inhabited trees. Today, humanity lives in buildings constructed with materials developed from earth and vegetation. The crucial difference between the way modern humanity protects itself and the way its prehistoric ancestors did is that now humanity dramatically alters earth and vegetation to make possible its own survival.

Current knowledge of human evolution suggests that the origins of the genus Homo, which includes modern humanity, took place in the African tropics approximately two million years ago. The only way the human species can survive in a place with a climate different from the African tropics at that time is by altering the place. During the last three hundred years, the power of humanity to modify the planet so it can survive in inhospitable places has become comparable to the very geological forces that shaped the planet itself. One of the principal tools humanity has invented to make uncongenial places habitable is urbanization. But, as in the case of New York City, humanity cannot sustain urbanization in a particular place unless it balances human needs with those of the biological and physical systems proper to that place and its bioregion.

The current crisis in New York City's garbage disposal exemplifies this situation. All but one of its dump sites are filled—Staten Island's Fresh Kills Marsh. The proposal to build burn-plants within the city attempts to solve one systemic problem by compounding already existing ones. The burn-plants will add still more pollutants to the region's already fouled air, which, in turn, will defile even more earth, water, and life forms. As it is, over 2,000 known contaminants currently are being spewed into New York State's air. The systemic solution lies in understanding human garbage as part of nature's recycling system.

When the interrelated needs of a particular region are not adequately considered in a habitat, the habitat deteriorates and eventually dies. If humanity does not move to another place, it will die with its habitat. Species survival depends on habitat survival because species and their habitats are inextricably bound together. In nature there is no such thing as a self-sufficient species or individual.

Despite the need to sustain patterns that connect humanity to natural systems, modern building practices make it appear that the human species does not depend upon its habitat. Glass skyscrapers, shopping malls, tract housing, and the ubiquitous lawn look alike wherever built. They have led people to believe that one place is much the same as any other and that humanity's well-being is not determined by individual places or the planet as a whole. But New York is not Boston, nor is it New Orleans. Each bioregion on the planet is different. Its open spaces are not empty lots waiting for development. Instead, open spaces constitute natural sites whose biological and physical processes have already developed them into systems vital to helping sustain the multitude of life forms within a bioregion. Along the Atlantic Ocean and within the Hudson River Valley, earth, air, water, and life forms other than humanity have structured patterns more complex than that area's urban sprawl. If humanity intends to sustain New York City, it must enter into a reciprocal relation with these patterns.

A MORE SUSTAINABLE CITY

Today private and public groups in New York City are developing plans that are reciprocal with the Earth because the plans strengthen patterns that connect the biological and physical systems of the New York City habitat. These groups are transforming their habitat by creating a new ecosystem that links earth, air, water, and life forms in more life-enhancing ways than previously existed. Whether the land in question is renovated, restored, managed, or changed, these rejuvenating plans indicate an understanding of New York City's relationship to the specific place it is located, to its bioregion, and to the planet as a whole.

For example, on landfilled salt marshes at defunct Floyd Bennett Airfield in the Gateway National Recreation Area, the Department of the Interior and the New York City Chapter of the Audubon Society are simulating Hempstead grasslands, an ecology unique to another part of Long Island. This simulation within

New York City of a rapidly disappearing regional ecology saves that ecology, provides a sanctuary for homeless plants and animals, enhances the city's biological systems, and maintains diversity by sustaining the natural systems of the bioregion. It is helping to make New York City more life-supporting. On Staten Island, plans to incorporate existing natural wetlands in South Richmond into a much-needed storm drainage system exemplify another form of reciprocity between humanity and the Earth within New York City's new ecosystem—a reciprocity that solves human problems, not by favoring one species, the human, over others, but by understanding the patterns that connect species of plants and animals to each other.

Other projects and policies are contributing to the new ecosystem. One such project allows indigenous vegetation to replace exotic species in parks designed by Olmsted and his partner, the English architect Calvert Vaux. Indigenous vegetation renews and enriches local ecologies, making the parks more sustainable and encouraging the return of native wildlife. This can be seen in deliberate departures from Olmsted's and Vaux's original design for Brooklyn's Prospect Park. These departures permit native plants to thrive, thus providing food and shelter for fish, frogs, insects, waterfowl, and birds, including pied-billed grebes, red-winged blackbirds, and a pair of black-crowned night herons.

Current policy guiding management of Riverside Park strengthens the new ecosystem through its reciprocity with the Earth. This policy reinforces human-created natural systems that are weakened by use of the park: the heavily used lawns and other grassy areas of Riverside Park are reseeded twice a year. Without constant restoration, these lawns would turn into dust bowls. In addition, the current tree planting program is replacing the monoculture created by park neglect with a rich diversity of trees: evergreen and sourwood trees now grow at Mt. Tom within the park instead of the all-too-common black cherry tree.

Another policy that supports the newly emerging urban ecosystem is one that is the exact opposite of Riverside Park's. In The Bronx, Van Cortlandt Park managers have keyed human use of that park's largely native forest to the natural systems of the forest's ecology rather than allowing activities that would destroy it. Recently marked trails involve those who follow them in forest life with only minor disturbances to the woodland. Such low-intensity human use makes frequent restoration, which is absolutely necessary in Riverside Park, unnecessary in Van Cortlandt Park's forest.

What is common to these two opposing park policies is their understanding of the give-and-take between humanity and the Earth—an understanding crucial to helping to sustain the human species and nature. Because humanity strains the human-made natural systems in Riverside Park more than it does the forest systems in Van Cortlandt Park, Riverside Park policy requires regular park restoration, forest policy in Van Cortlandt Park does not.

In yet another life-supporting proposal, the New York City Parks Department intends to change existing features in some parks that are being restored in order to reincorporate indigenous ecologies: in Alley Pond Park in Queens, current plans call for rehabilitating salt marshes. A particularly outstanding effort to create greater human reciprocity with the Earth is the cultivation of native plants endangered by the human species. Botanists searching on Staten Island for native plant species have already found thirteen of the twenty-seven plants on the state's endangered species list, including green milkweed, sweet bay, and lowland fragile fern. These plants will be introduced into natural sites throughout New York City.

The above-mentioned policies and others like them for New York City's natural sites begin to reconstruct New York as a city more responsive to its place on the Earth. The proposals integrate human intention with other natural forces that act on the city and its bioregion. Much more needs to be done to make New York City sustainable, but the patterns that are being revealed through place-responsive revitalization of the city's natural sites could become models for the rest of the city. They could guide the creation of a New York City habitat characterized by life-supporting relationships between the human species, the built environment, and the Earth—relationships in which humanity no longer ignores or exploits the Earth but maintains a reciprocity with it. The details of this phase of the human adventure have yet to be written, but its outline emerges as humanity recognizes itself as part of the Earth.

"Earth, is this not what you want,
Invisibly to arise within each of us?"
Ninth Duino Elegy, Rainer Maria Rilke

THE BRONX

The Bronx is the name given to a peninsular extension of the North American continent that forms New York City's only mainland borough. Its terrain creates a varied landscape of craggy heights and low valleys, rocky shores and coves, saltwater and freshwater marshes, bogs, swamps, meadows, and forests, including one that shelters a grove of hemlock trees.

Ecologies representative of the borough's diversified natural environment are located in Pelham Bay Park on Long Island Sound, in The Bronx Greenbelt District on the shores of the Hudson River, in Bronx Park along the Bronx River, and in Van Cortlandt Park, through which Tibbett's Brook flows. Today naturalists from the Natural Resources Group of the New York City Department of Parks and Recreation and from The New York Botanical Garden are systematically identifying the plants and animals that make these sites their homes. Along the Hudson, where community groups are organizing to establish public access to the river, the naturalized Asian ring-necked pheasant has been sighted. In Pelham Bay Park on the borough's eastern shores raccoons, opossums, skunks, muskrats, cottontails, and chipmunks live. Mussels and green crabs live at the mouth of the Bronx River, the northern and southern sections of which are being restored. In Van Cortlandt Park naturalists have verified that sugar maples are regenerating and that deer as well as red-tailed hawks can be seen.

CARING FOR THE LAND

The Natural Resources Group and the Administrator's Office for Pelham Bay Park and Van Cortlandt Park and for the management of Riverdale Park and Seton Falls Park are develop-ing management plans for these natural sites based on inventories of vegetation and wildlife. Ten years ago park policies often interfered with the workings of nature or even destroyed vital ecologies to build single-purpose recreational areas. Today management plans, when based on inventories, frequently favor the immediate needs of plants and nonhuman animals by allowing nature to take its course. For instance, such park policies no longer clear forests of dead, decaying trees to satisfy the human aesthetic preference for manicured, highly unecological forests. Decaying trees provide nutrients needed by soil, vegetation, and forest organisms.

Converting forests and marshes into single-purpose recreational areas, such as ballfields and playgrounds, became particularly popular during the 1930s, 40s, and 50s. At that time, humanity seems to have forgotten the benefits it receives from allowing the biological and physical systems of the Earth to function. To begin with, many city dwellers spend precious vacation days going far afield to find functioning ecologies. These vacationers seek the psychological and physical relief from streets and buildings that forest, marsh, bay, and beach provide. The cyclical round of migratory and resident animal life and of budding, flowering, and dormant plant growth in all natural sites as well as the hypnotic tides in saltwater environments rejuvenate the human species. Experiences of these natural events reaffirm humanity's relationship to the vital patterns that connect earth, air, water, and life forms.

As well as bringing the psychological and physical relief of nature right into the urban habitat, the natural systems of The Bronx offer ecological benefits: Bronx forests help make city air breathable by cleaning it, and its marshes spawn fish that are

caught in surrounding waters and eaten by urban inhabitants. These salt meadows as well as the borough's forests also produce oxygen, which helps keep not only water and wildlife alive but also humanity.

Proposing to allow nature to take its course in forests and marshes within Pelham Bay Park, Van Cortlandt Park, and Riverdale Park can mean permitting earth, air, water, and life forms other than humanity to interact in as close to pre-urban patterns as possible. Park policies that encourage pre-urban patterns align present-day human activities in these park sections with the ancient geological processes that created the precolonial Bronx landscape. More than 480 million years ago the region of the present Bronx habitat formed part of a great trough-like depression that extended over what is now the mountain and plateau areas of the Eastern United States. This prehistoric depression filled with rock fragments that through a series of dramatic geological events transformed into craggy mountains. Continuous erosion wore the mountains down into the land forms found today in The Bronx.

The future geological evolution of The Bronx landscape is unknown. Management plans that permit the biological and physical systems of the Earth to function in natural sites in The Bronx couple the evolution of the human species with that of the Earth. Their authors, recognizing that humanity has the potential to destroy, create, or reciprocate with these systems, choose to reciprocate. They recognize that human desires, conceived in isolation from these systems, disrupt not only the Earth's evolution but threaten humanity's survival.

PELHAM BAY PARK

Within the 800 forested acres of Pelham Bay Park letting nature take its course necessitates a certain amount of human cooperation. Native Americans and colonists cut so many conifers on Hunter Island, which is within the park, that today this forest has fewer of these trees than it would have had if humanity had not interfered with the forest's growth. Management plans call for creating a forest ecology similar to the one that existed before the conifers were cut. To do this, exotic weed trees—such as the tropical, ill-scented ailanthus—will be replaced with native conifers. Planting conifers encourages the return of great horned owls, barn owls, and snowy owls, which feed and shelter in these trees. The resulting forest will, of course,

not be exactly the same as the pre-urban one. It is impossible to simulate precisely an ecology that has been disturbed. Instead, a new kind of forest ecology will emerge—one in which humanity, rather than being disruptive as it has often been in historic times, recognizes its reciprocity with the forest and works to strengthen the forest's ecology.

Observers notice that the natural features of the coastline of Pelham Bay Park resemble Maine's. Exactly. The firm bedrock of New England reaches down to the water's edge in The East Bronx. Pelham Bay Park protects approximately two and a half to three miles of the southernmost extension of that New England rock complex. This rocky shore, like the Pelham Bay forests, is yet another aspect of the park's 2,764 acres that made it "the grand park on the Sound" that its 19th-century creators wanted for New York City. One hundred years ago the New York Park Association boasted that this site possessed "diversified grounds, rolling, healthful, well-wooded, almost sea-surrounded, and of generous amplitude." The park still has such lands today, and with present proposed management plans it promises to rejuvenate their ecologies.

BRONX PARK

Geological processes caused all three of the principal rock formations found in The Bronx—Manhattan schist, Fordham gneiss, and Inwood marble—to lay the foundation for what became the 721 acres of Bronx Park. The influence of these rocks can be seen in the differing land forms found in this park. For instance, Inwood marble, which erodes the most easily of the New York City rocks, created the low, wet spongy areas of the park. The harder rocks—Manhattan schist and Fordham gneiss—formed the basis for the park's forty-acre New York Botanical Garden Forest.

Known for its hemlocks, this forest boasts a four-acre Hemlock Grove that is the furthest south along the Atlantic Ocean that these trees grow. Currently, The New York Botanical Garden is trying to reduce the human impact not only on the Hemlock Grove but throughout the entire forest. A team of scientists and managers has begun a long-term study of the changes in its plant and animal communities. They have set aside permanent plots that are twenty meters square where they are studying how nature behaves without direct human intervention in a region with over 17 million people. They are committed to doing noth-

ing in these areas except observe. The management objective for the forest is to promote the reproduction and growth of native species while minimizing changes caused by human activity. The study is being repeated in the forests of Pelham Bay Park and Van Cortlandt Park. Soon we will have unique information on how urban nature functions within three natural sites in a borough that is usually associated with rubble-strewn lots and abandoned buildings.

VAN CORTLANDT PARK

Inwood marble and Fordham gneiss, as well as Yonkers gneiss, structure the 1,146 acres of Van Cortlandt Park. Inwood marble forms the basis for one of the major geological features of the park, the watershed basin that now holds Tibbett's Brook and Van Cortlandt Lake. Fordham and Yonkers gneiss constitute the two high ridges bordering that watershed basin.

These rocky ridges resulted from millions of years of water erosion from the original Tibbett's Brook. On these ridges today botanical and wildlife habitats can be found that nourish groves of native hardwoods, shrubs, and other woodland plants. In summer, next to 100-year-old black, red, and white oaks, tulip trees lift their flamboyant blossoms skyward. In open areas between the trees, the curled fronds of twelve varieties of fern unfurl every spring, among them bracken, cinnamon, Christmas, sensitive, and royal. Naturalists from the Natural Resources Group have also found plants, such as golden seal, listed on the New York Natural Heritage Special Plant List of Rare and Endangered Plants. There has been no record of this plant living in The Bronx until now. Places like the forest in the northwestern section of Van Cortlandt Park typify the park's 600 forested acres. These woodlands were never farmed nor cut in the way that the Hunter Island forest in Pelham Bay Park was. To function ecologically, therefore, the Van Cortlandt Park forests need less human assistance than the Hunter Island forest does.

The sluggish waters of Tibbett's Brook originate in Yonkers and flow southward through The Bronx to empty into the Harlem River. Along the way, these fresh waters pass through the Tibbett's Brook marshes in Van Cortlandt Park, three of which are human-created. Then the waters flow through the human-built Van Cortlandt Lake, which is also fed by water from the Croton Reservoir. Because nearby highways drain into the marshes, the marshes require human assistance. If they are not dredged and if city sewers are not provided to divert the highway drainage, the marshes will soon silt up and disappear. Thus, in Van Cortlandt Park forests, letting nature take its course means less human support of natural systems than is needed in the woods on Hunter Island in Pelham Bay Park, but in Van Cortlandt Park marshes, the management policy calls for decisive action to prevent their destruction.

During fall and spring migration, the Van Cortlandt marsh and lake areas are a favorite haunt of the human species, because these sites are frequented by red-winged blackbirds, swallows, crows, mallards, woodcock, myrtle and yellow warblers, kinglets, goldfinches, phoebes, barn owls, shovelers, grebes, canvasbacks, mergansers, wood ducks, bittern, little green herons, great blue herons, and American egrets. Starlings, blue jays, cardinals, mockingbirds, and mourning doves who reside here year-round can also be seen, while purple grackles, thrushes, thrashers, robins, and catbirds visit during the summer.

These treasures in Van Cortlandt Park, like those in Pelham Bay Park and Bronx Park, exist today within one of the world's largest and busiest cities, stirring the imaginations of all those who explore and discover the natural lands of The Bronx. These lands serve as a reminder of the nature that once completely occupied the city's site. But humanity now surrounds these few remaining vestiges of nature in The Bronx, just as it surrounds it in the rest of the city. Plans to let nature take its course in sections of Riverdale Park, Pelham Bay Park, Bronx Park, and Van Cortlandt Park are beginning to reverse the destruction of the Earth in New York City. Soon natural sites in The Bronx could become a symbol of a new, coevolutionary relationship between humanity and the Earth, one structured to connect earth, air, water, and life forms within New York City in more life-perpetuating patterns.

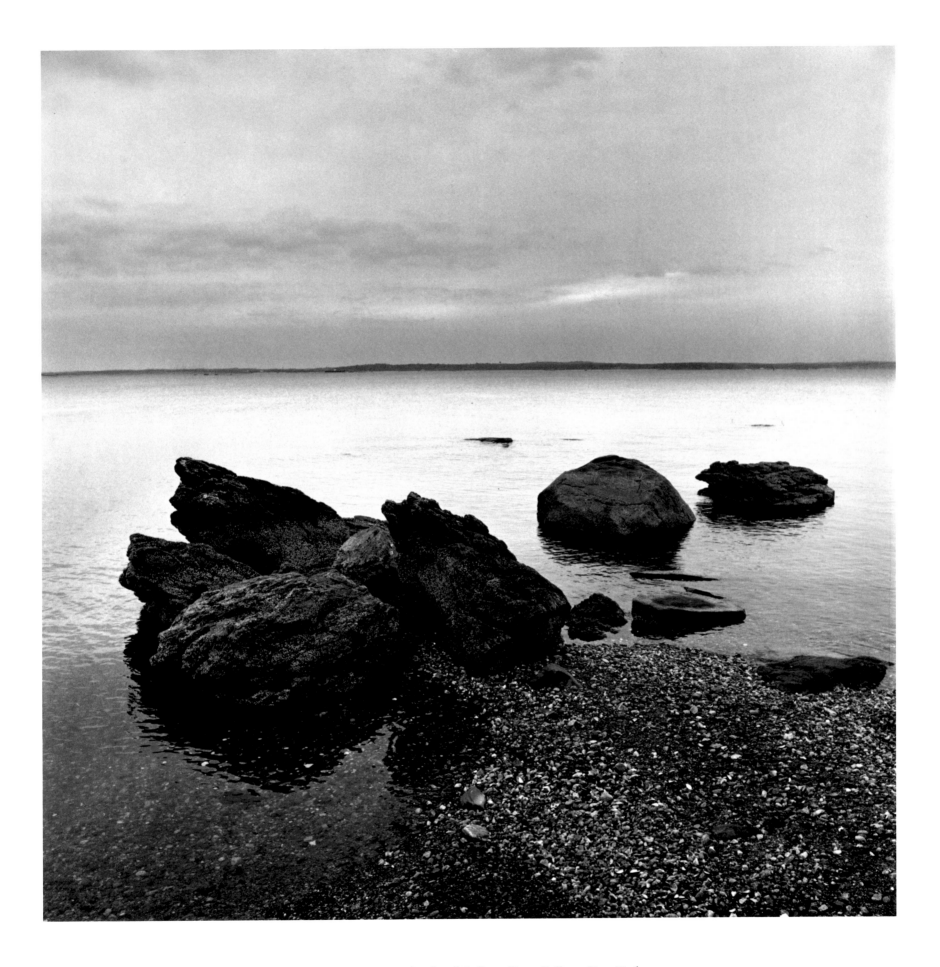

Plate 3. Hunter Island and Pelham Bay, Pelham Bay Park.

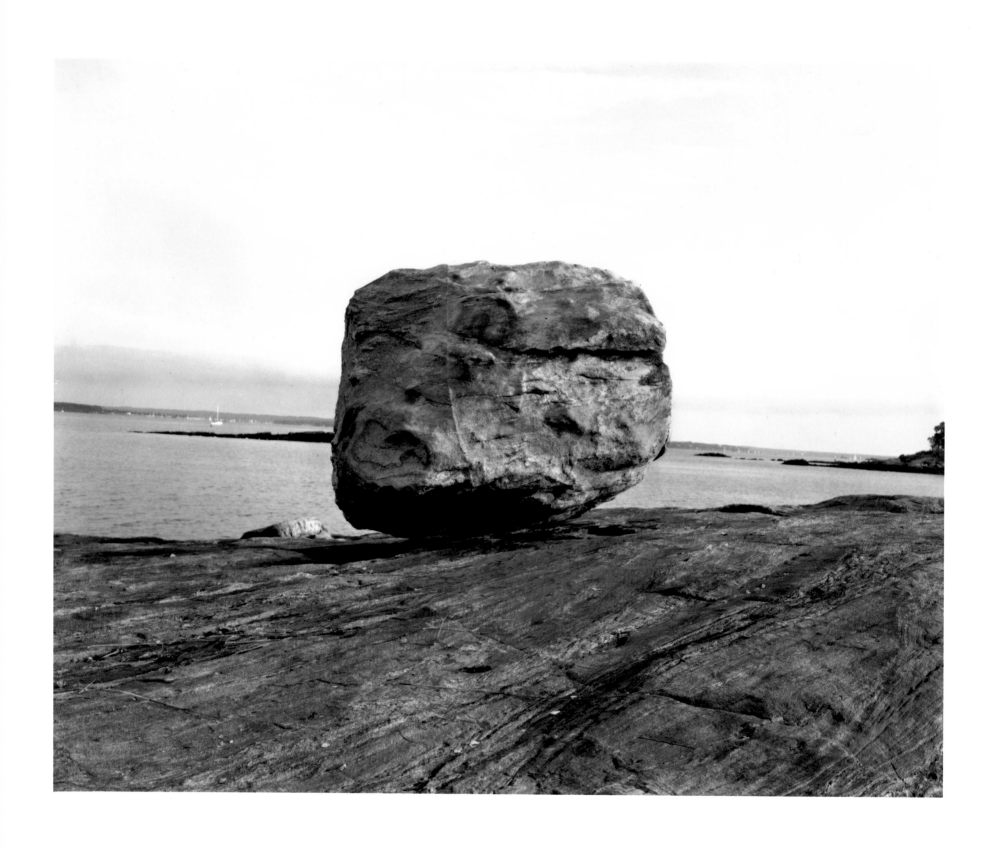

Plate 4. Glacial Erratic Boulder, Hunter Island, Pelham Bay Park.

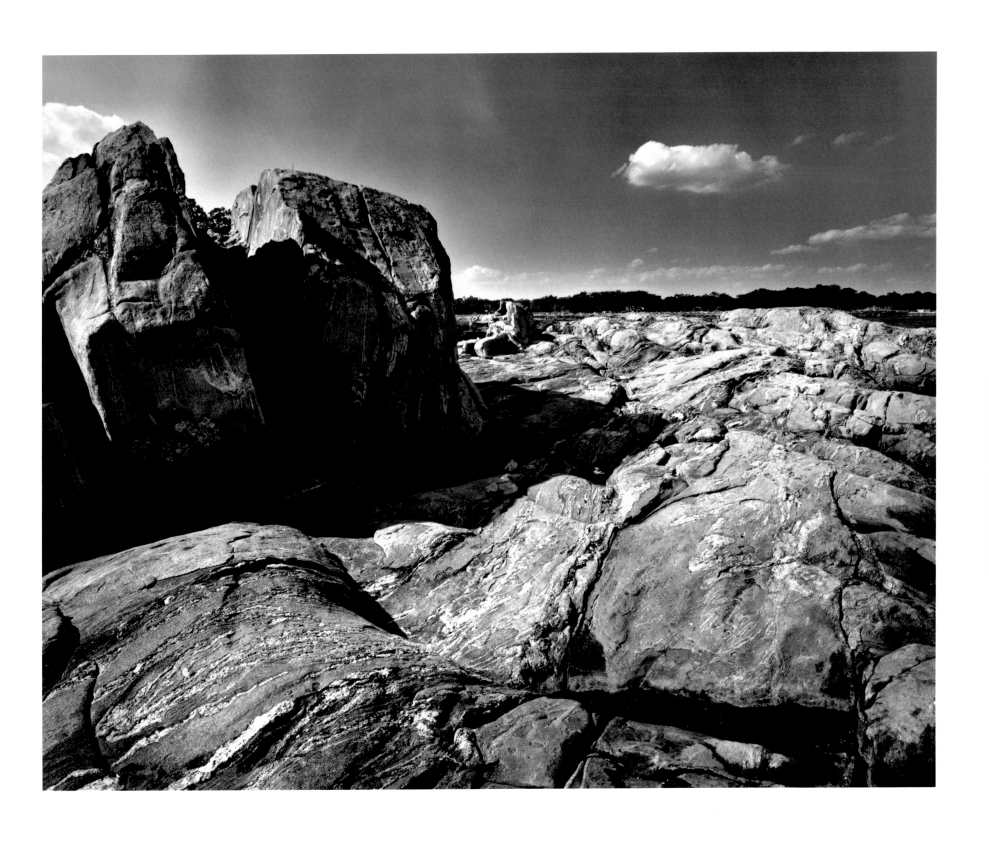

Plate 5. Rocky Shoreline, Hunter Island, Pelham Bay Park.

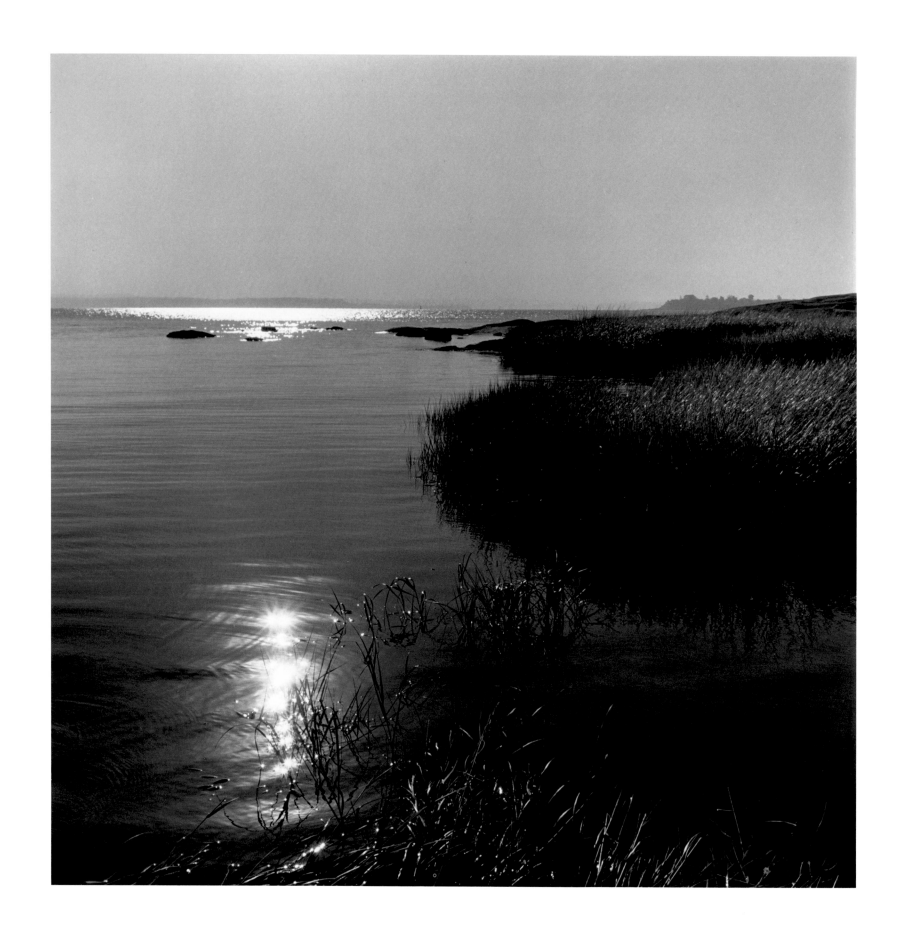

Plate 6. Bay and Marsh, Hunter Island, Pelham Bay Park.

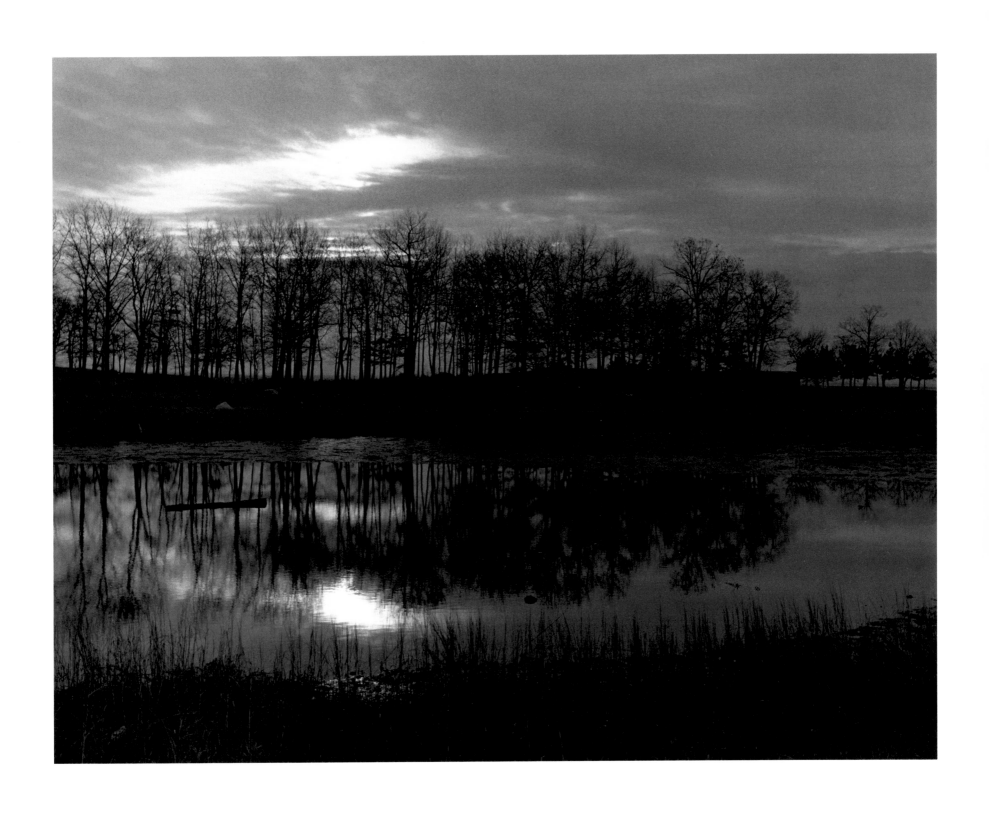

Plate 7. Twin Islands, Pelham Bay Park.

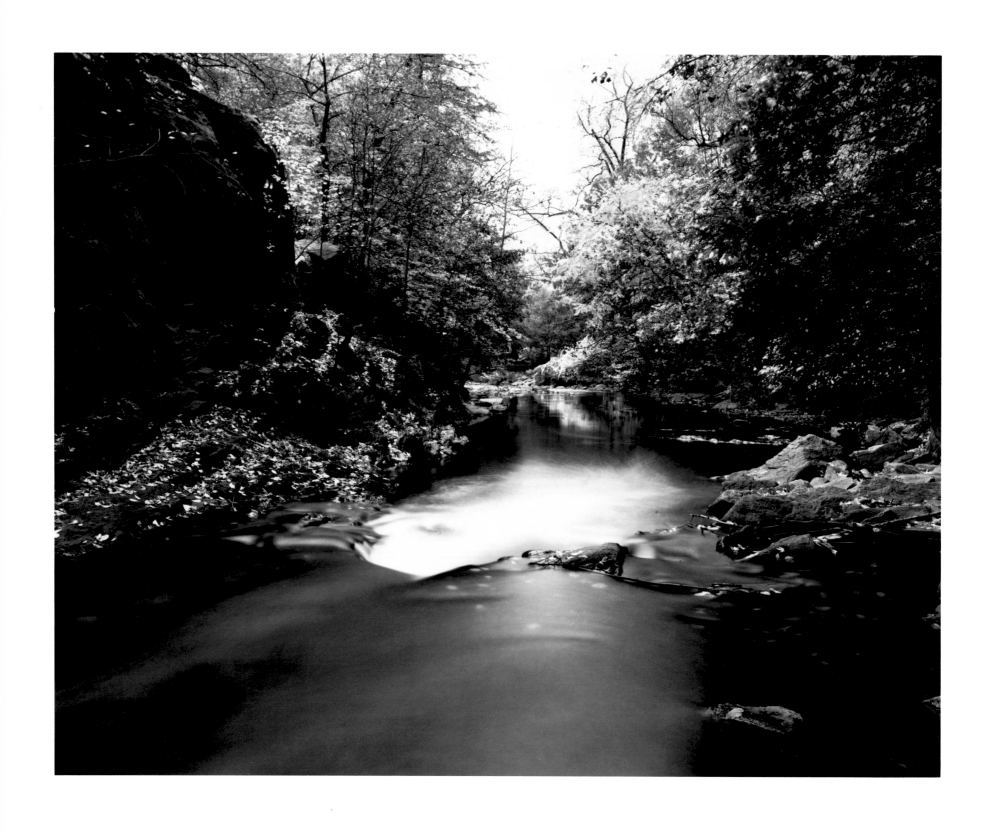

Plate 8. Bronx River, The New York Botanical Garden, Bronx Park.

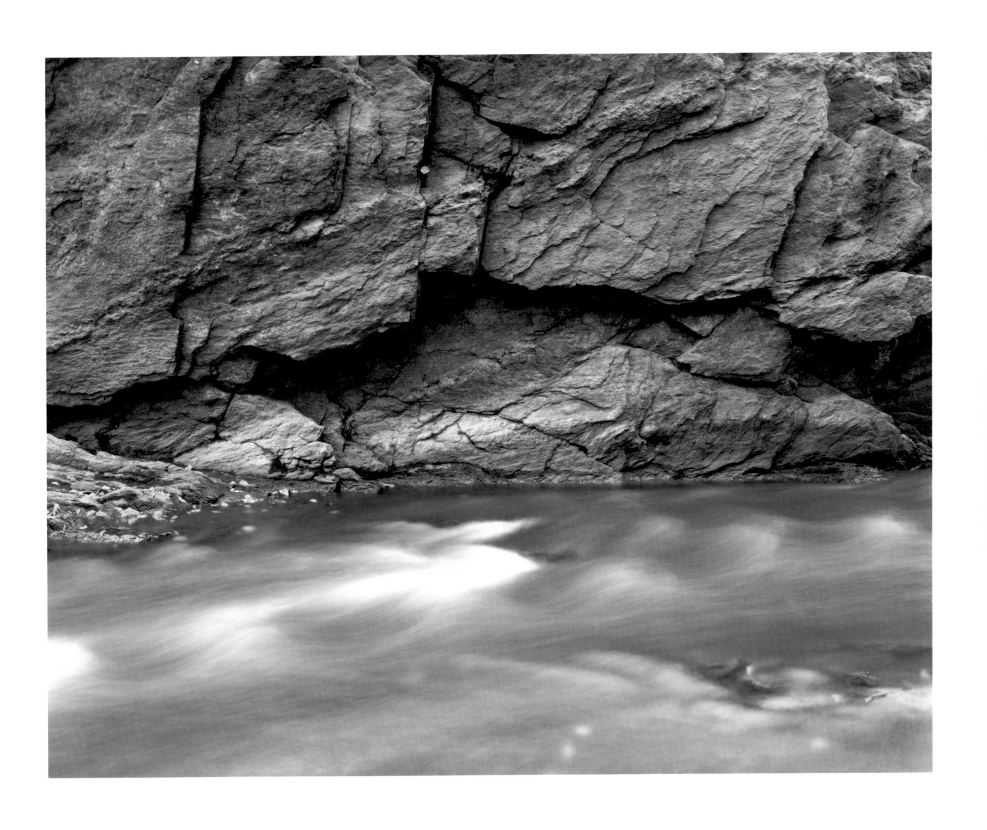

Plate 9. Bronx River, The New York Botanical Garden, Bronx Park.

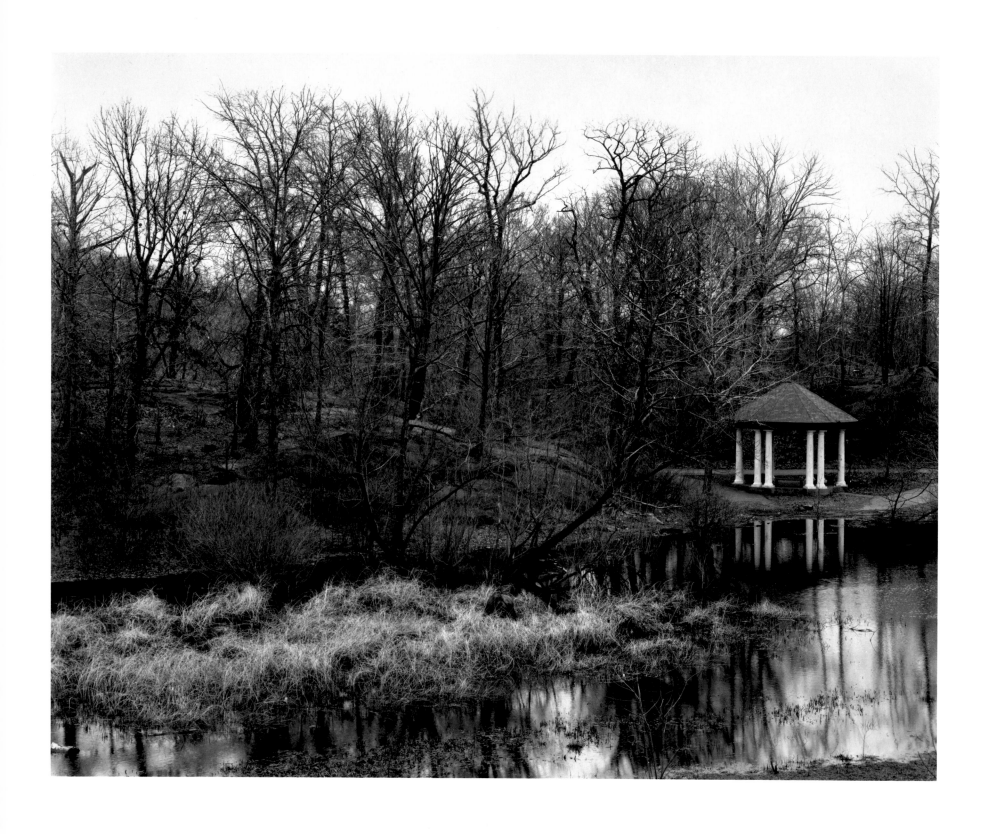

Plate 10. Marsh, The New York Botanical Garden, Bronx Park.

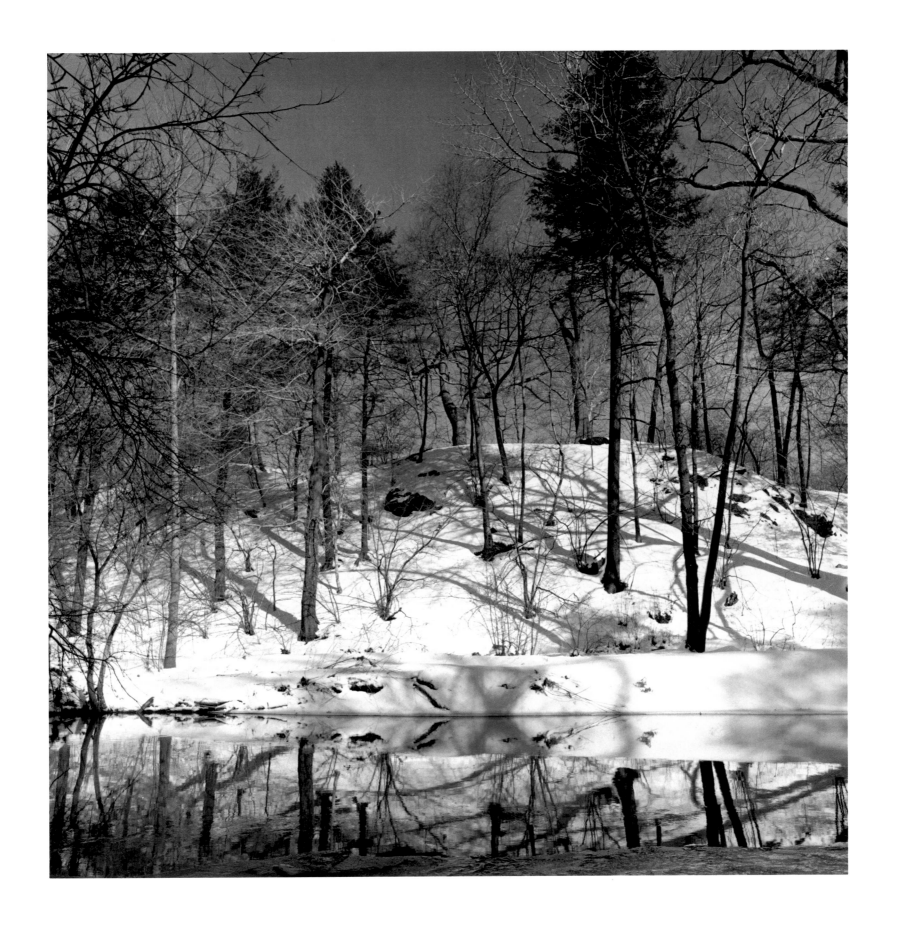

Plate 11. The New York Botanical Garden Forest and Bronx River, Bronx Park.

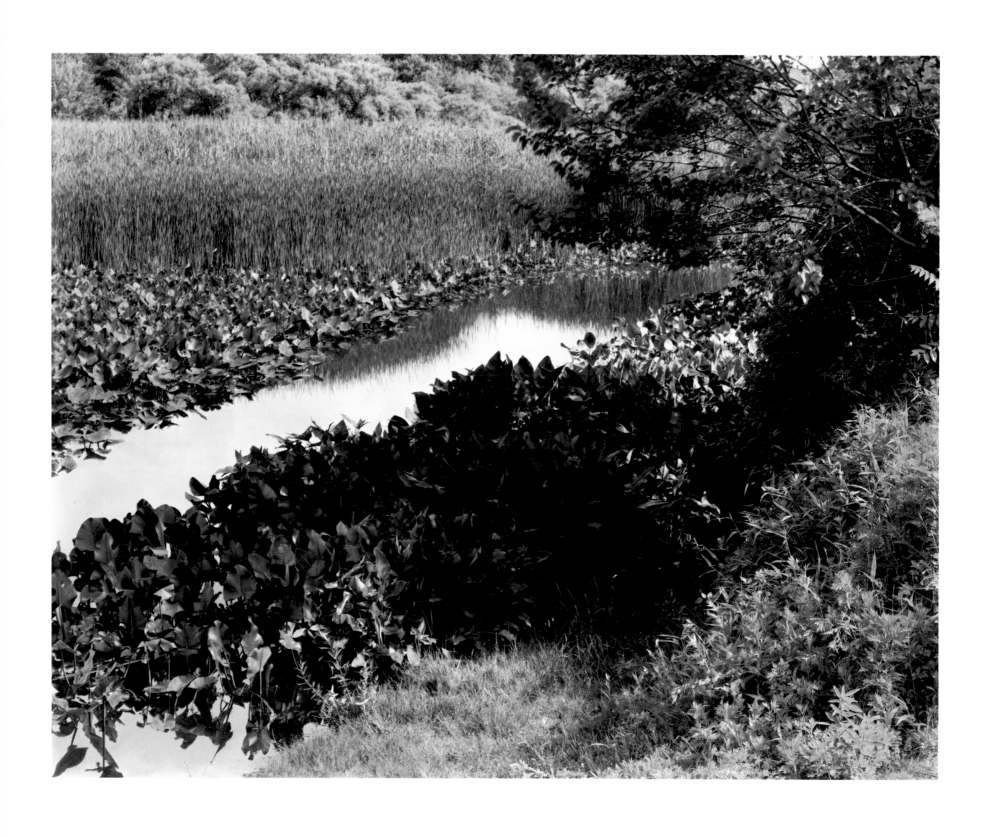

Plate 12. Tibbett's Brook, Van Cortlandt Park.

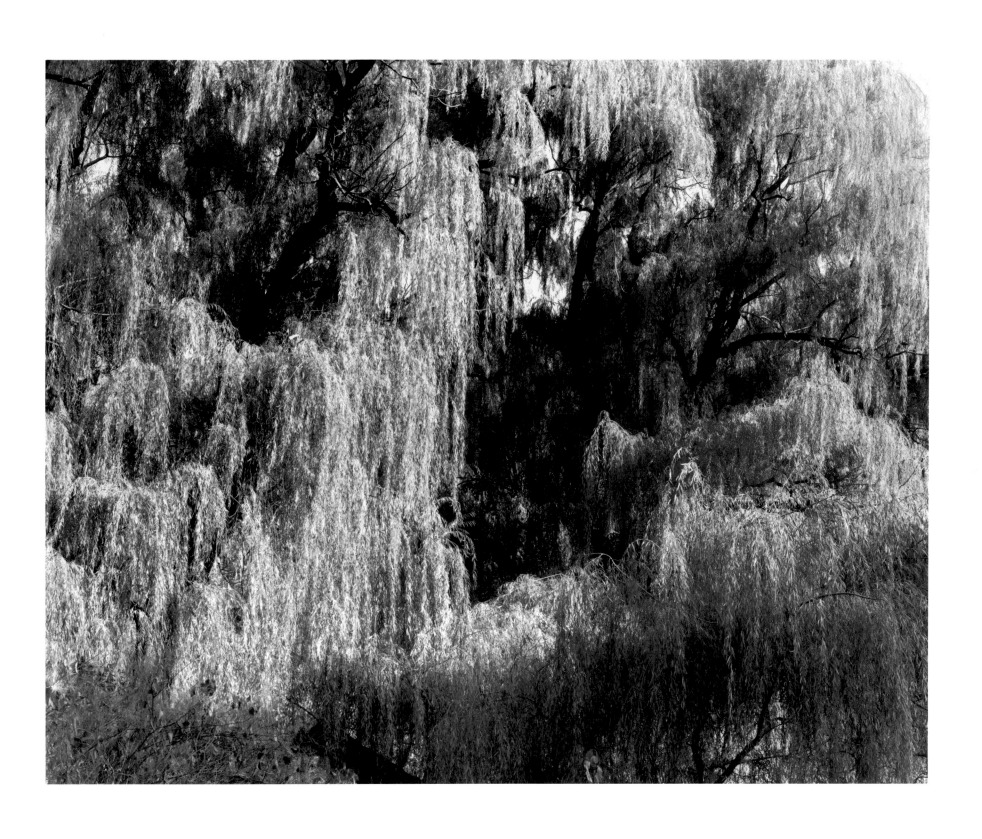

Plate 13. Willow Trees, Van Cortlandt Park.

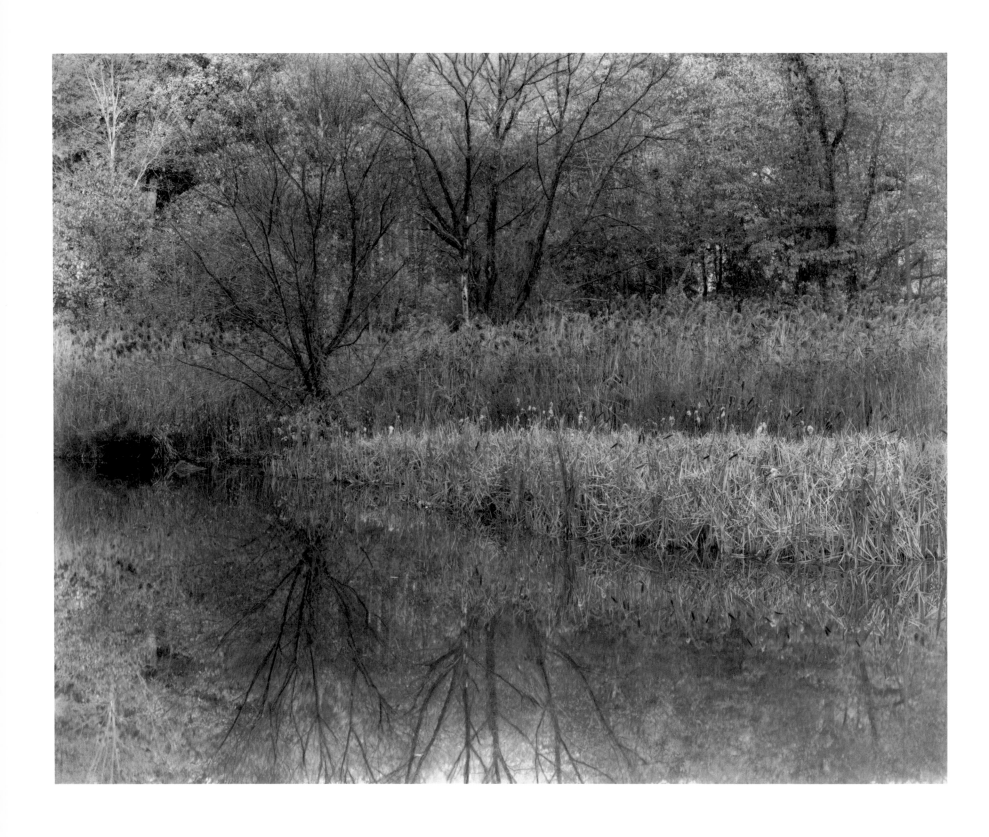

Plate 14. Shrub Wetland, Van Cortlandt Park.

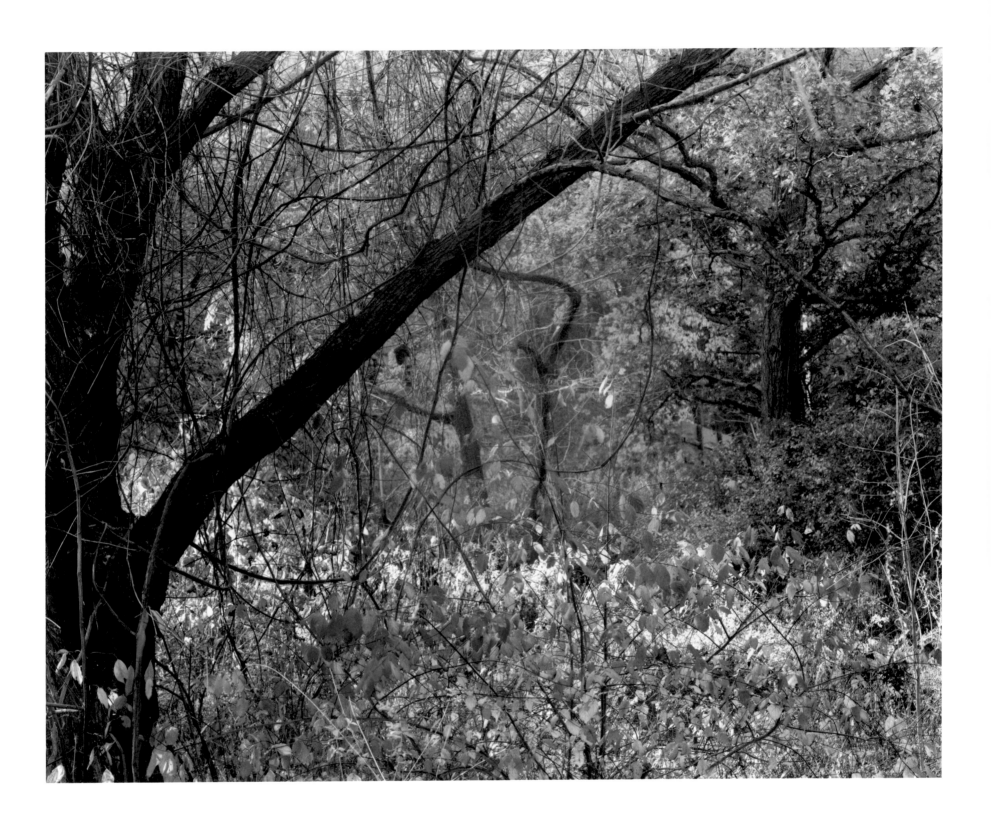

Plate 15. Forested Wetland, Van Cortlandt Park.

MANHATTAN

~

Three hundred years ago a dense forest edged by salt marshes covered the island that would become the center of New York City. Streams and brooks meandered among rock outcroppings and bear, deer, and elk fed on the island's abundant vegetation. This favorable site proved to be one of the most commanding locations on Earth for a city.

Native Americans called it "Manna-hatin" or "island of mountains." Their mountains resulted from the first of two mountain-building eras that created the Manhattan of today. The mountains that Native Americans knew metamorphosed 360 million years ago on an older terrain of between 450 million to 480 million years old. Weathering and erosion have worn the majestic 360-million-year-old peaks down to the stumps that are now characteristic of present island bedrock. At their highest point in Fort Tryon Park, they reach 270 feet. Today, however, residents and visitors to Manhattan see an island that is in the midst of its second mountain-building era. The new skyscraping landmasses use stone quarried from all over the Earth. The force of nature that is creating these new skyscraping "mountains"—humanity—is debating heights of 2000 feet.

CITY-BUILDING

Seeing humanity as a natural force and city-building as a natural transformation of Earth's materials helps to clarify the relationship between the human species and the Earth. The buildings, streets, and open spaces of Manhattan, far from being extraneous to their island site, are actually integral to it. Such artifacts constantly add to and subtract from the Earth; they affect its air and water quality, its climate, vegetation, and inhabitants, just as all the other forces of nature do.

Nor does the ability of the human species to affect cities consciously make cities any less natural than anthills. Skyscraping mountains, like anthills, result from an animal species that collectively inhabits a place on the Earth. And, again like anthills, cities change the places they occupy and depend for their survival on the degree to which those changes are life-supporting.

In the midst of Manhattan's present mountain-building era, its natural sites help New York City to be life-sustaining. They promote ecological health and unite Manhattan's urban residents with their origins by providing them with opportunities to experience the Earth from which the human species evolved. The time that people spend in natural sites also nurtures familiarity with animals whose instinctual life mirrors theirs, helping them to understand their own primal behavior. Witnessing a startled bird's response to an intruder in its territory helps the human observer decipher his or her own reactions when an unexpected word or movement takes him or her by surprise. Watching a chipmunk furtively skirt an unfamiliar presence, with a combination of fear and interest, strikes a chord of recognition in anyone who has felt uncontrollable curiosity.

Natural sites within Manhattan also make visible the island's ancient past. Manhattan's past can still be seen in Central Park. The southernmost exposure on the island of its 360-million-year-old rock foundation marks the boundary of the park at 59th Street. Below 59th Street, city streets and buildings hide the

bedrock from view. At the north side of Washington Square Park, the bedrock dips to a depth of several hundred feet below the Earth's surface. At Chambers Street, it again comes back to within one hundred feet of the surface and stays there until the southern tip of the island. Thus, the greatest densities of skyscrapers, in Midtown and the Wall Street area, result directly from the closeness of bedrock to the Earth's surface. Like the effect of buildings on air and water quality, climate, and vegetation, this interrelationship between the location of bedrock and the siting of skyscrapers is another indication of the connection between humanity and the Earth.

CENTRAL PARK

The competition for the design of Central Park in the 1850s began the modern city's design-conscious efforts to include large natural sites within its limits. Frederick Law Olmsted, the landscape architect whose vision helped to shape today's urban nature, and the English architect Calvert Vaux created the winning design to rework the 843 acres in the middle of the island into Central Park. At that time, no one could imagine the day when the barren wasteland selected as the location of Central Park might be coveted as a site for buildings that would "scrape the sky." But the twists of history have made Midtown Manhattan a commercially thriving area. As a consequence, two different methods that humanity has developed for its habitation of the Earth—parks and buildings—now dramatically juxtapose each other in Midtown.

Today, after more than 125 years of human use and abuse, Central Park is being restored. The intrusion over the years of vegetation, facilities, and uses not intended by the park designers, along with years of limited maintenance, are complicating efforts of the Central Park Conservancy to create a true historic restoration. Ironically, strict adherence to the park's original design is impossible to achieve because Central Park's original plans were never intended to be complete. Olmsted and Vaux did much of the detailed work of landscape design, such as placing vegetation, while out on the site itself. Rather than a replica of the original park or a modified version that addresses the problems of 20th-century urban nature, current restoration efforts are producing a curious potpourri of artifacts—buildings, statues, lawns, woodlands, and waterbodies—the styles of which represent many different periods in Central Park's history.

RIVERSIDE PARK

The tremendous popular response to the creation of Central Park led the city over the years to set aside other major park sites in Manhattan: three parks—Riverside Park, Fort Tryon Park, and Inwood Park—hug the banks of the Hudson River, which is the southernmost fjord in the world. In 1875 Olmsted designed the 72nd Street to 125th Street section of Riverside Park, parts of which preserve cliffs that overlook the Hudson. In 1902 city engineer F. Stewart Williamson, guided by Olmsted's naturalistic design principles, extended the park from 125th Street to 153rd Street. But, instead of using rusticated stone walls as Olmsted had, Williamson incorporated buttresses into the bluffs of the Hudson River that resemble castles and ramparts. Then in 1937 Park Commissioner Robert Moses expanded sections of the park into the river. The paths and other park features in Moses's addition of 132 acres are laid out in simple geometric shapes rather than irregularly-formed ones as in Olmsted's earlier park sections. As a result of these three park-building eras, Riverside Park's 316 acres use design features and building and plant materials that are not consistent with each other. Furthermore, much of its land is fill with only two or three inches of topsoil to nourish its vegetation.

Currently, the Office of the Director of Riverside Park has developed a Restoration and Improvement Plan that celebrates the contrasts between the remaining Olmstedian landscapes, those areas added by Williamson, and the newer Moses park sections. The plan integrates obtrusive additions, takes responsibility for managing the vegetation growing on the landfill, and provides a framework for fulfilling future needs without predicting them. The Director of Riverside Park has based this Restoration Plan on observation of the design character of the processes at work in Riverside Park. The Plan is a unique example of the power of a unifying design concept to transform the disparate parts of an existing park into a continuum that balances its historic and modern features. Here park rejuvenation has become unification of the different time periods in the park's history in ways that sustain nature in an intensively used urban park.

FORT TRYON PARK

In the early 1930s Olmsted's son, Frederick Law Olmsted, Jr., laid out the sixty-six acres of another park along the edges of the Hudson River, Fort Tryon Park. Luckily, no major changes have ever been made to it. In a recent study of the park, landscape architects and architects Quennell Rothschild Associates determined that the aims and philosophy of the park's planting scheme, which places vegetation according to seasonal uses of park slopes, are still valid today. They recommend, however, that new plantings not follow the original plant list because many of the 1,600 species originally used are now either too expensive or not suited to the site. Their restoration plan also proposes a managed-nature philosophy for the park's extensive woodlands. This approach monitors the natural processes of reforestation and takes steps to preserve the most important of the park features designed by Olmsted, Jr. As a result of this study, revitalization of Fort Tryon Park has become an affirmation of the park's initiating design with modifications based on the lessons of time.

In the original designs for Riverside Park and Fort Tryon Park, both Frederick Law Olmsted, Sr. and Frederick Law Olmsted, Jr. appreciated the spectacular sites of their respective parks—an appreciation reinforced by present revitalization plans. Father and son, like today's designers, made the principal attraction in these parks the setting sun. There are few places on Earth where it is possible to stand on 360-million-year-old bedrock and see the 10-billion-year-old sun sink behind a 200-million-year-old Palisades. Riverside Park and Fort Tryon Park are two such places.

INWOOD HILL PARK

Inwood Hill Park's 196 acres straddle a 200-foot-high cliff of Manhattan schist that also overlooks the Hudson. Time has etched this area with glacial potholes and with caves, which were used by the Delaware people of the Shorakapkok tribe. But, perhaps, most memorable here are experiences from its bluffs. Below is "the river that flows two ways," as Native Americans called the Hudson, and stretching to the south is the "island of mountains"—Manhattan—created by fire, water, and now, human desire.

Experiences like those from the Inwood cliffs stir humanity to understand that rivers and mountains are no less a part of the human habitat than buildings. Rather than being extraneous to the needs of humanity, Earth's rivers, mountains, and other features are as integral to these needs as protection from the elements.

Over the centuries, as cities have grown denser and higher, garden and park areas have become more and more an essential part of them. In recent times the urban parks of newer cities often simulate or retain local or regional ecologies rather than imposing alien forms on natural sites. For instance, New York City contains more open spaces with local native ecologies than older European cities contain. The more urbanized and built-up the Earth becomes, the more the need for ecologically functioning lands within cities.

During its second mountain-building era, Manhattan, with its memorable site, bold skyscrapers, and diversified human community, could become a human dwelling place of life-supporting nature and architecture. To do so, its inhabitants should encourage building efforts whose clients and architects understand the constructing of cities as a natural activity that affects the biological and physical systems of the Earth. Integrating natural systems into new skyscraping mountains and new open spaces as well as into park and building restoration would make Manhattan more life-nourishing. It would also create an entirely new era in city building.

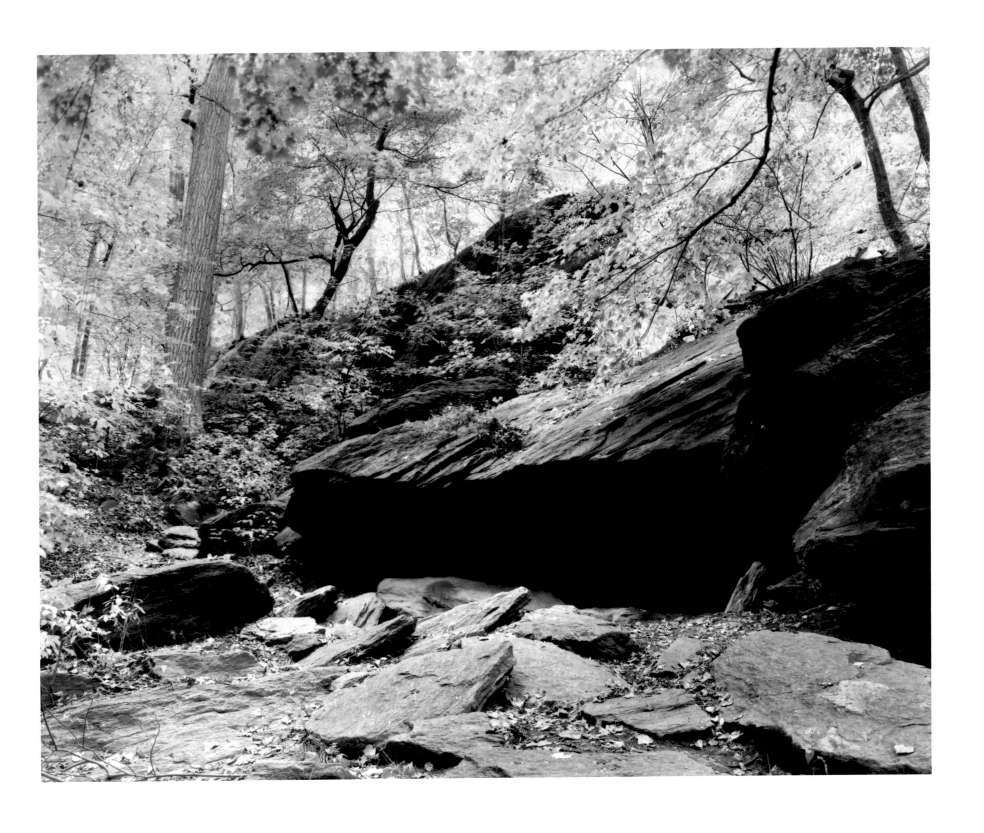

Plate 16. Native American Cave, Inwood Hill Park.

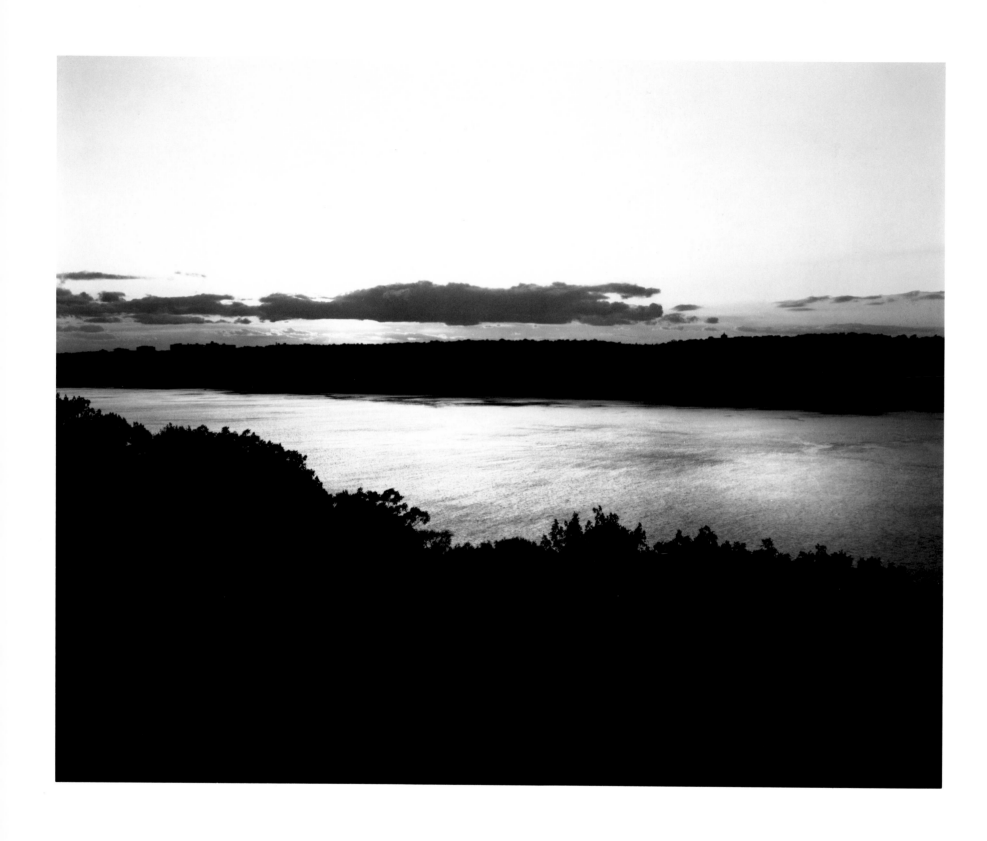

Plate 17. Hudson River and New Jersey Palisades from Inwood Hill Park.

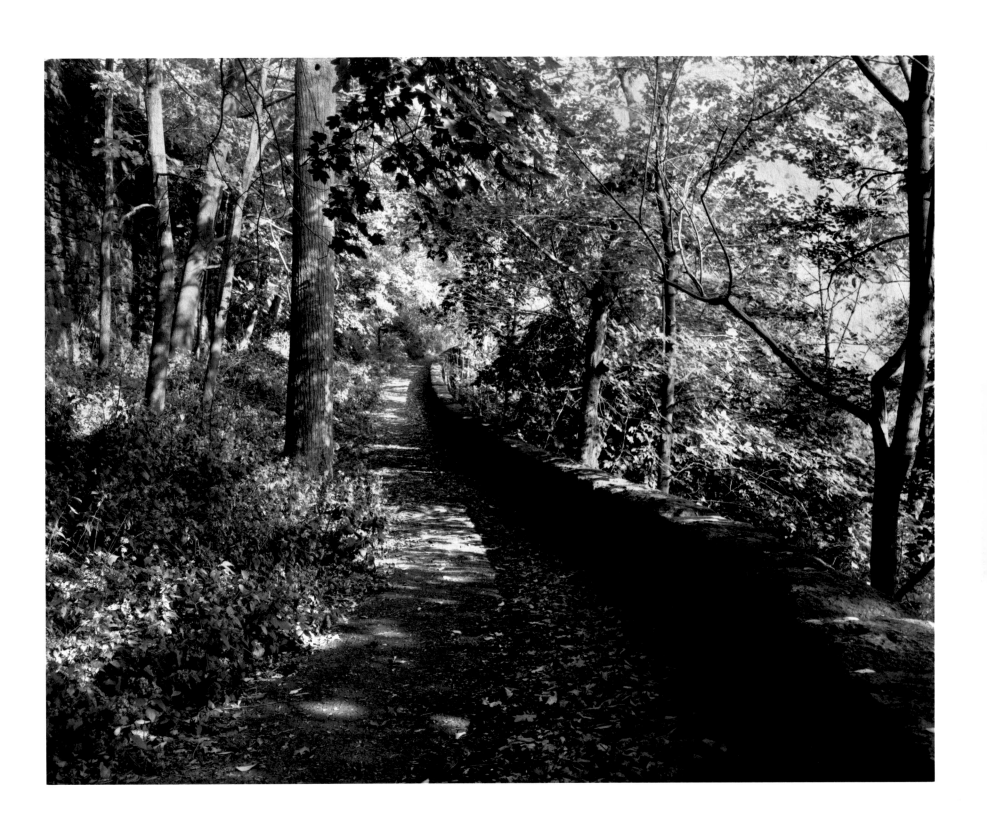

Plate 18. Forest Walk, Fort Tryon Park.

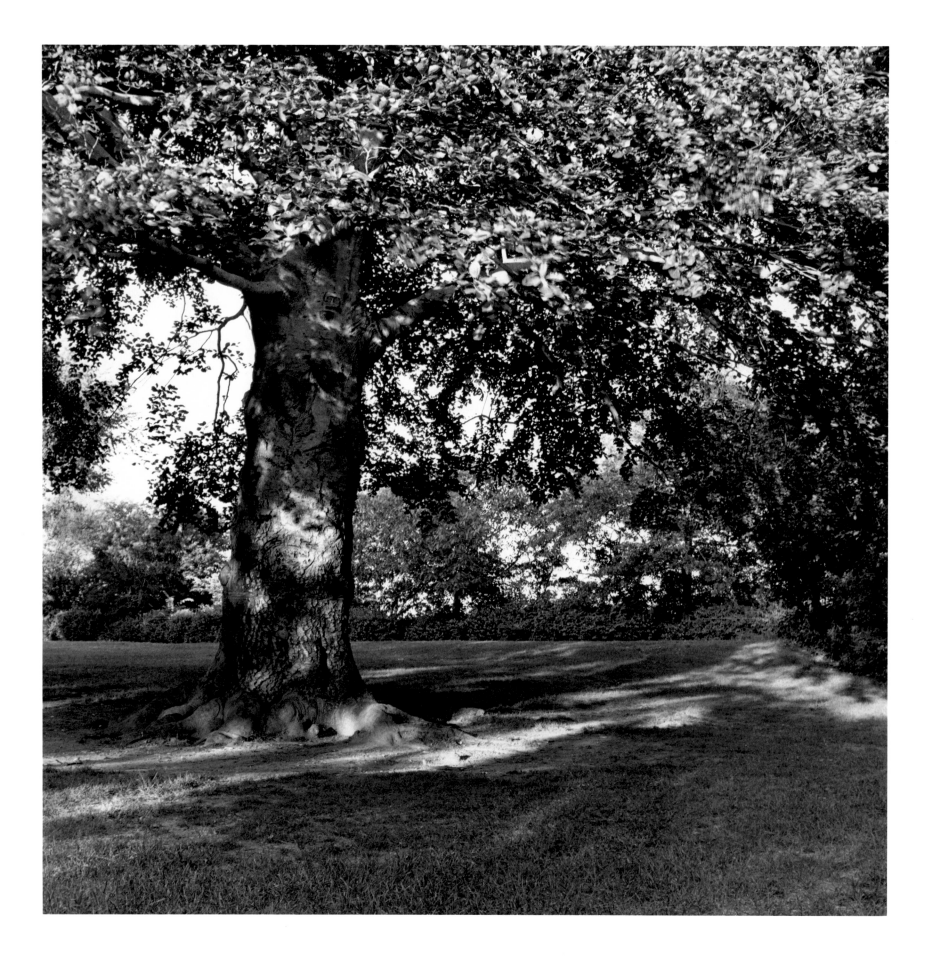

Plate 19. Copper Beech, Fort Tryon Park.

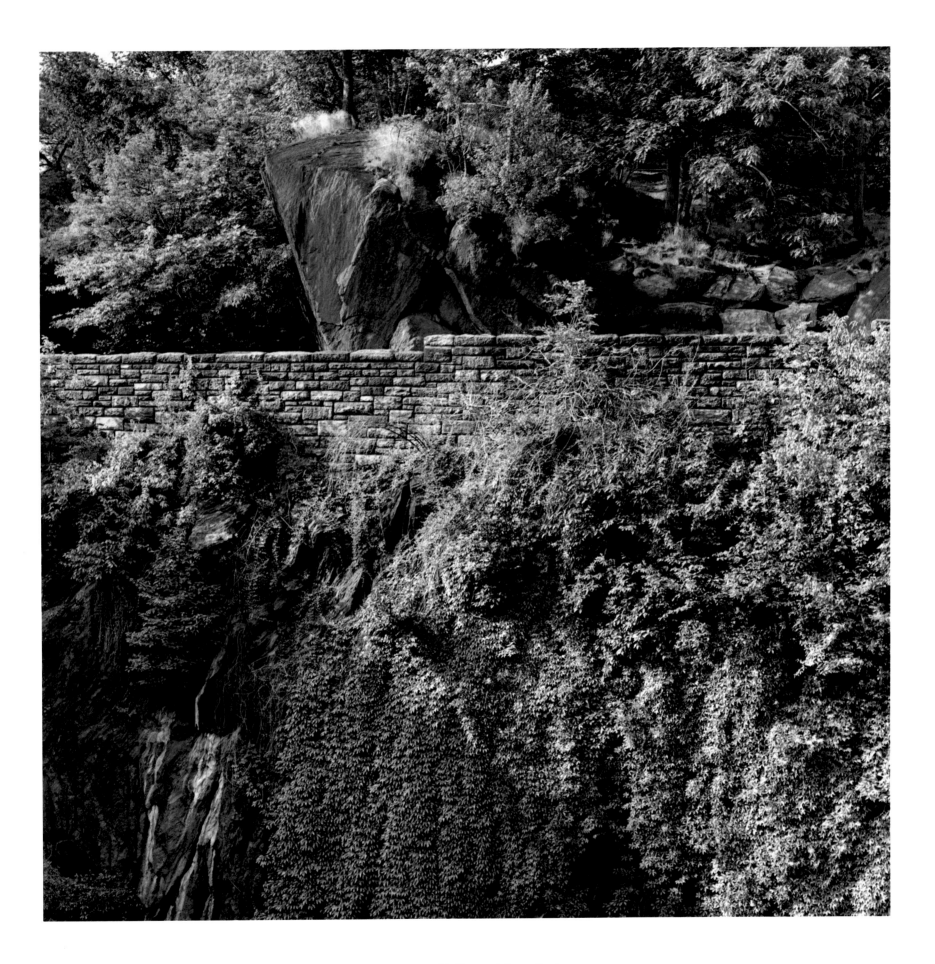

Plate 20. Cliff, Fort Tryon Park.

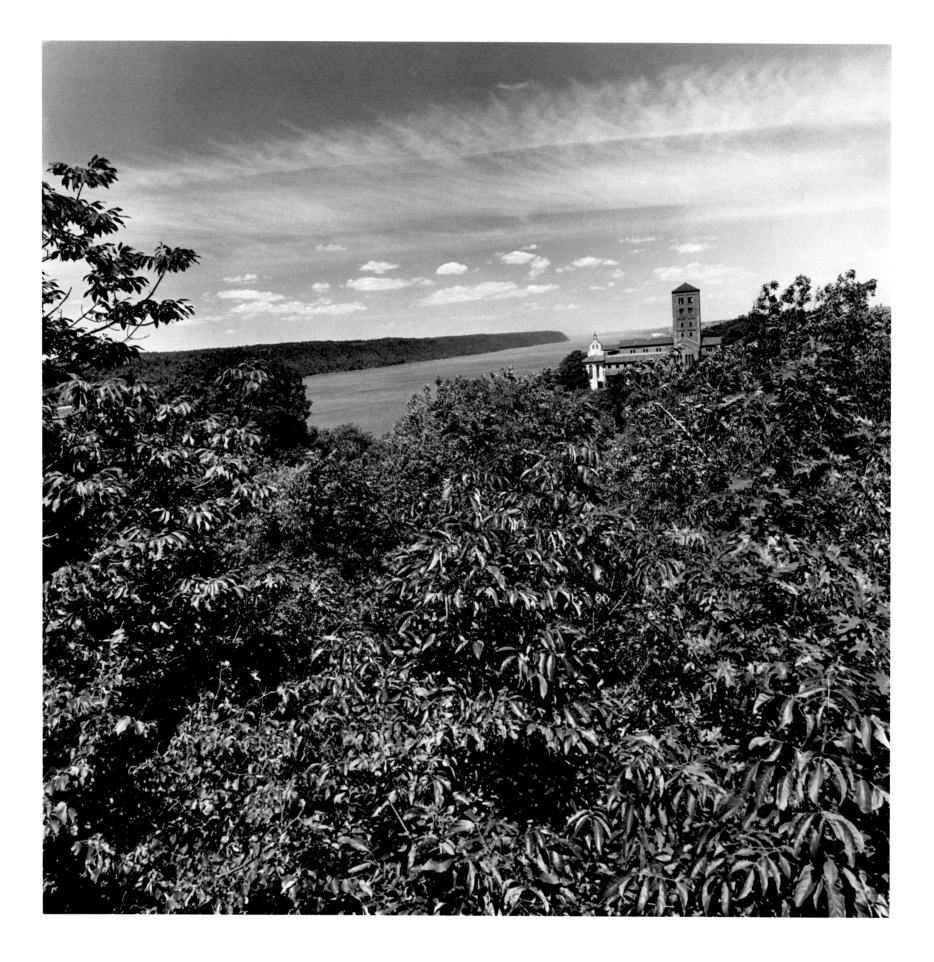

Plate 21. The Overlook, Fort Tryon Park.

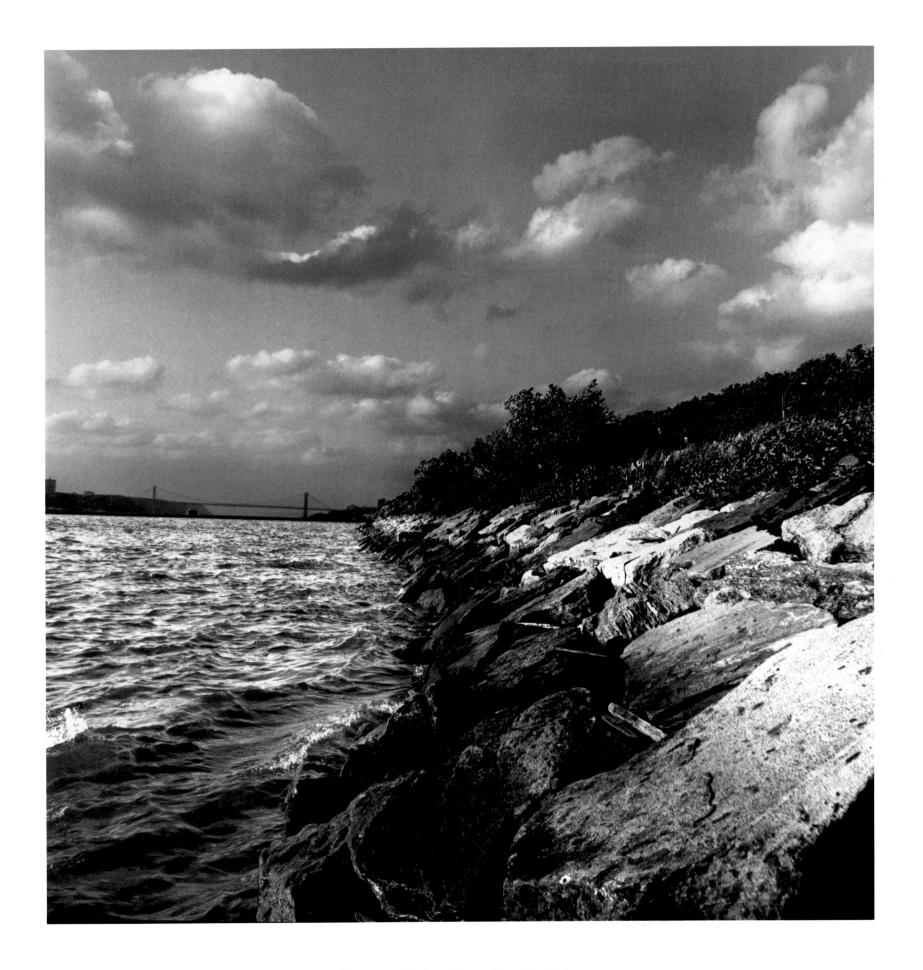

Plate 22. Hudson River, Riverside Park.

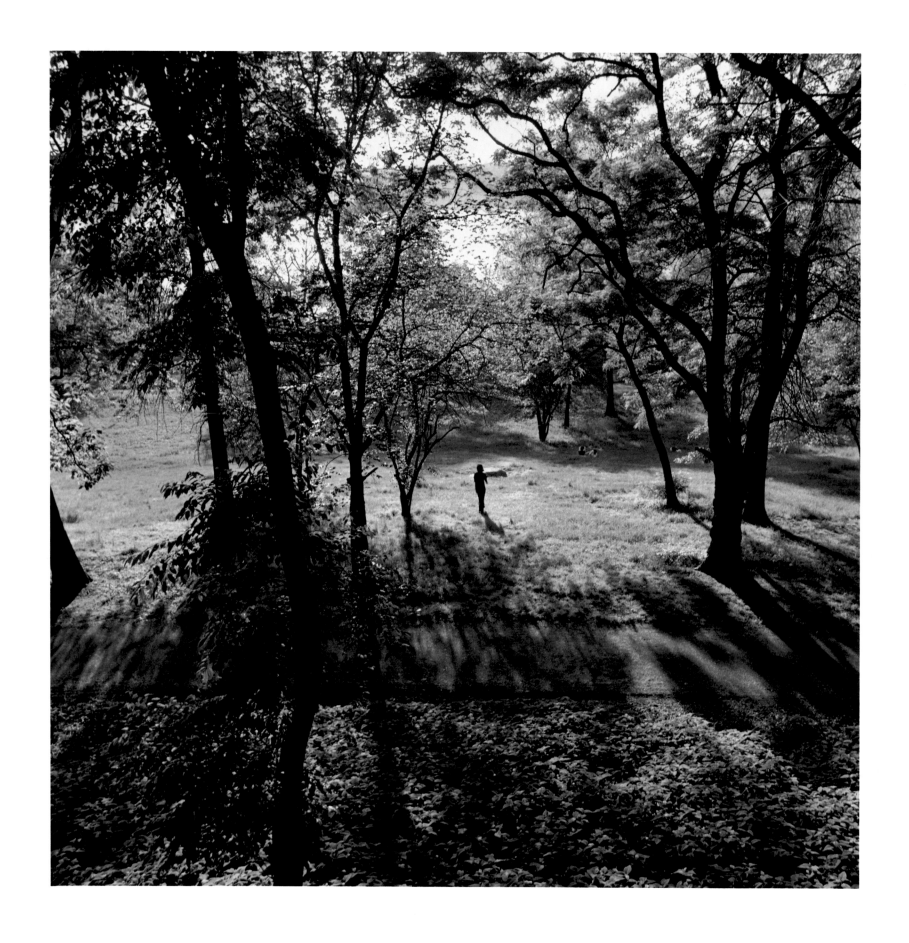

Plate 23. Honey Locust Trees, Riverside Park.

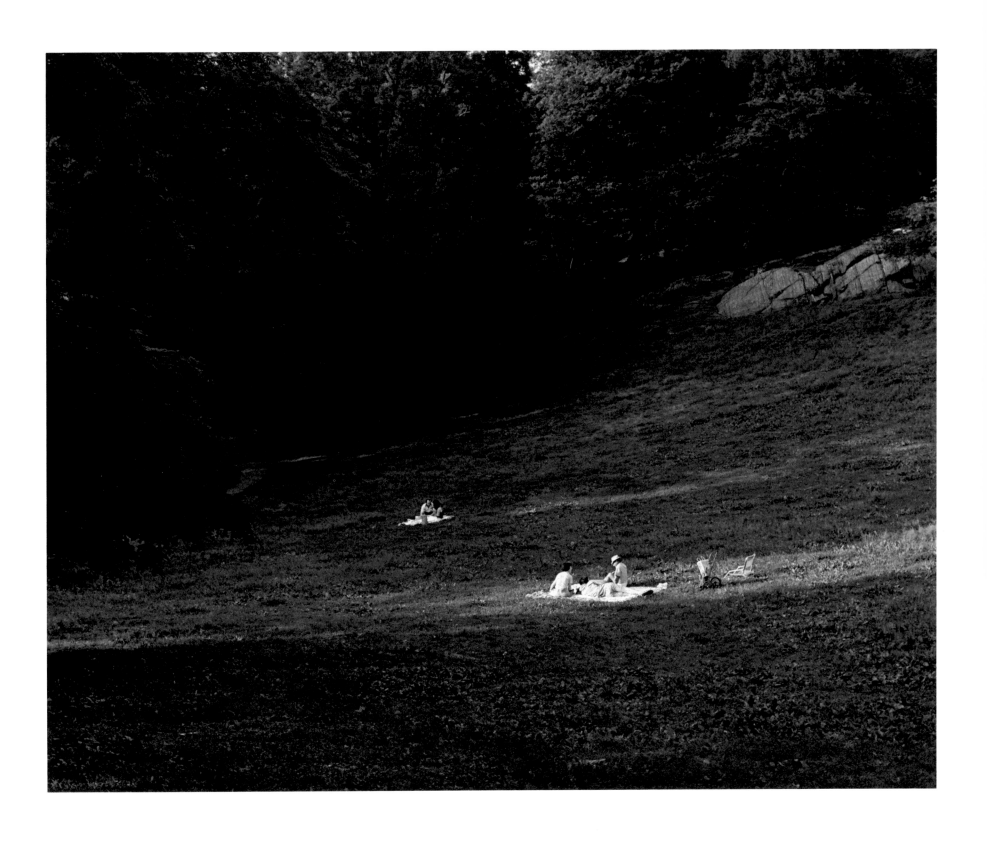

Plate 24. Lawn, Riverside Park.

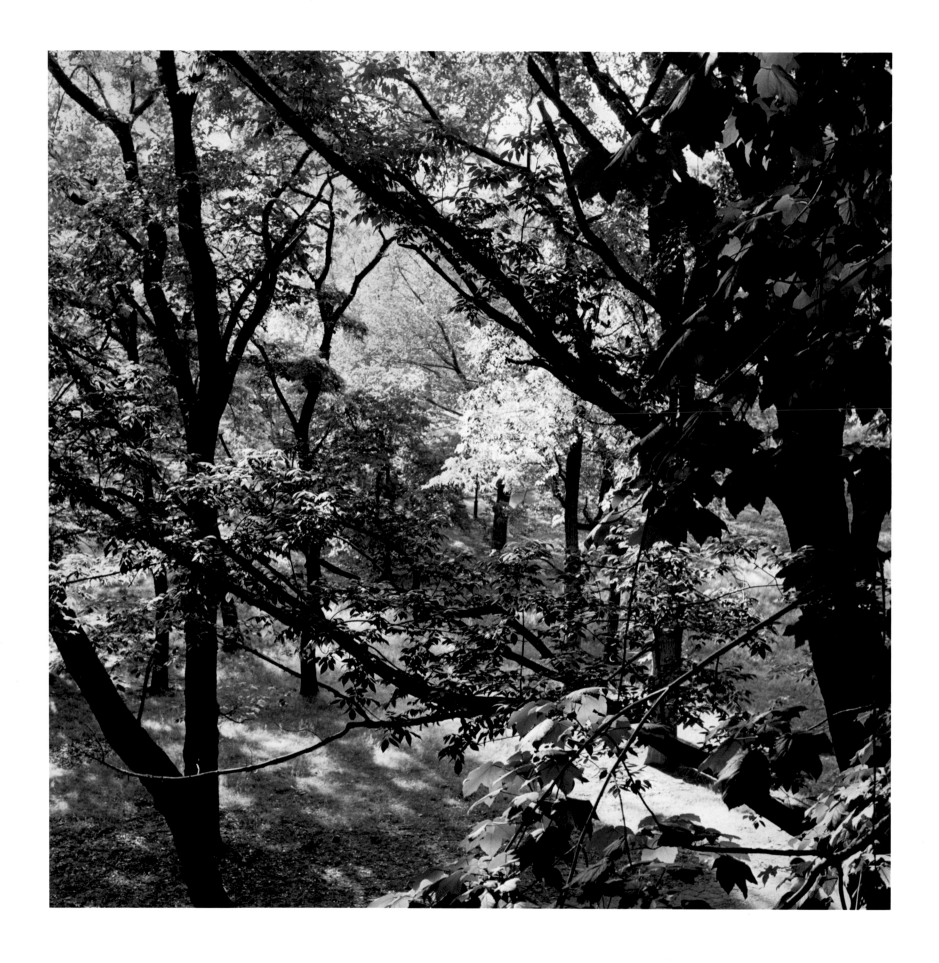

Plate 25. Forested Hillside, Riverside Park.

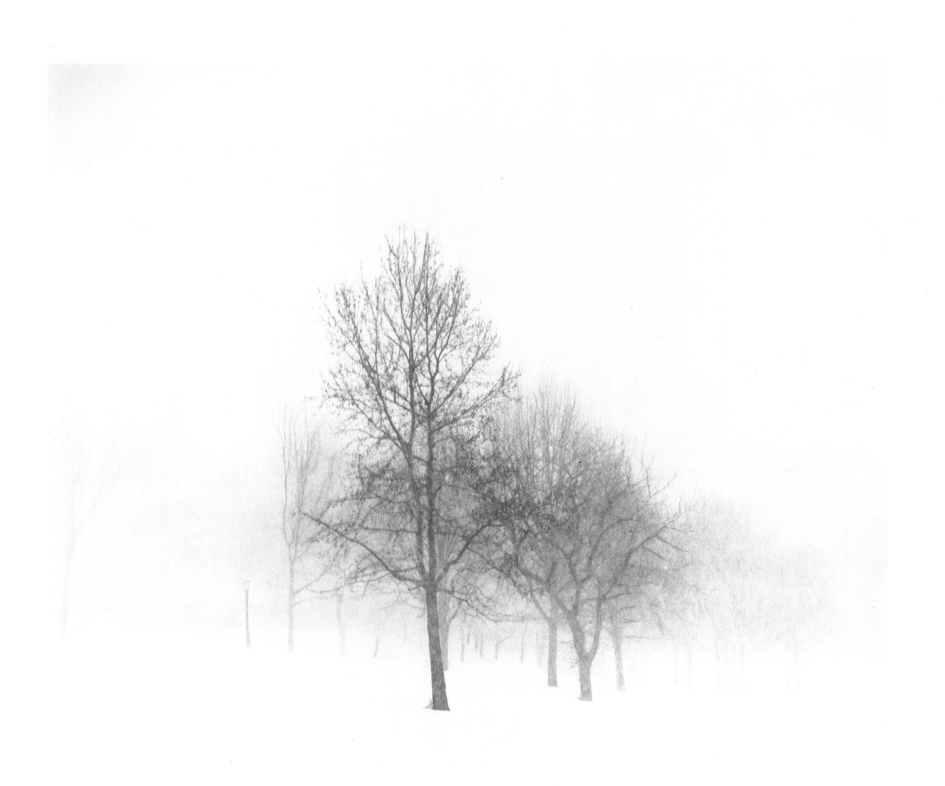

Plate 26. Snow Storm, Riverside Park.

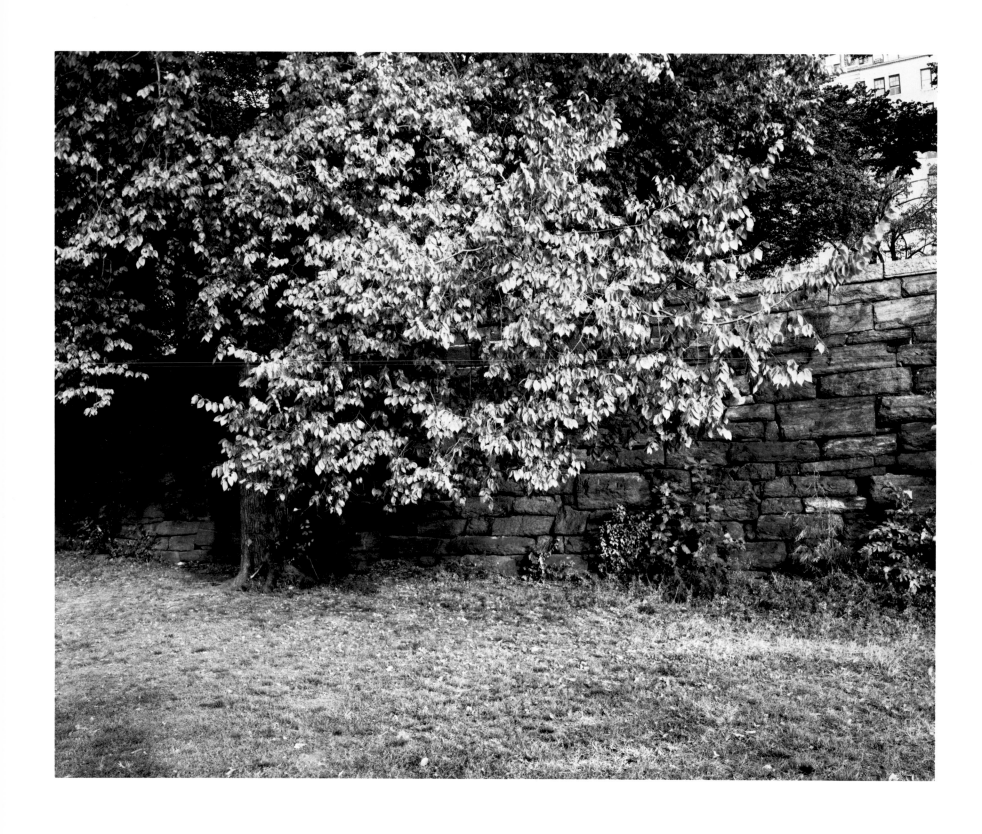

Plate 27. Tree and Retaining Wall, Riverside Park.

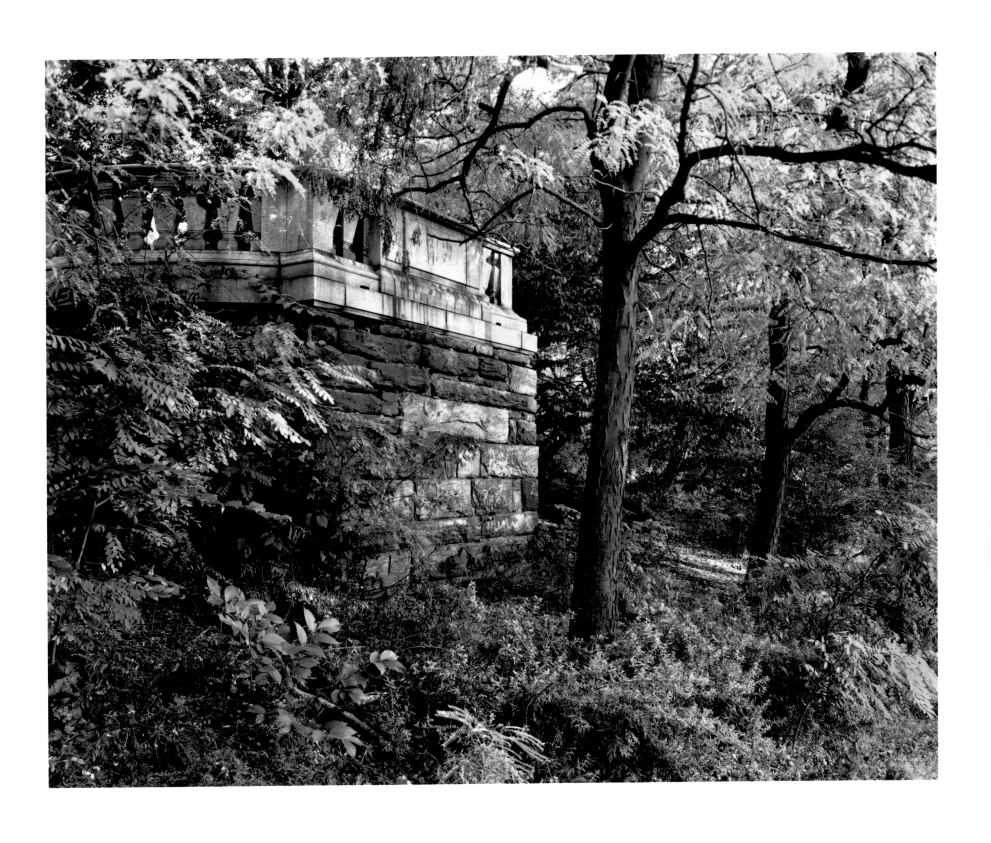

Plate 28. Stone Wall, Riverside Park.

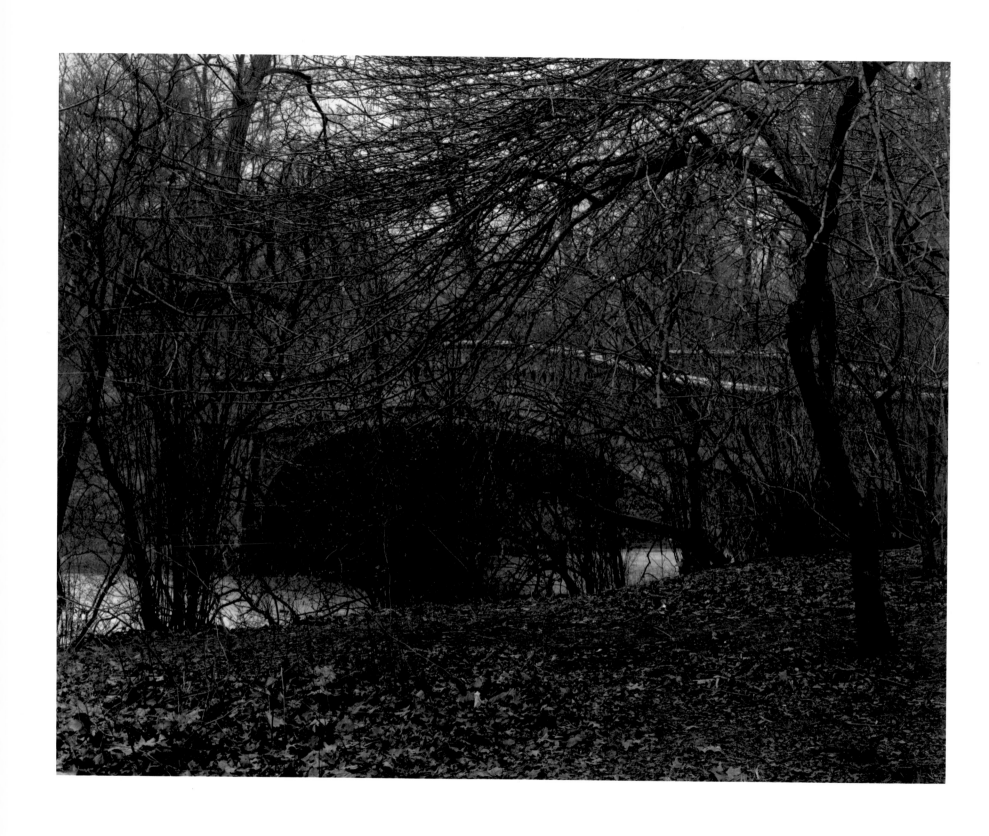

Plate 29. Bow Bridge, Central Park.

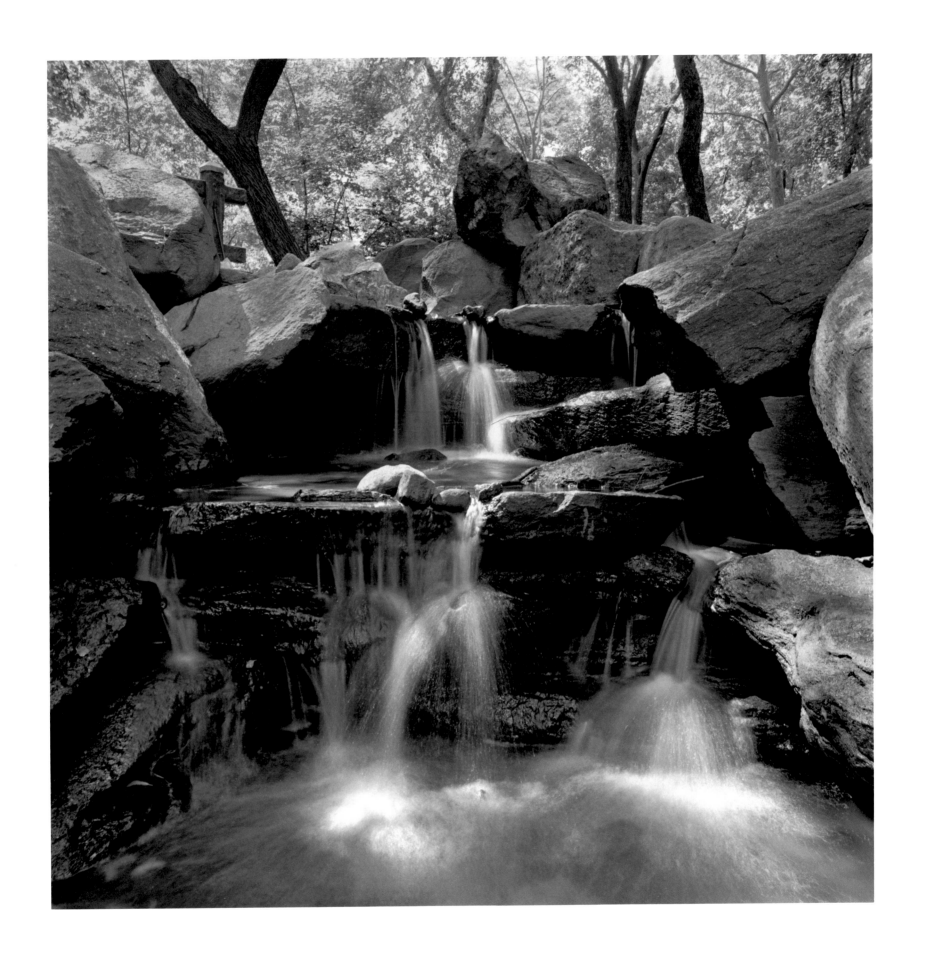

Plate 30. Waterfall, The Ravine, Central Park.

Plate 31. Bedrock, Central Park.

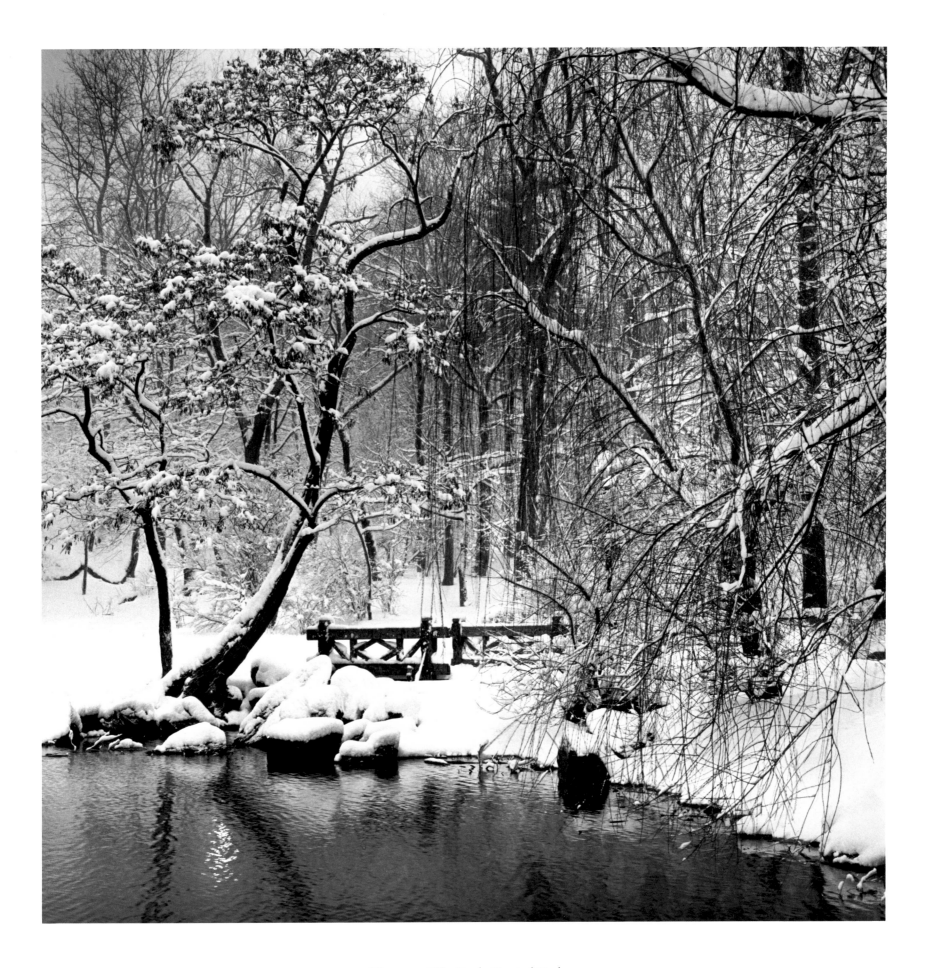

Plate 32. The Pool, Central Park.

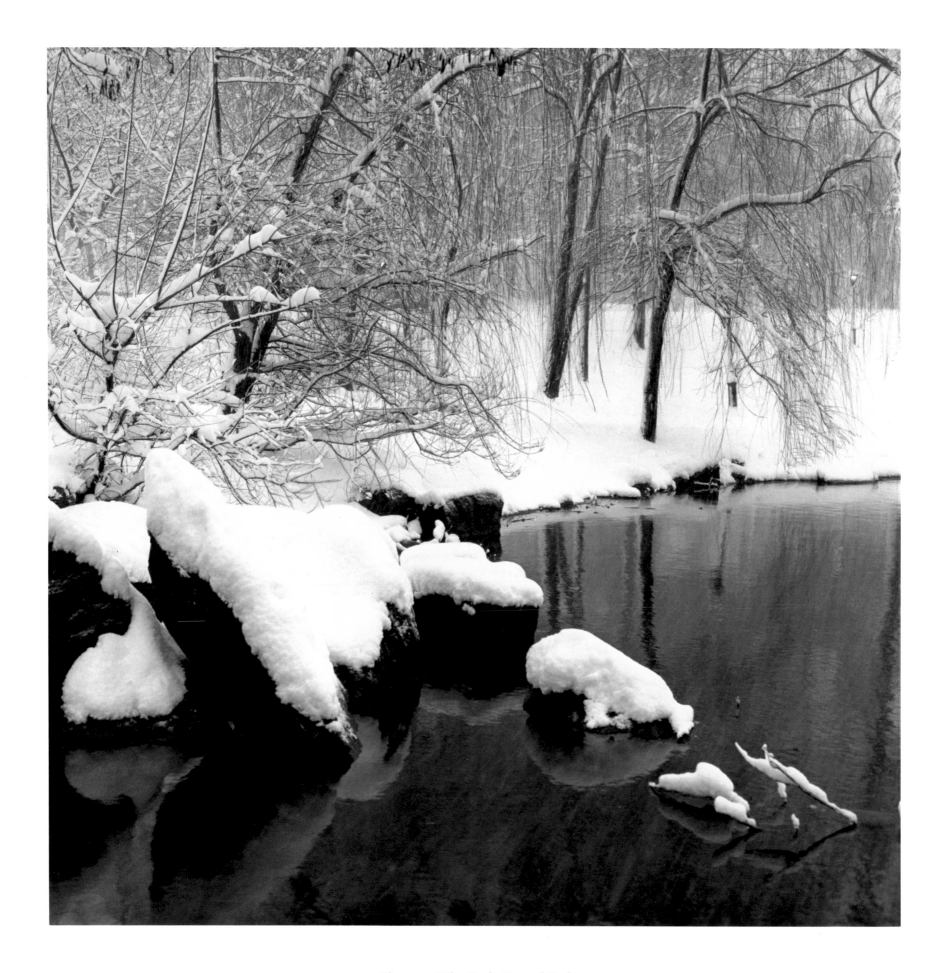

Plate 33. The Pool, Central Park.

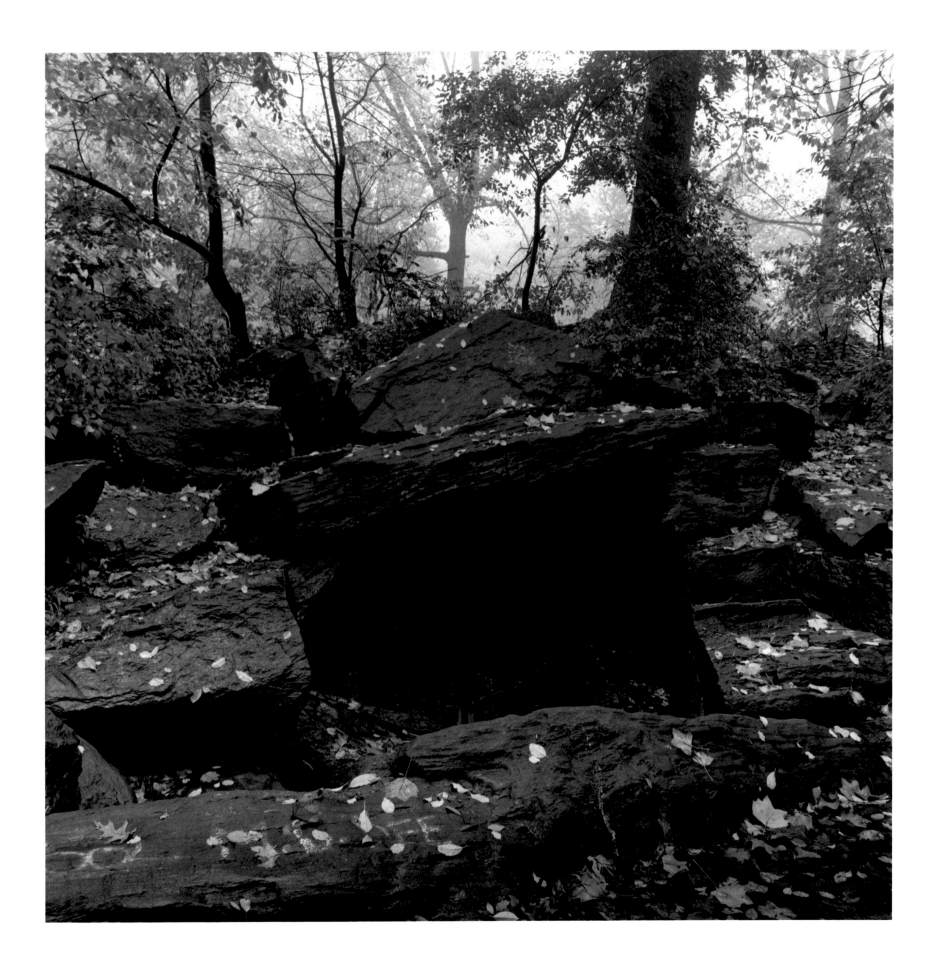

Plate 34. Rockwork, The Ramble, Central Park.

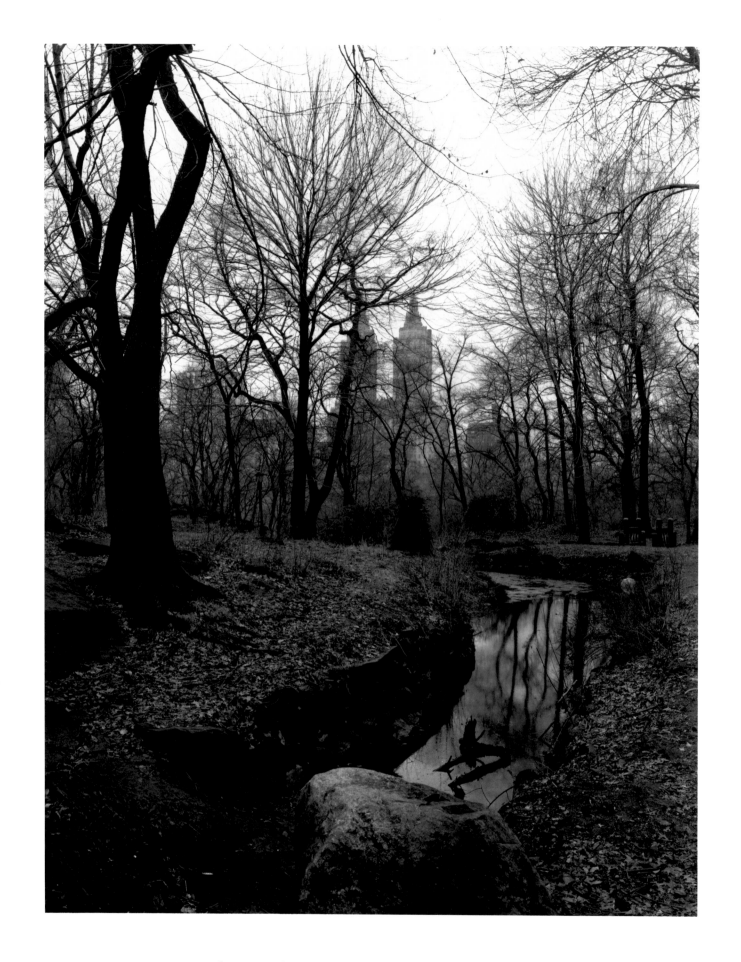

Plate 35. The Gill Stream, The Ramble, Central Park.

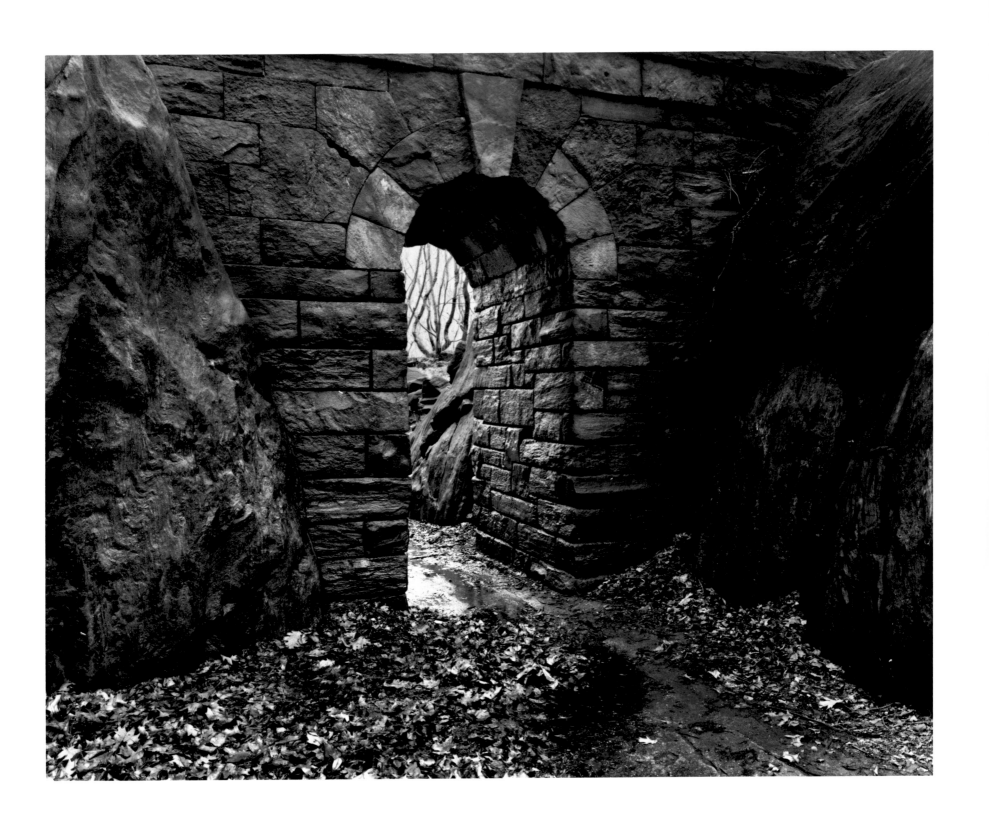

Plate 36. The Arch, The Ramble, Central Park.

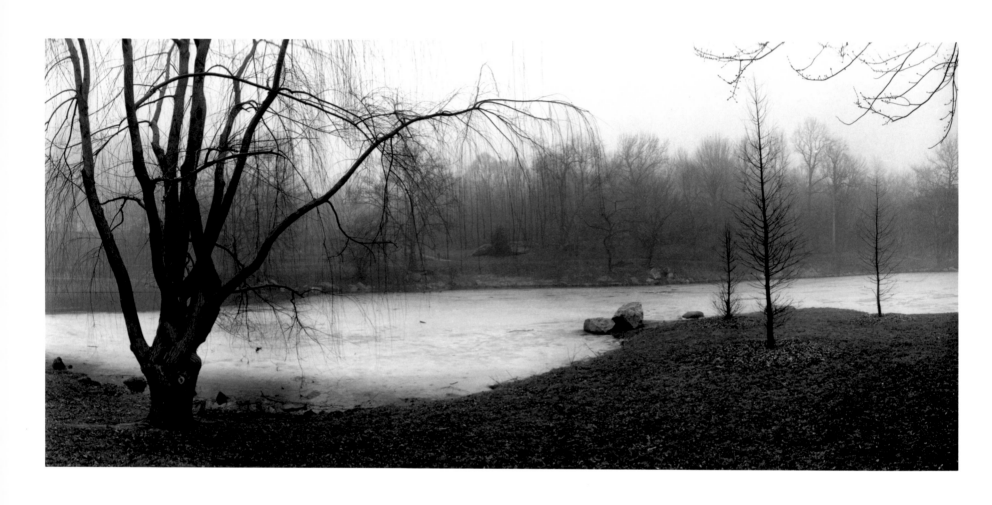

Plate 37. Frozen Pool, Central Park.

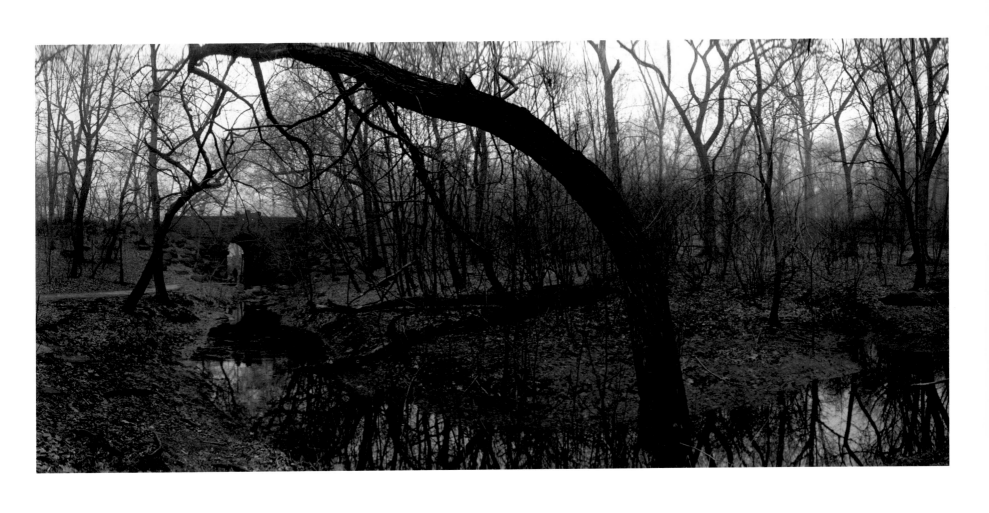

Plate 38. The Loch, The Ravine, Central Park.

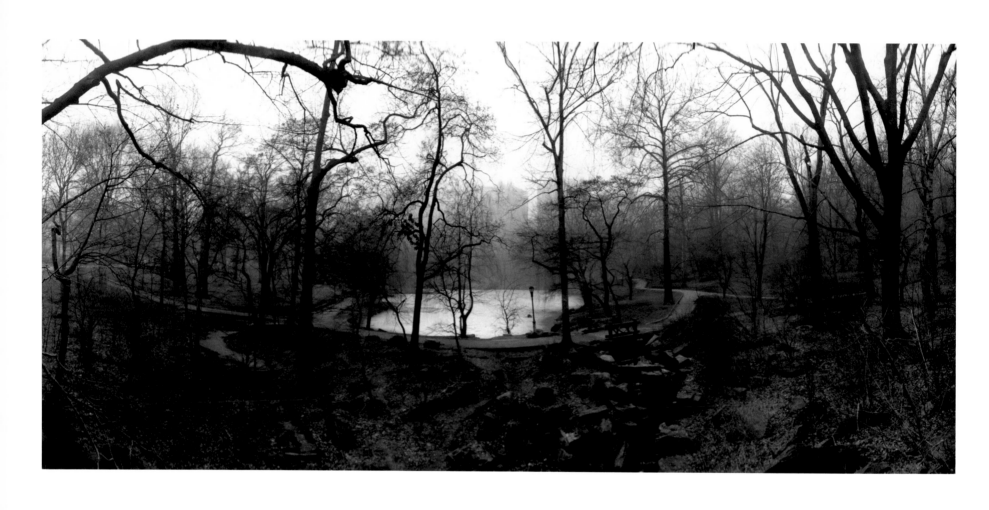

Plate 39. The Pool, Central Park.

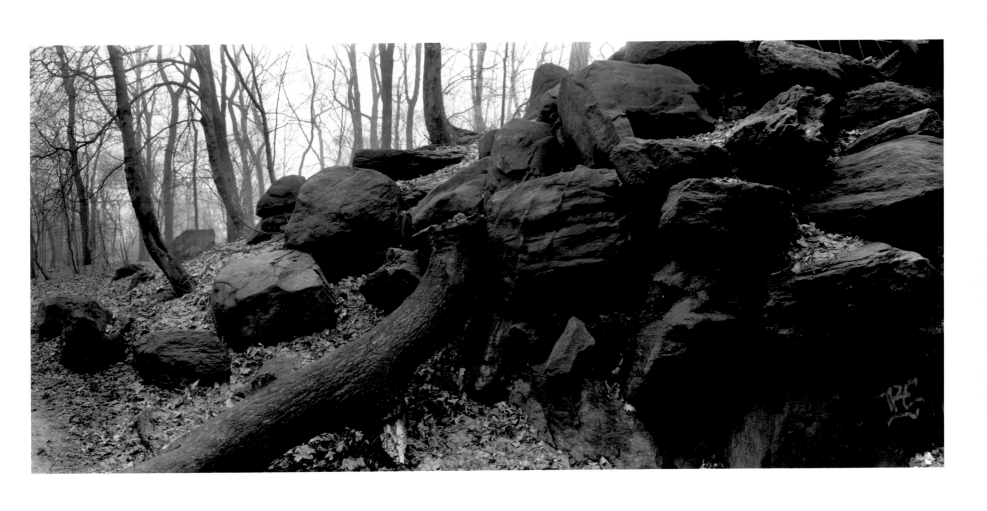

Plate 40. Glacial Boulders, Central Park.

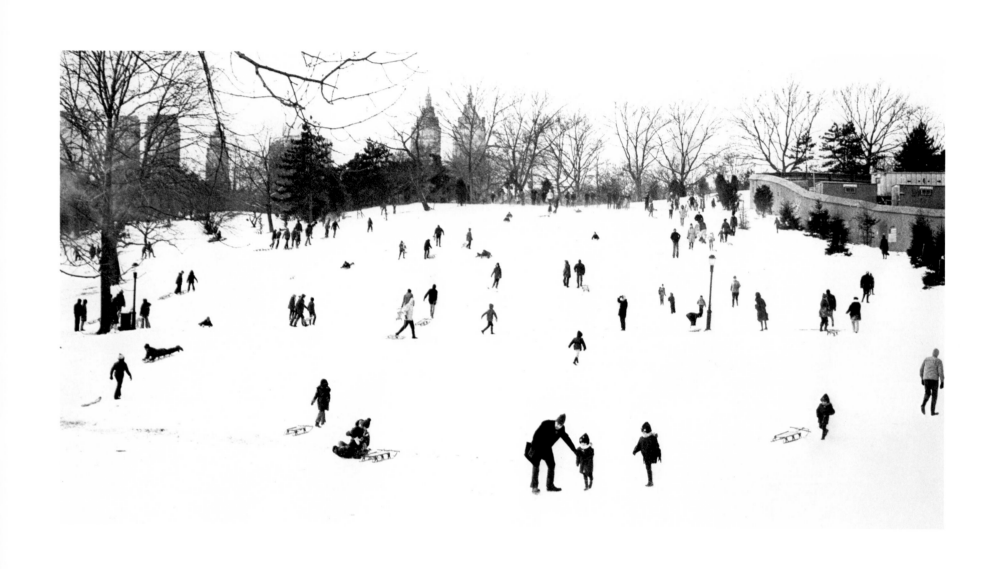

Plate 41. Sledding, Central Park.

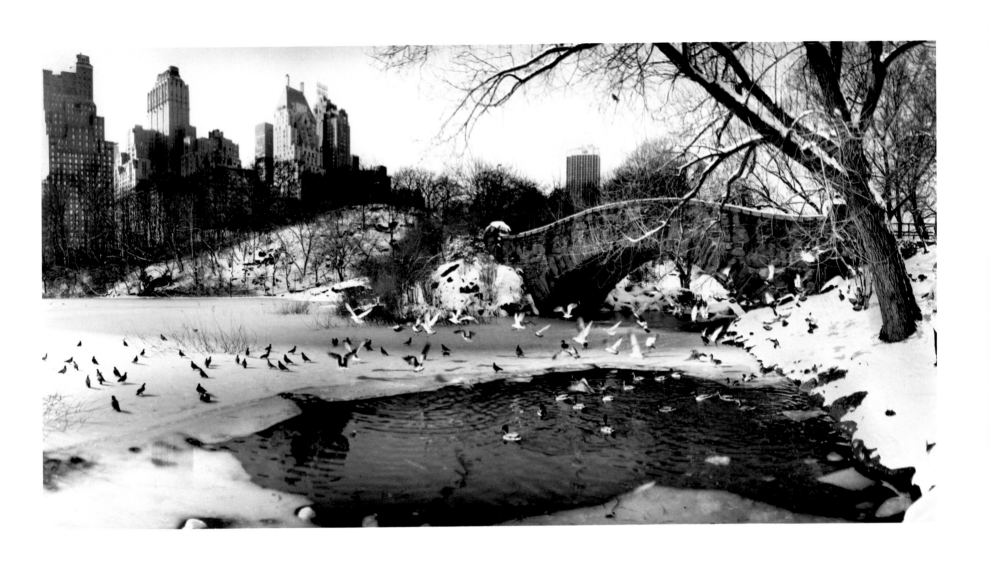

Plate 42. The Pond, Central Park.

QUEENS AND BROOKLYN ON LONG ISLAND

❧

The New York City boroughs of Queens and Brooklyn lie on the western end of Long Island. A dramatic geological event—the Wisconsin Glacier—laid the foundation for the unique ecosystem of this island. Remnants of that system survive today in the ecologies of the large natural sites in Queens and Brooklyn. Currently, in these sites, community, city, and federal groups are shaping a new ecosystem for Long Island and New York City.

The Wisconsin Glacier, described in the Introduction, is the most extensive and most recent of the gigantic ice masses to blanket parts of present-day Long Island. Approximately 15,000 years ago when the glacier began to melt, chunks of ice broke off from it and were buried in glacial debris. When the ice blocks melted, depressions formed. Some of them filled with water, creating ponds. The resulting landscape of hills and depressions, evident in Queens and Brooklyn along the glacier's southernmost edge or terminal moraine, is known as a "knob and kettle" landscape. The forests of Alley Pond Park, Cunningham Park, and Forest Park in Queens and the grounds of the Brooklyn Botanic Garden and the Long Meadow and Ravine sections of Prospect Park in Brooklyn—all are located on hills and in valleys that the glacier built.

Today the Natural Resources Group of the New York City Department of Parks and Recreation is taking an inventory of the vegetation and wildlife of the forests that grow on the "knob and kettle" landscape in Alley Pond, Cunningham, and Forest Parks. The inventories have verified that historic native species of vegetation and wildlife survive in these woods.

Making such inventories represents an attitude toward forests that has rarely existed since Europeans arrived on this continent. Colonists viewed forest vegetation and animal life as capital to be exploited for profit. During the last fifty years or so, the woodlands themselves have most often been seen as prime development sites. The Natural Resources Group's surveys reveal, instead, that these forests are highly developed natural ecologies that are crucial to the continued functioning of the biological and physical systems of Long Island. At one time, perhaps eighty-five percent of Long Island was forested. Presently in Queens and Brooklyn, only a small percentage of these forests remain to sustain the functioning of natural systems on this part of Long Island.

ALLEY POND PARK

A community group in Queens, recognizing the vital importance of these remaining forests and of adjacent wetlands, has been working for nearly twenty years to safeguard and restore Alley Pond Park. Currently, they plan to revitalize park marshland that was destroyed in the 1930s and 50s to build the Cross Island and Long Island Expressways. During these two waves of highway building, approximately 150 acres of park wetlands were filled, obliterating tidal and freshwater marshes as well as the mill pond for which the park was named.

Members of the Alley Pond Environmental Center plan to dig a new two-acre freshwater pond in the highway landfill. Water pumped by a windmill—similar to those used in the park's wetlands at least 200 years ago—will fill the new pond. The plan calls as well for vegetation typical of a marsh ecology to be planted around the pond. Its authors hope to encourage the return of fish, amphibians, and reptiles. They also envision an interpretative trail that will make the human presence compatible with these other life forms. The trail will come close to the pond

edge at two or three points, where there will be overlooks. A platform will jut out from the shoreline to allow visitors to observe the waterlife firsthand.

When this community-created pond is finished, it will exemplify the creative power of humanity to balance its habitat needs with other natural functions. Members of the Environmental Center have understood how their desire for contact with nature, for a sense of history, and for participation in shaping the use of local lands can overlap with other habitat needs such as a circulating water system, wildlife feeding and nesting grounds, and vegetation niches. In this project, instead of working against natural processes, humanity is working with them.

The Wisconsin Glacier also formed the basis for the ecologies directly to the south of the terminal moraine in Queens and Brooklyn. As the Earth warmed, the melting glacier formed streams that flowed southward from the ice. Their waters carried glacial gravel, sand, and silt that in time built up an extensive plain. The southern parts of Prospect Park and the Queens and Brooklyn sections of the Gateway National Recreation Area are located on this plain. Over the last hundred years or so in these sites, as in the land that became Alley Pond Park, the human species has made often-disruptive changes in the natural ecologies. These changes have created today's opportunities to develop new patterns of connection between the functions of earth, air, water, and life forms within the New York City habitat.

PROSPECT PARK

Prospect Park is built on the terminal moraine and outwash plain of the Wisconsin Glacier. In it, Central Park's designers, Frederick Law Olmsted and Calvert Vaux, retained or simulated landscapes they had known from living and traveling in the northeastern part of the United States and in England. By 1870, when they designed Prospect Park, settlers had transformed many of the densely forested regions of the northeastern United States into a patchwork of cultivated green spaces punctuated by rugged, naturally forested hills and meandering rivers. These mountainous woods, open fields, and winding waterbodies bore striking resemblances to features that Olmsted and Vaux also admired in the English landscape garden—its picturesque forests, pastoral meadows, and reflective pools. Olmsted believed that these English landscape features, like their

New England counterparts, affected the imagination in ways that enabled humanity to experience itself as part of the life and movement of nature.

By the 1980s the rugged forests, expansive meadows, and open waters of Prospect Park had changed in ways that Olmsted and Vaux could not have anticipated. Their work, of course, predates our modern ecological understanding of how natural systems change over time. The Office of the Administrator of Prospect Park, aided by the New York City Chapter of the Audubon Society and the Brooklyn Bird Club, has carefully evaluated the present-day park, designating park areas as either (1) close to what the designers wanted, (2) totally overgrown and nothing like what the designers were after or (3) inappropriate to current park purposes.

The Administrator's Office has used this evaluation, along with other important considerations, to develop a plan to revitalize Prospect Park. Of particular importance was the park's historic value as a work of art, embodying as it does 19th-century ideas about humanity's relationship to nature. Also, Olmsted and Vaux considered Prospect Park's design superior to Central Park's because they were able to apply there what they had learned from that first park plan. Of further concern to the Administrator's Office was reinforcing the designers' intention to allow park visitors to experience themselves as part of the life and movement of nature. Another consideration was the park's environmental impact on Brooklyn. A hundred years ago, when Long Island was still sparsely settled, Olmsted's and Vaux's park had little influence on the biological and physical systems of Brooklyn or its surrounding countryside. Now these systems are interwoven with those in Prospect Park because the park is one of the few remaining open green spaces in Brooklyn.

Prospect Park's plan for rejuvenation calls for Prospect Park Lake to be restored. Olmsted and Vaux had created the Lake as a major feature in their park. Another important consideration in restoring the Lake is the fact that this designed waterbody is the only lake in Brooklyn. It will be dredged and the ice skating rink, which is not part of the original design, removed. The plan also indicates that certain areas should remain untouched even though they differ from those Olmsted and Vaux initially built. For instance, an open pool behind the music pagoda has become a silted-in swamp with a large wildlife population. Restoring the pool would leave the wildlife homeless within a borough that has few natural sites left. For this reason and because the swamp

fulfills the designers' intention to create places for urban dwellers to experience themselves as part of nature, it will be retained.

The seemingly contradictory decisions—on the one hand to restore the lake Olmsted and Vaux built and on the other hand to integrate a spontaneously evolved swamp ecology—both recognize the urgency today for designed parks to fulfill natural functions. Such parks can provide space for trees, shrubs, flowers and other vegetation to structure niches, make soil, produce oxygen, clean the air, and sustain the water cycle. They give opportunities to many species of mammals, birds, insects, fish, reptiles, and amphibians to feed and build their homes and offer to the human species places to experience its connections to the rest of the natural world.

On an increasingly urbanized Earth the rural areas that once sustained the natural functions so vital to urban habitats are being built over. To be sustainable today, cities must find ways to make natural functions an integral part of their own structures. The plan for revitalizing Prospect Park demonstrates several noteworthy ways to do this.

GATEWAY NATIONAL RECREATION AREA

The Gateway National Recreation Area also epitomizes how humanity can make the biological and physical systems of the Earth a part of a city. As indicated in the Introduction, the Natural Resources Management Division of the park administration is digging a two-acre pond in landfill as well as creating a grassland ecology at the no-longer-used Floyd Bennett Airfield. The decision to create this new ecology rather than to restore the site's original salt marshes, which were filled to make the city's first airport, arose from several considerations: New York City and Long Island need to sustain or to simulate as many different regional ecologies as possible within their remaining natural sites so that the functions associated with them can continue. Urbanization of Long Island is destroying its regionally unique grasslands, dramatically seen in the rapid disappearance of the Hempstead Plains. Grassland birds have begun to feed and nest at the Floyd Bennett Field instead and a simulated grassland ecology would preserve the flat, open landscape of the historic airport.

At Floyd Bennett Field humanity has created a precedent for managing urban natural sites. New natural functions can be incorporated into a city on the basis of studies that assess ecological changes to the immediate region. Characteristics of disappearing or lost regional ecologies can be related to traits of available sites within the city. If enough of the traits of the urban site are similar to those of a disappearing or lost regional ecology, then it can be simulated on an urban site. The regional ecology is saved, the sustainability of the city increased, and the reciprocity between the human species and the Earth strengthened.

In the 9,155 acres of Gateway's Jamaica Bay Wildlife Refuge the Natural Resources Management Division is using a different approach to compensate for the loss of natural functions in the bay and in surrounding areas. When the National Park Service took over administration of the Refuge in 1974, it discovered that although the bay successfully provided food and cover for over 320 species of birds, its amphibian and reptile population was less diverse than expected because of the impact of the human species on the bay and the adjacent region. The Park Service also recognized that not just the species of amphibians and reptiles indigenous to the bay were disappearing. Additional species native to other Long Island ecologies were also nearing extinction. To compensate for these local and regional losses, the Park Service is introducing into the bay several species of reptiles and amphibians native to the bay or to other similar island ecologies. Park management envisions a balanced, self-perpetuating animal community in Jamaica Bay that simulates not only the pre-urban bay's animal community but also includes animals whose ancestors lived in similar pre-urban Long Island ecologies.

These efforts in Jamaica Bay and at Floyd Bennett Field to create conditions in which natural phenomena and natural processes indigenous to Long Island can function unobstructed epitomize the remarkable life-sustaining actions of the human species in the natural sites of Queens and Brooklyn. Surveying the forests and wetlands in both boroughs, recreating destroyed marshes in Alley Pond Park, or creating entirely new ecologies in Prospect Park or the Gateway National Recreation Area—all these efforts are the newly developing patterns of connection between the biological and physical systems on Long Island and in New York City that are making New York City and its bioregion increasingly more life-enhancing.

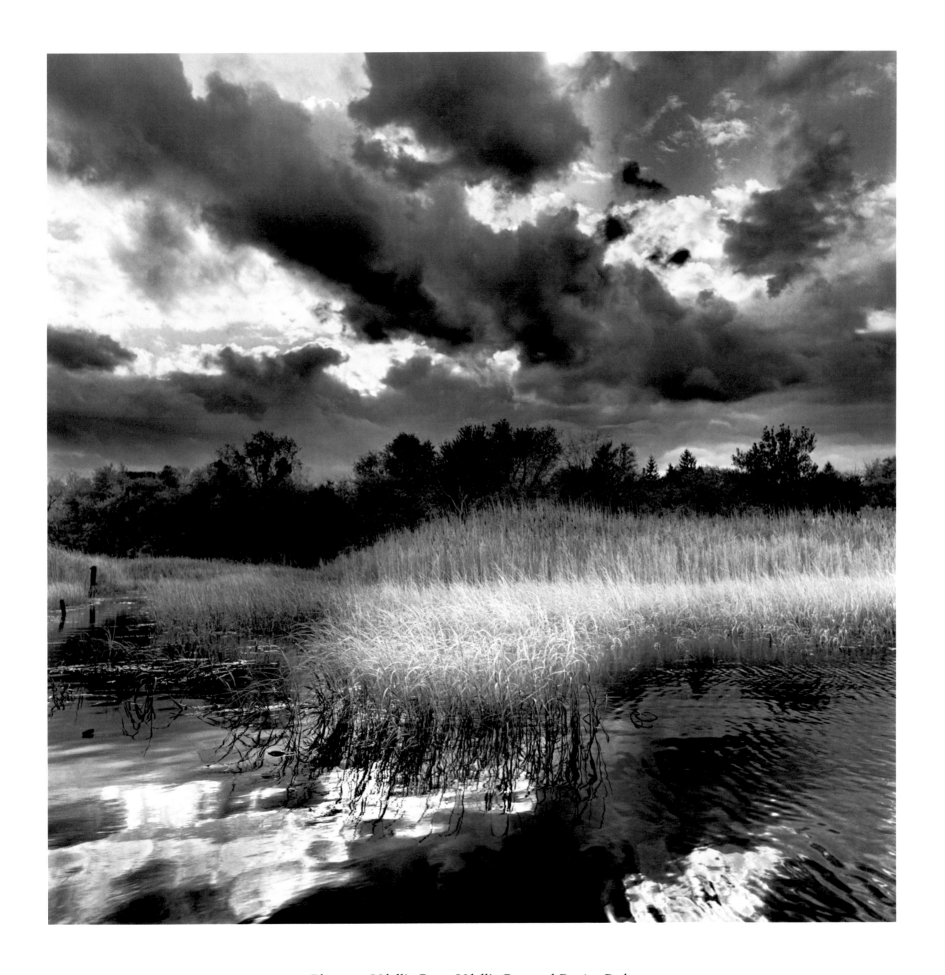

Plate 43. Udall's Cove, Udall's Cove and Ravine Park.

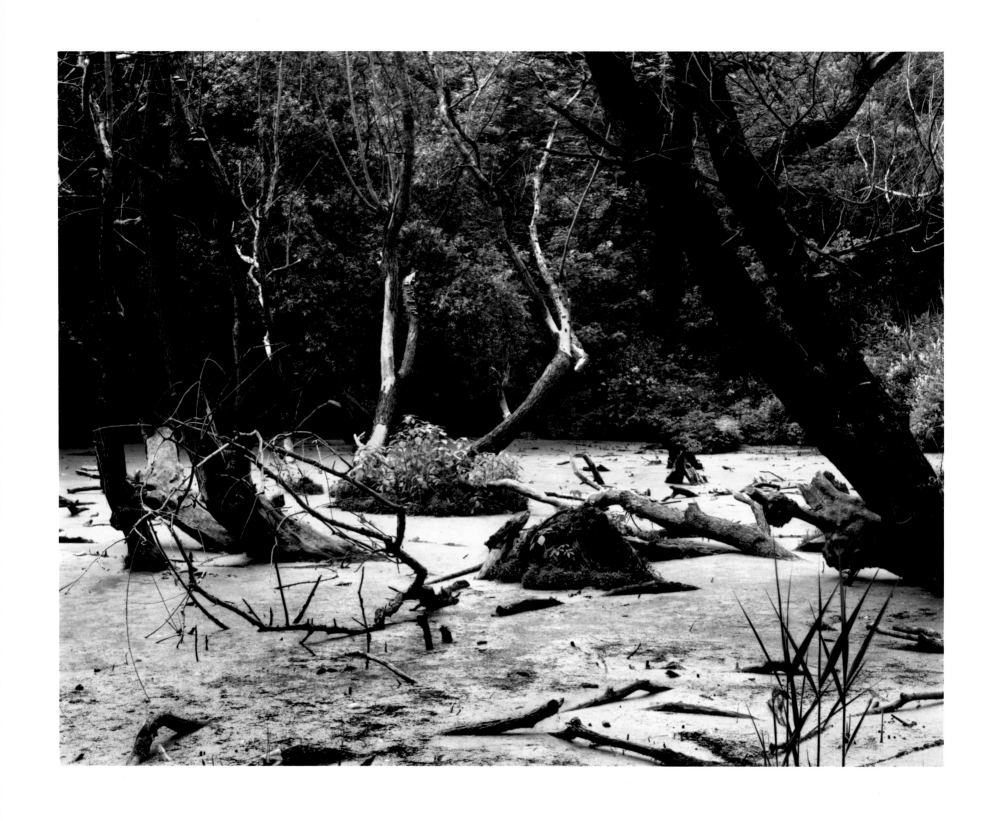

Plate 44. Ravine, Udall's Cove and Ravine Park.

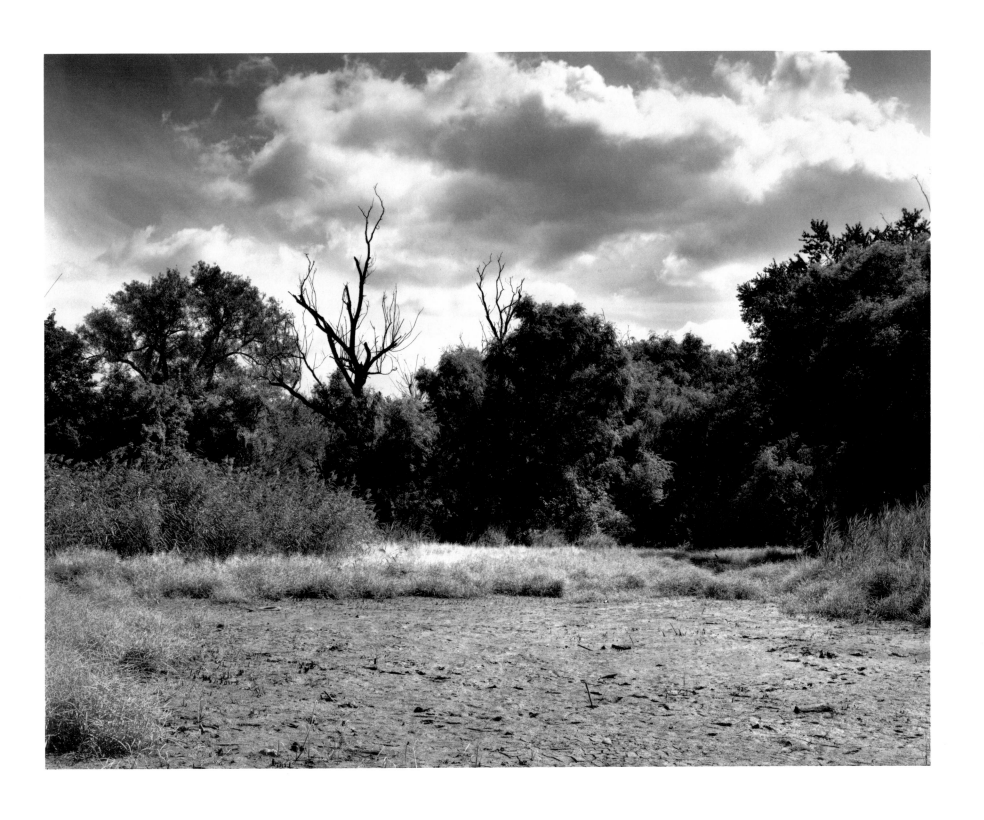

Plate 45. Wetland, Udall's Cove and Ravine Park.

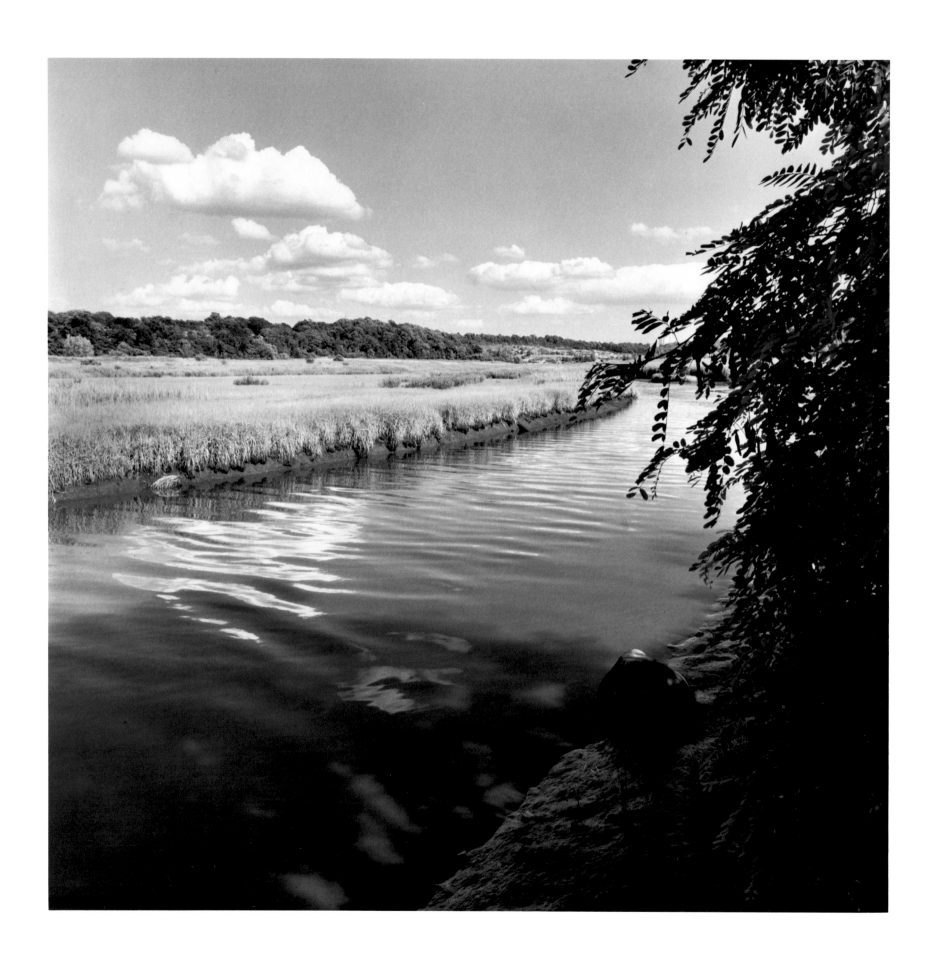

Plate 46. The Alley, Alley Pond Park.

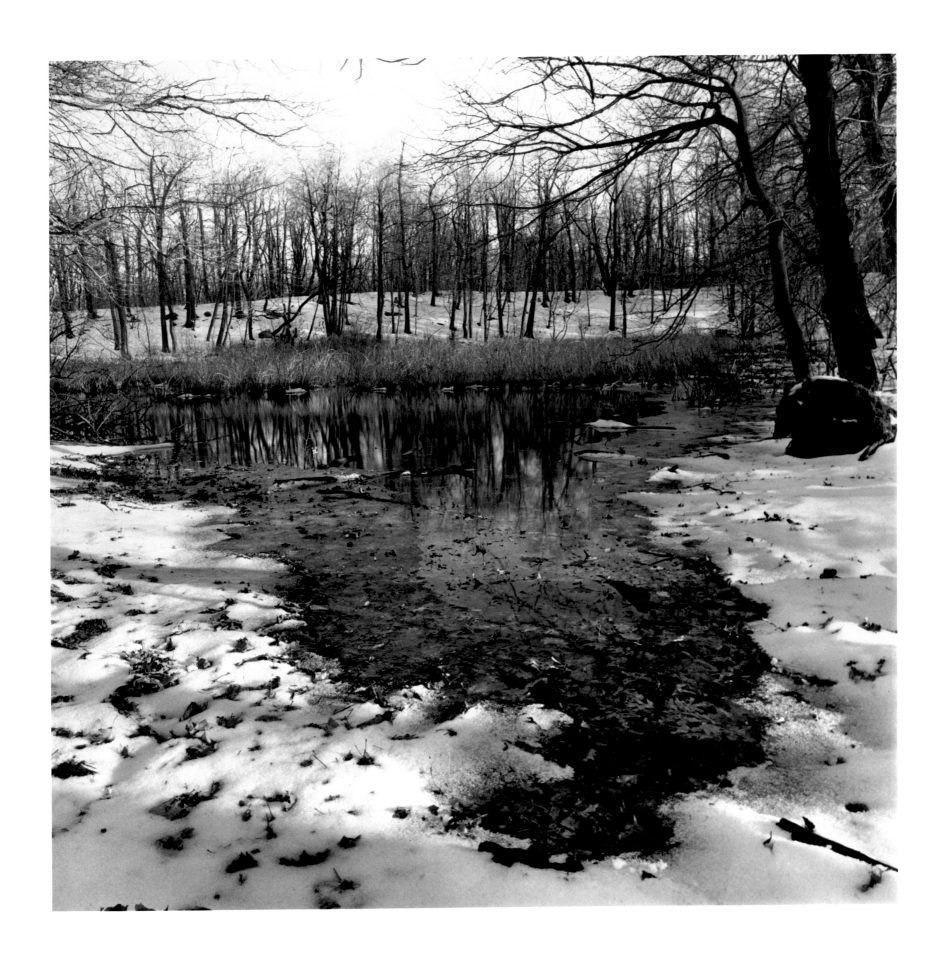

Plate 47. Kettle Pond, Alley Pond Park.

Plate 48. Forest, Alley Pond Park.

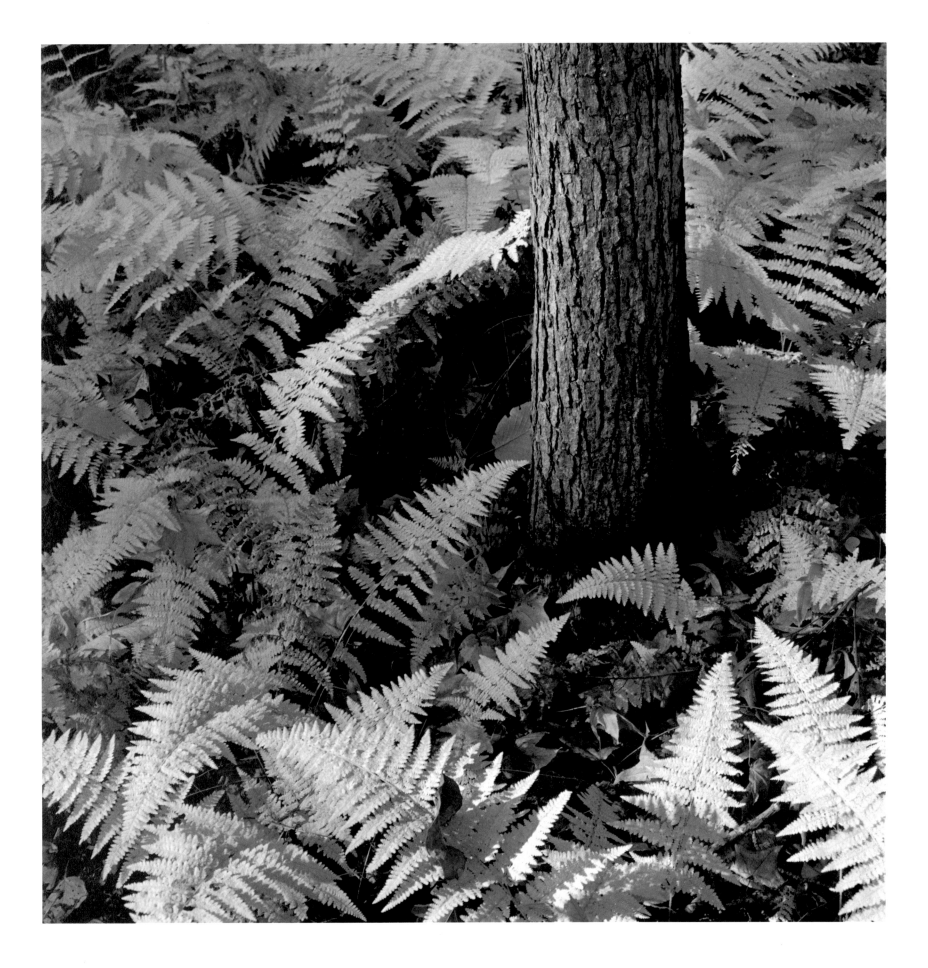

Plate 49. Lady-Fern, Cunningham Park.

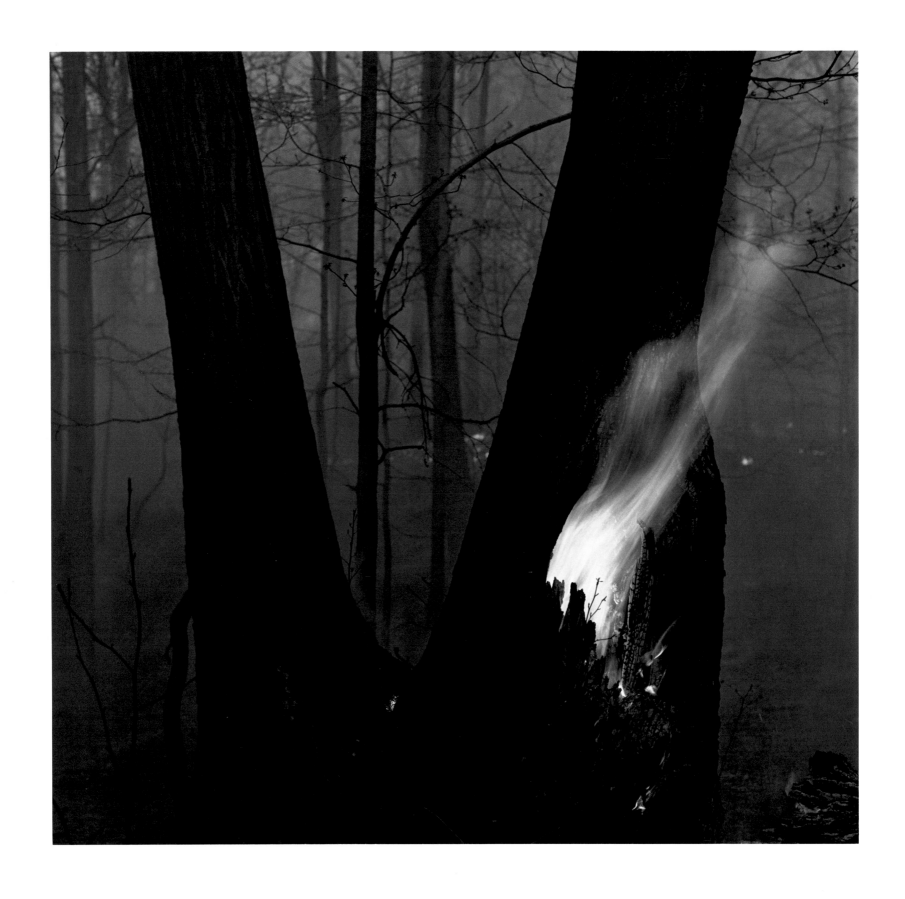

Plate 50. Fire, Cunningham Park.

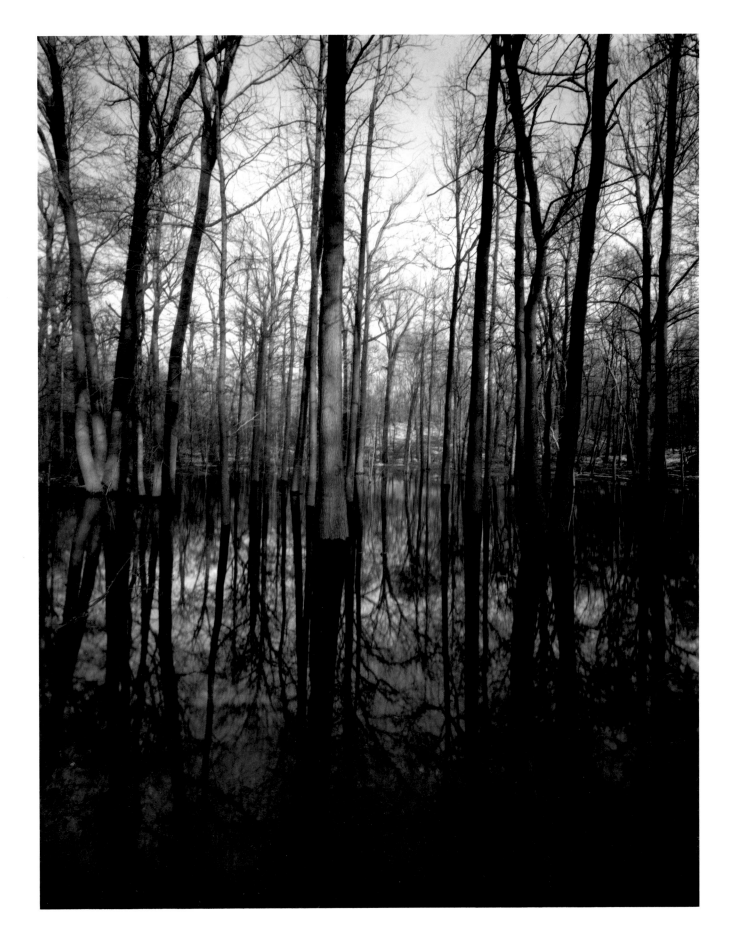

Plate 51. Forest, Cunningham Park.

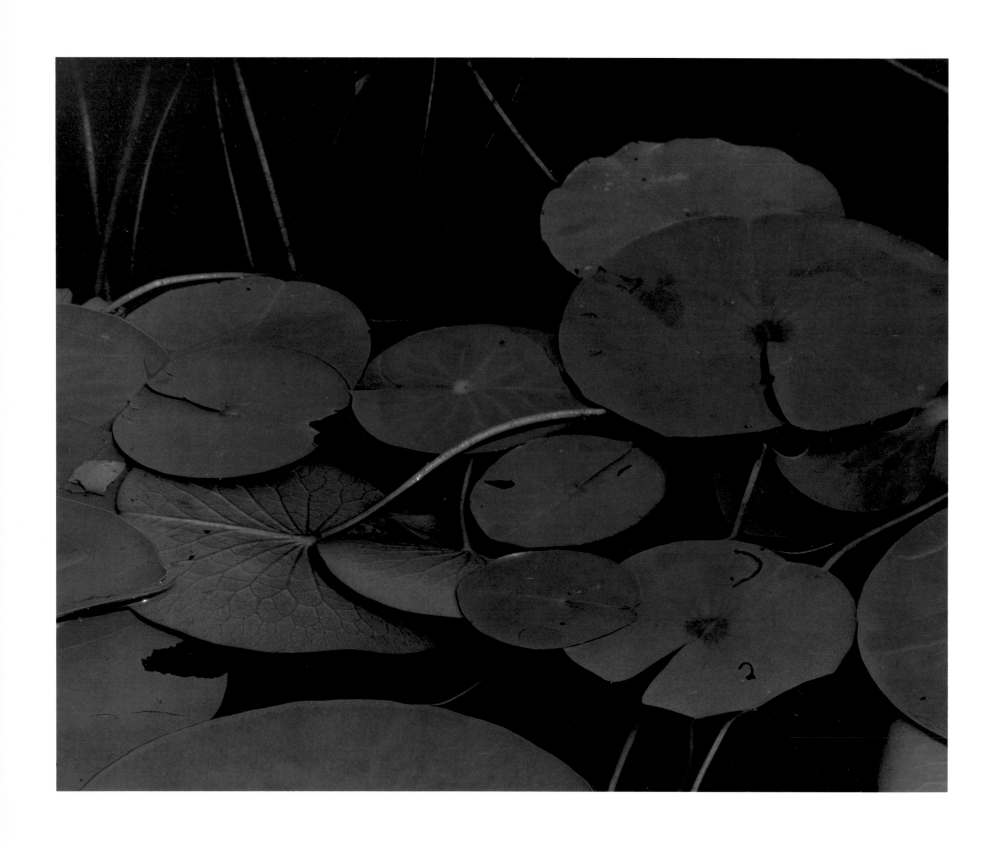

Plate 52. Water Lilies, Oakland Lake.

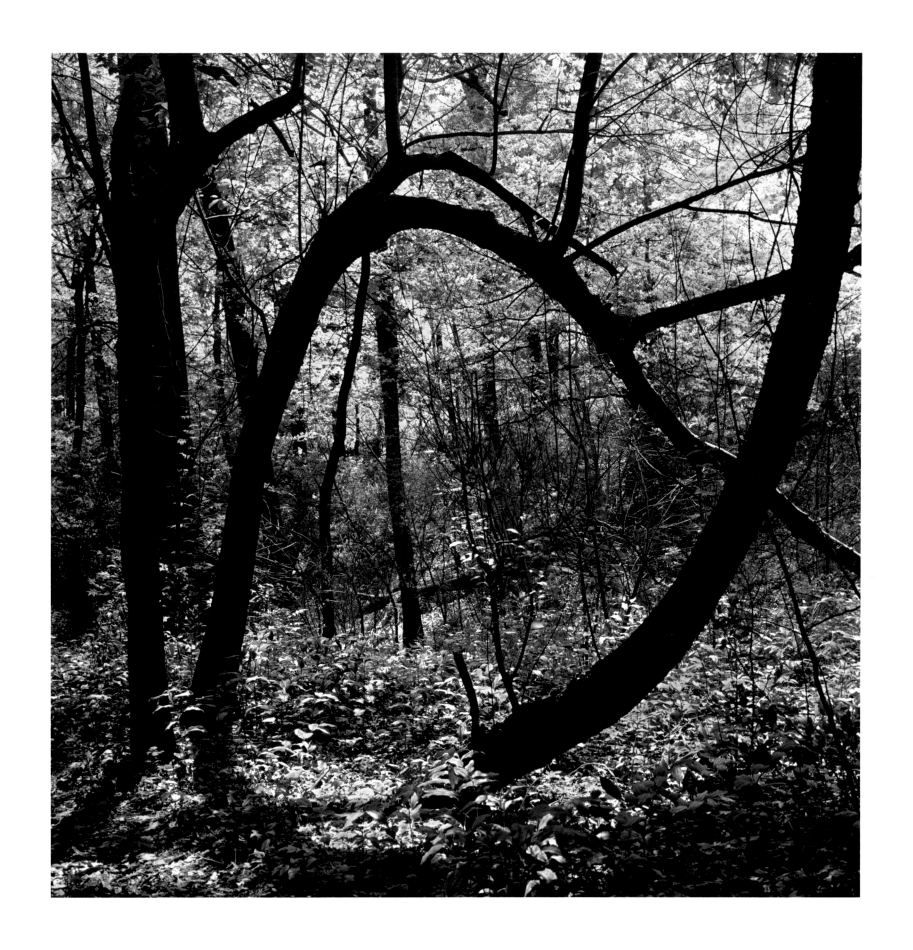

Plate 53. Oak Forest, Forest Park.

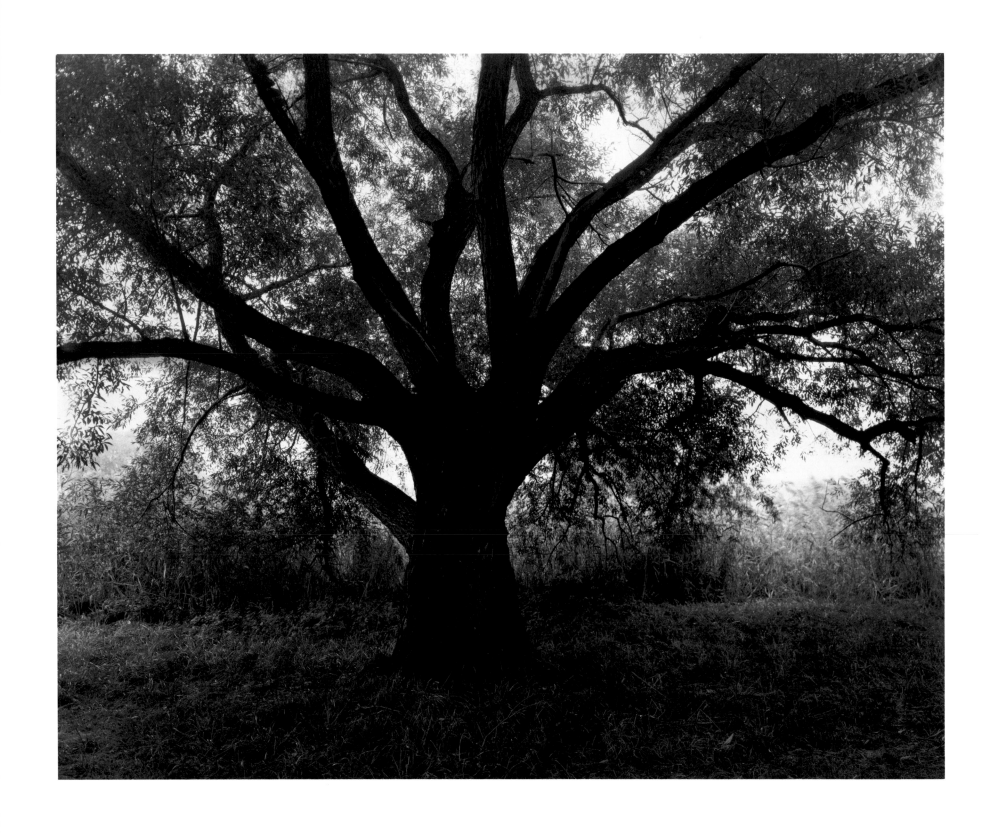

Plate 54. Willow Tree, Willow Lake, Flushing Meadows Corona Park.

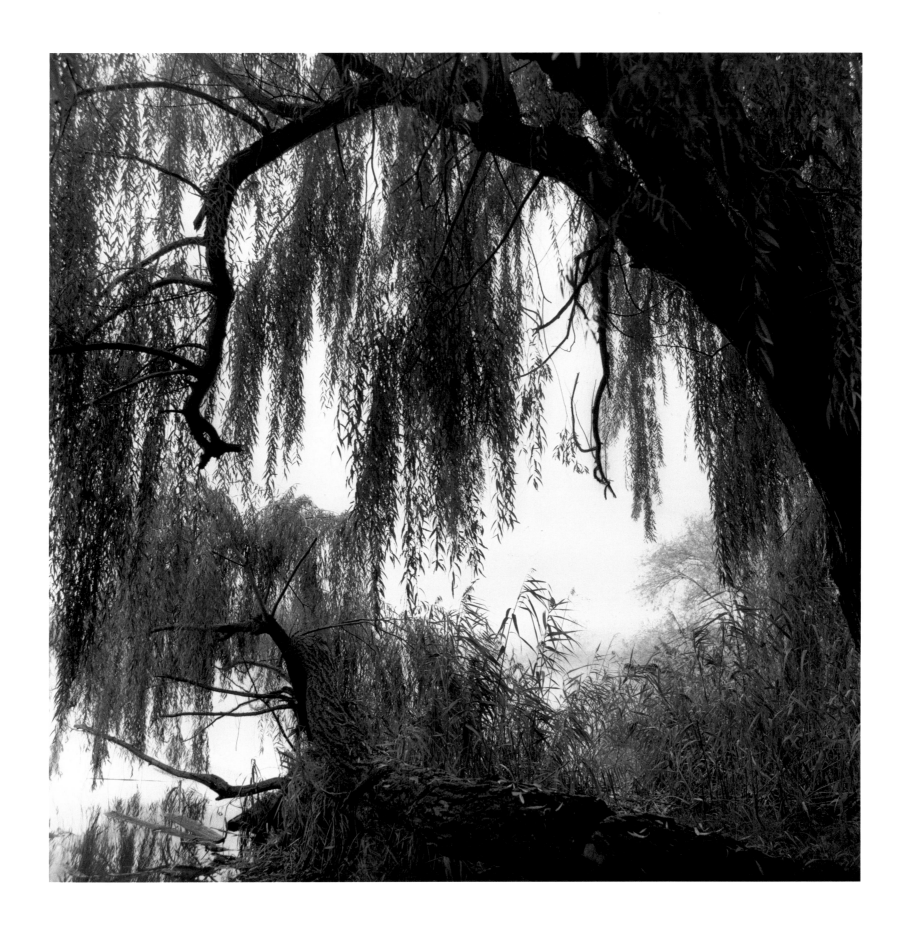

Plate 55. Willow Branch, Willow Lake, Flushing Meadows Corona Park.

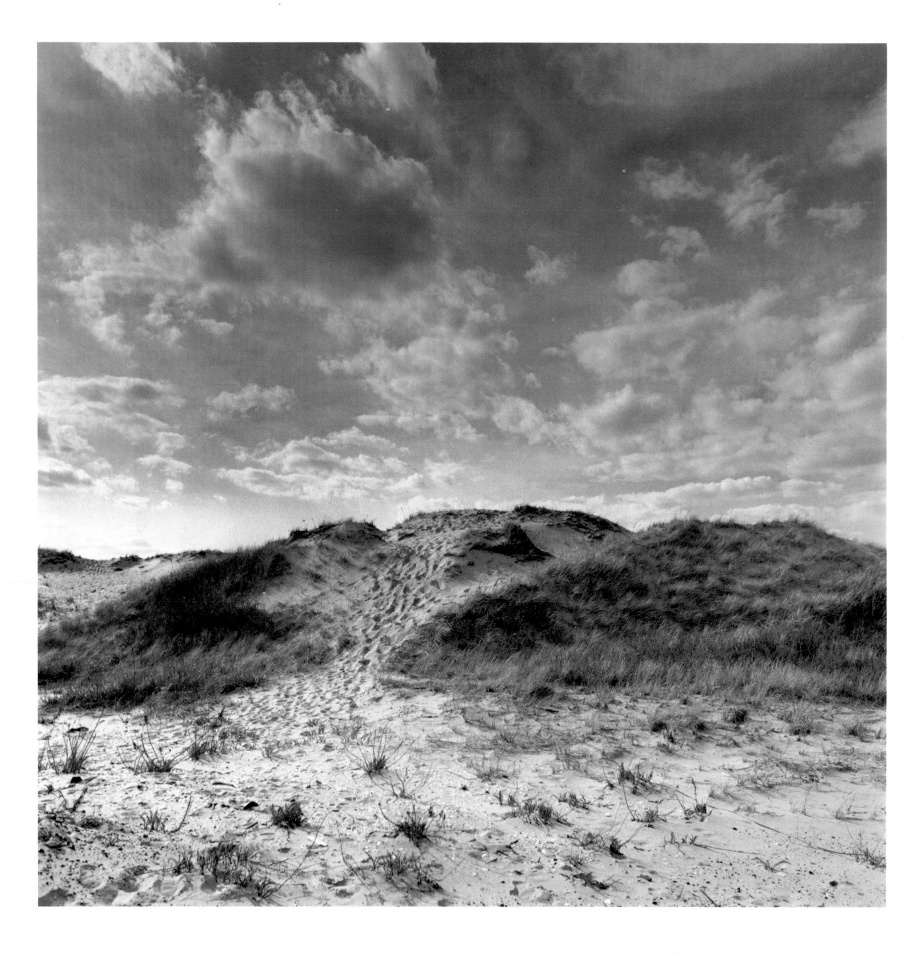

Plate 56. Fort Tilden Beach, Gateway National Recreation Area.

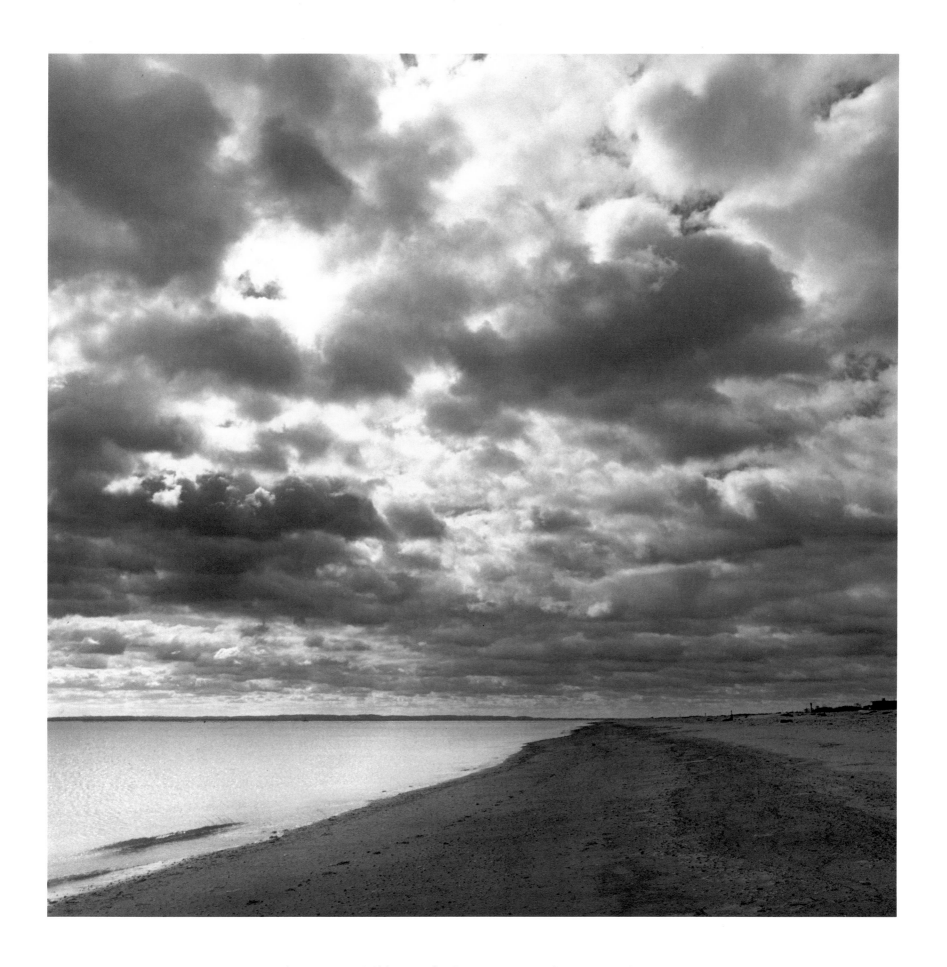

Plate 57. Fort Tilden Beach, Gateway National Recreation Area.

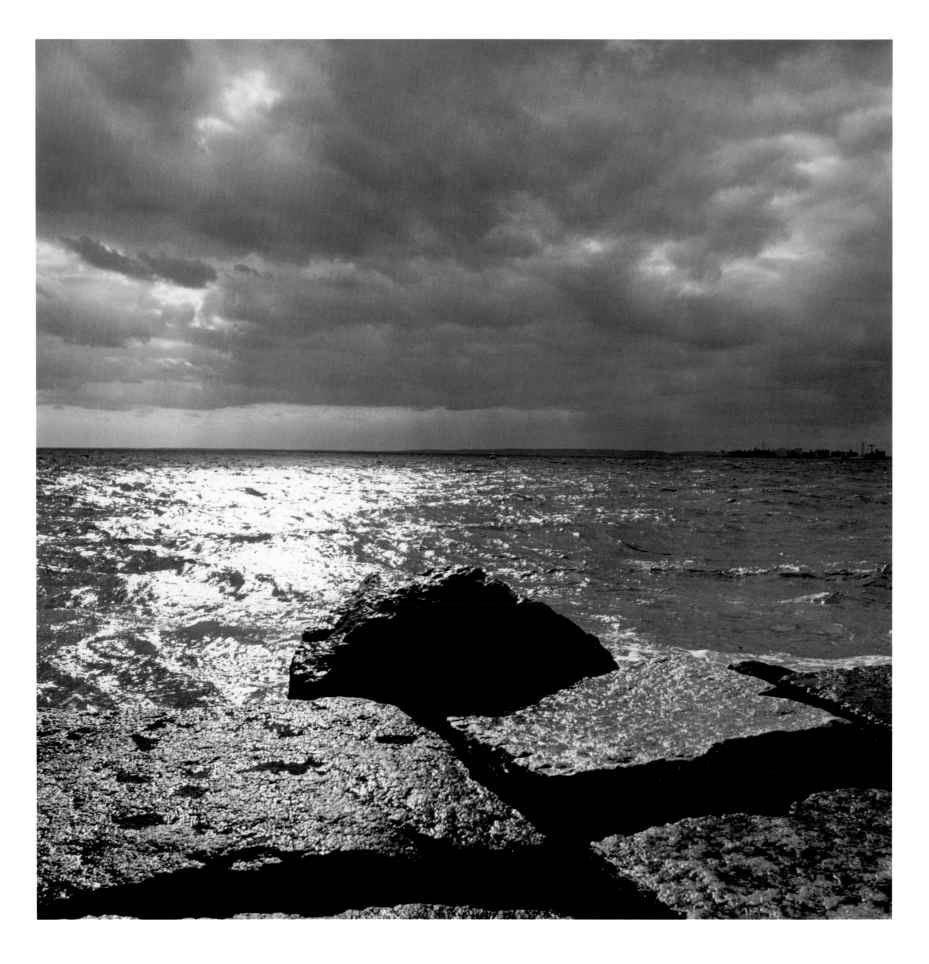

Plate 58. Breezy Point, Gateway National Recreation Area.

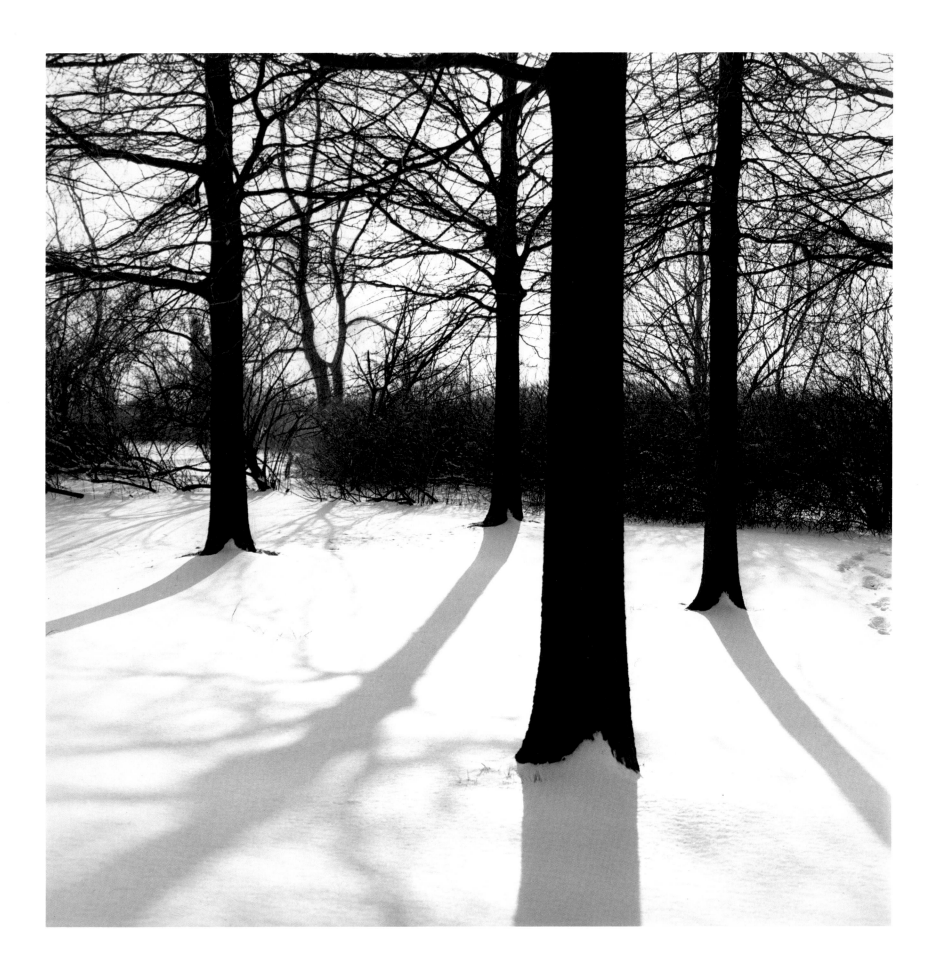

Plate 59. Upland Trees, Jamaica Bay Wildlife Refuge, Gateway National Recreation Area.

BROOKLYN

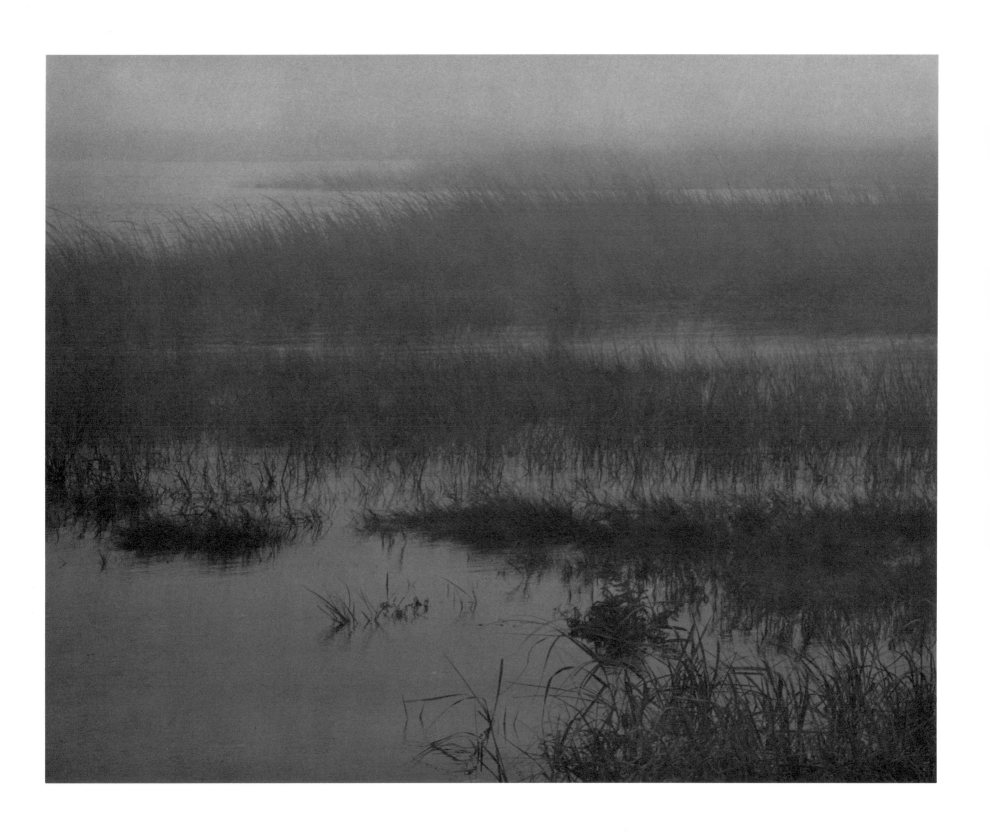

Plate 60. Fog, Jamaica Bay, Gateway National Recreation Area.

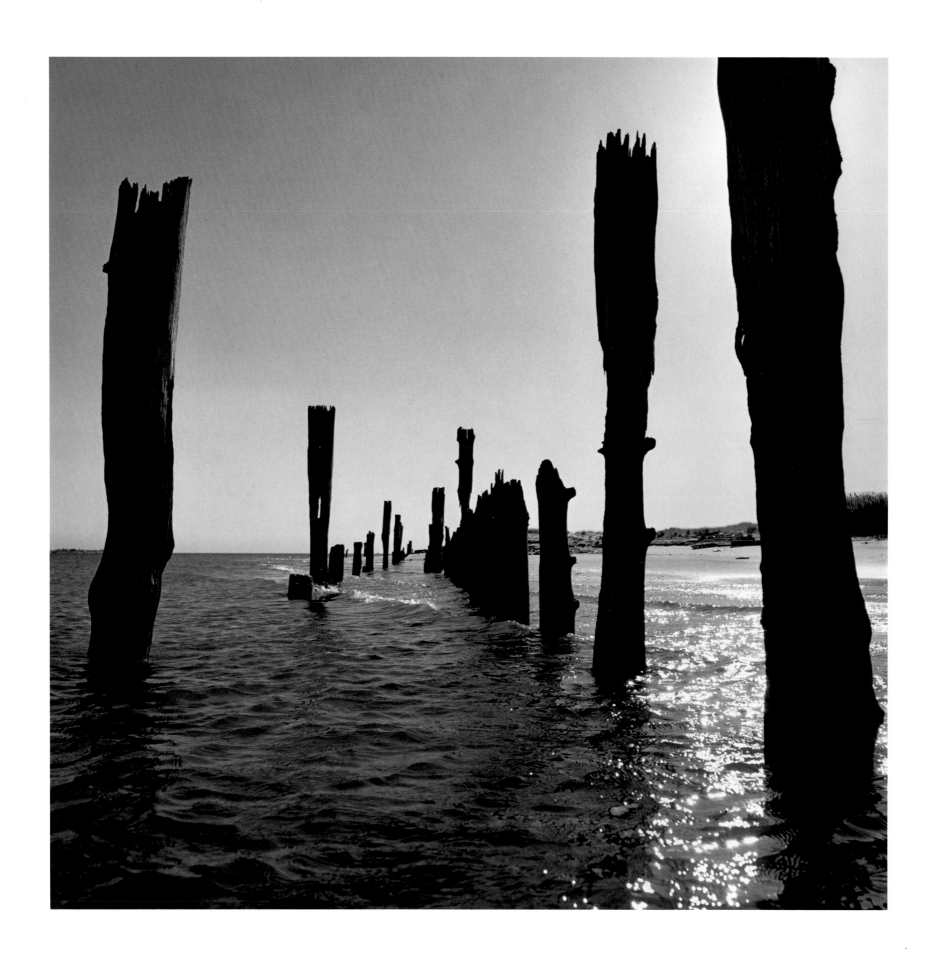

Plate 61. Dead Horse Bay, Gateway National Recreation Area.

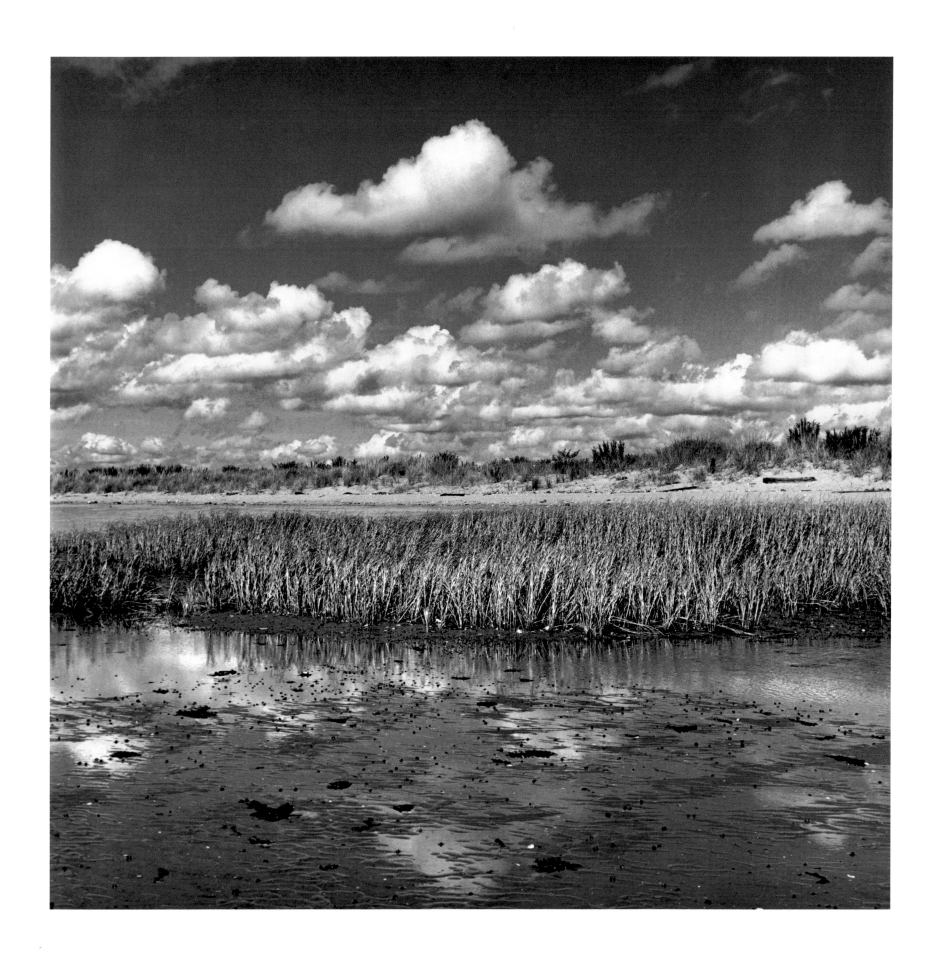

Plate 62. Plumb Beach, Gateway National Recreation Area.

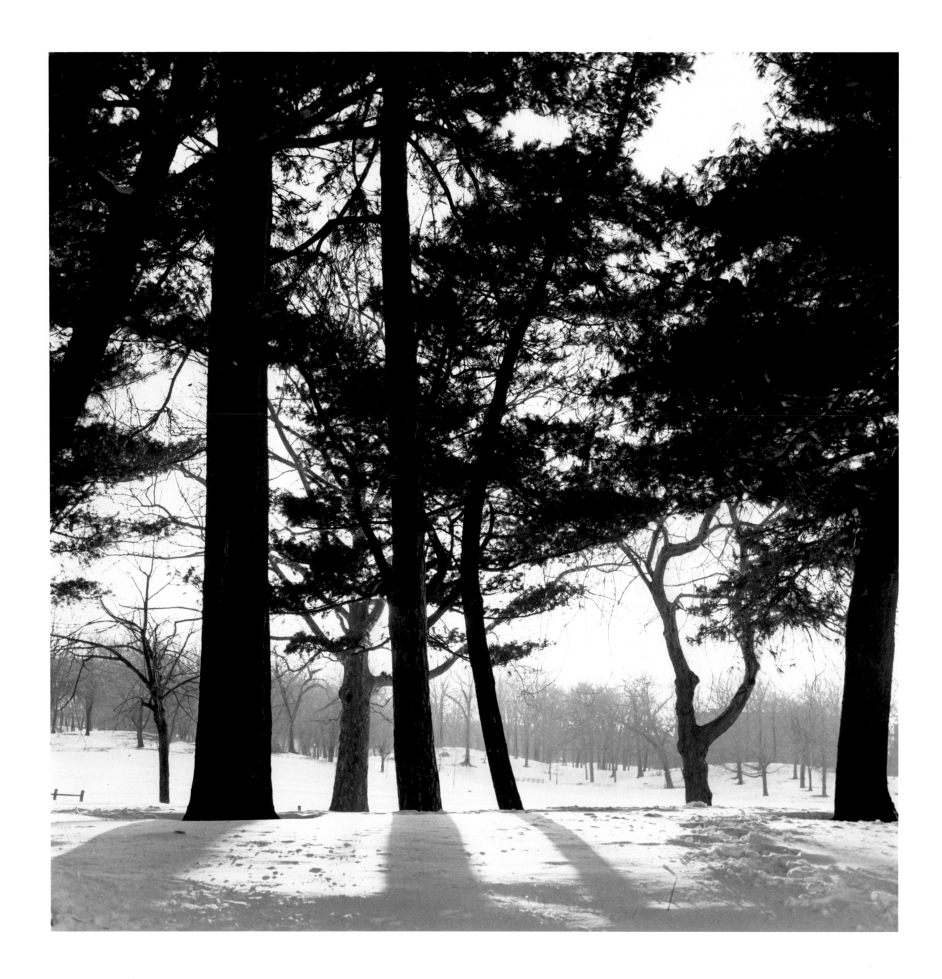

Plate 63. Trees, Prospect Park.

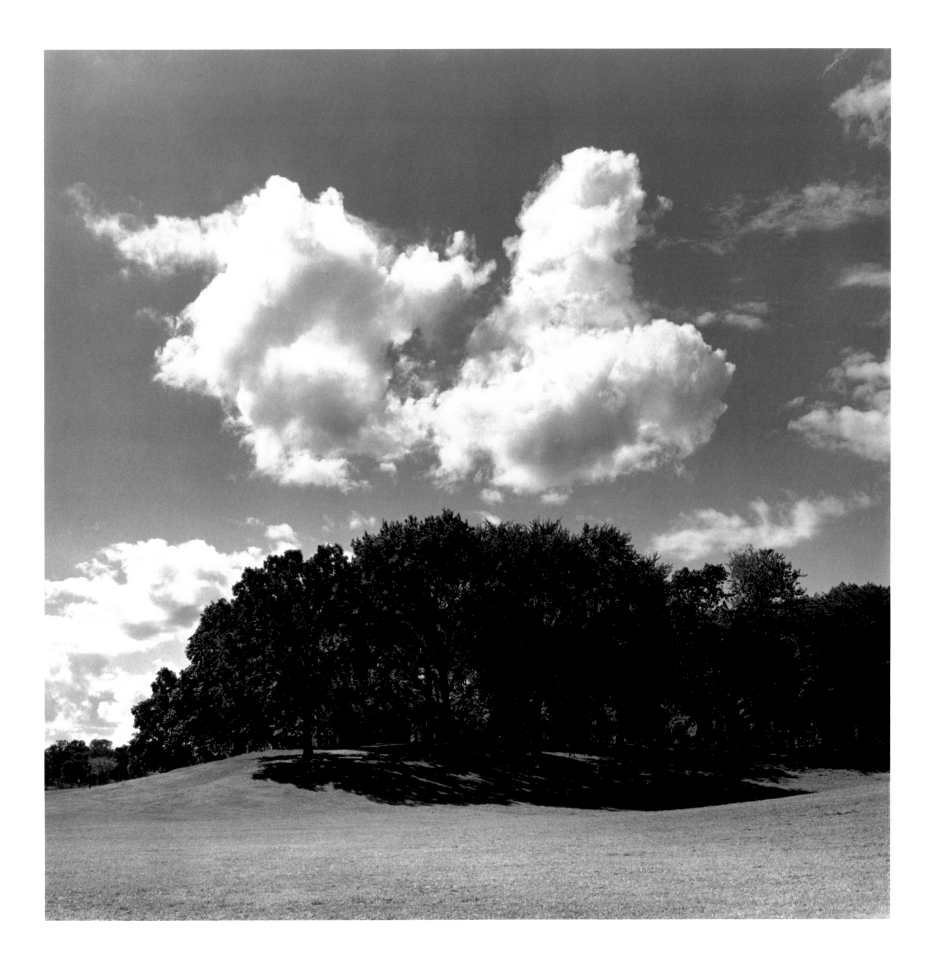

Plate 64. The Long Meadow, Prospect Park.

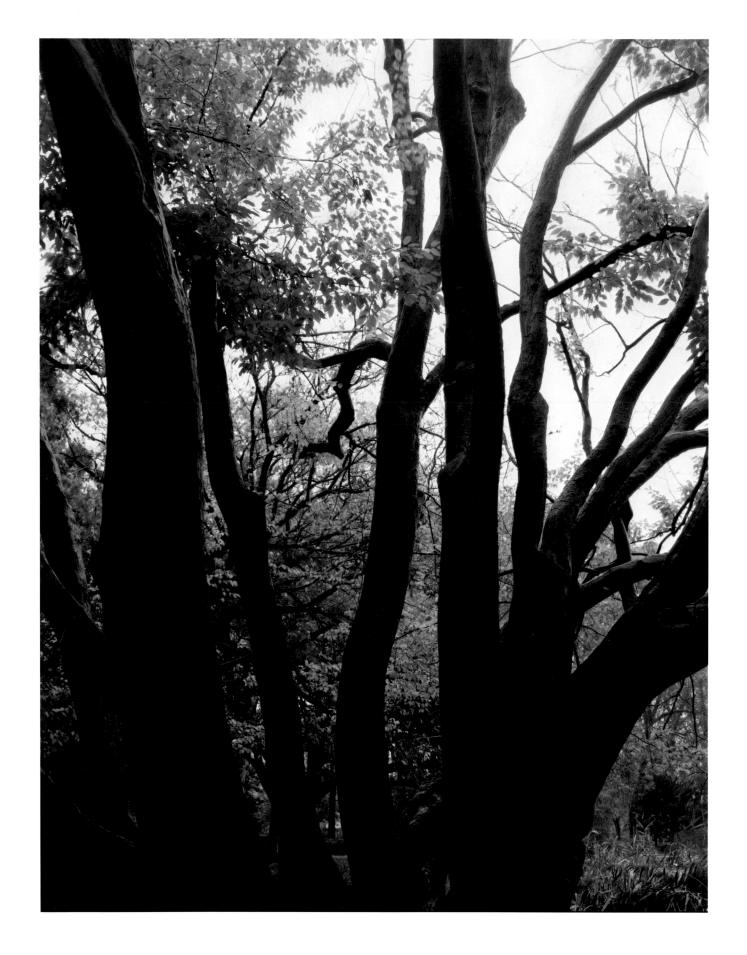

Plate 65. American Hornbeam, Breeze Hill, Prospect Park.

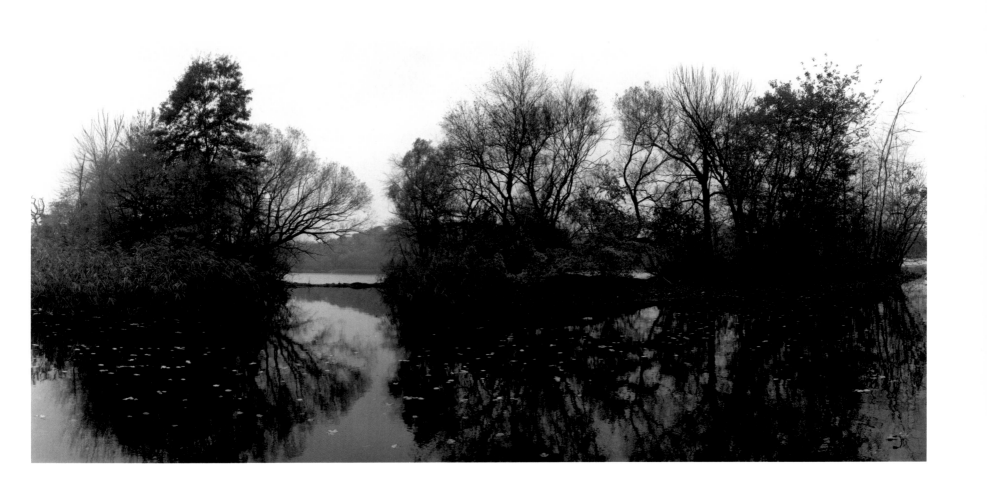

Plate 66. Islands, Prospect Park Lake, Prospect Park.

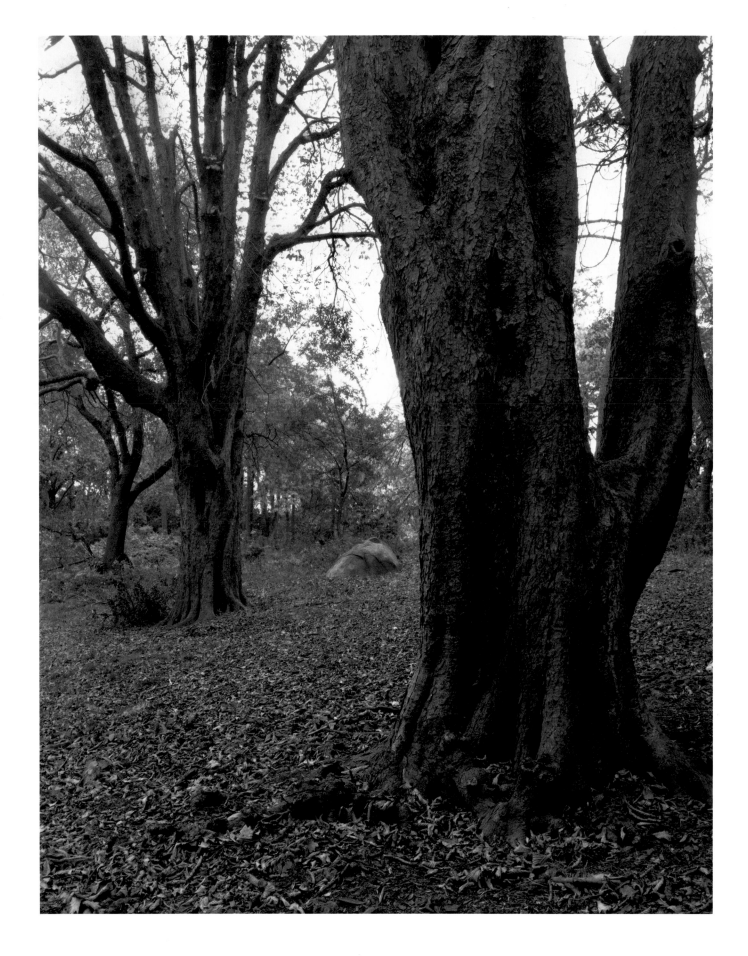

Plate 67. Forest, Prospect Park.

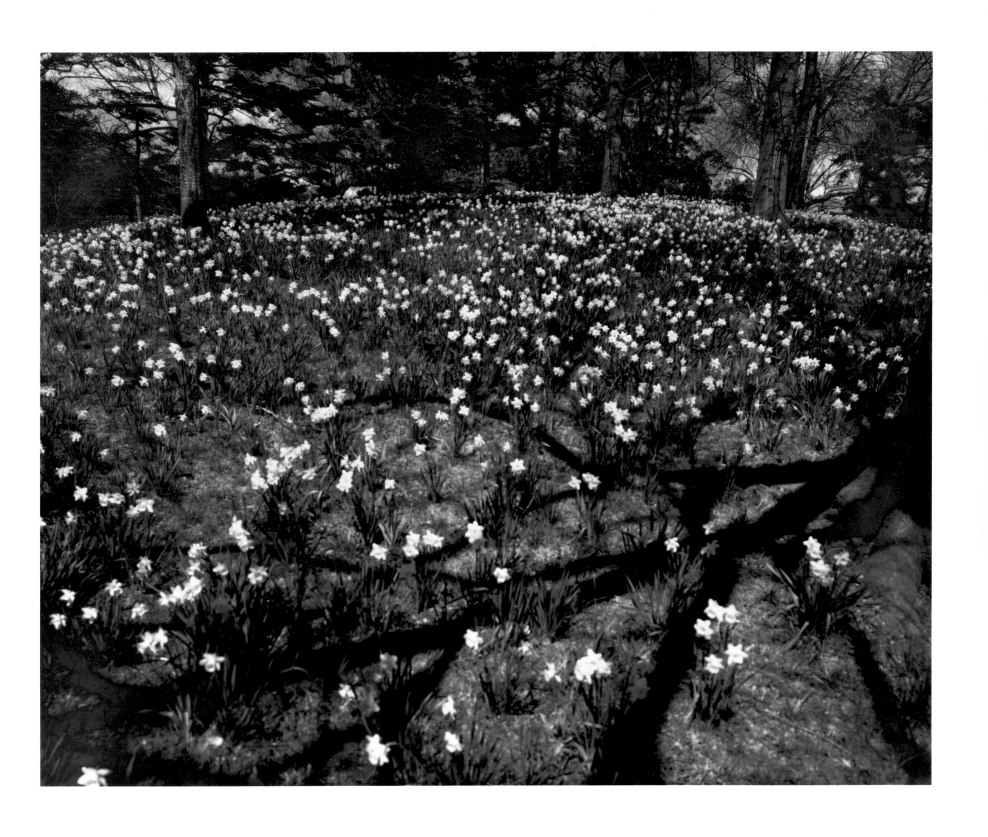

Plate 68. Daffodils, Brooklyn Botanic Garden.

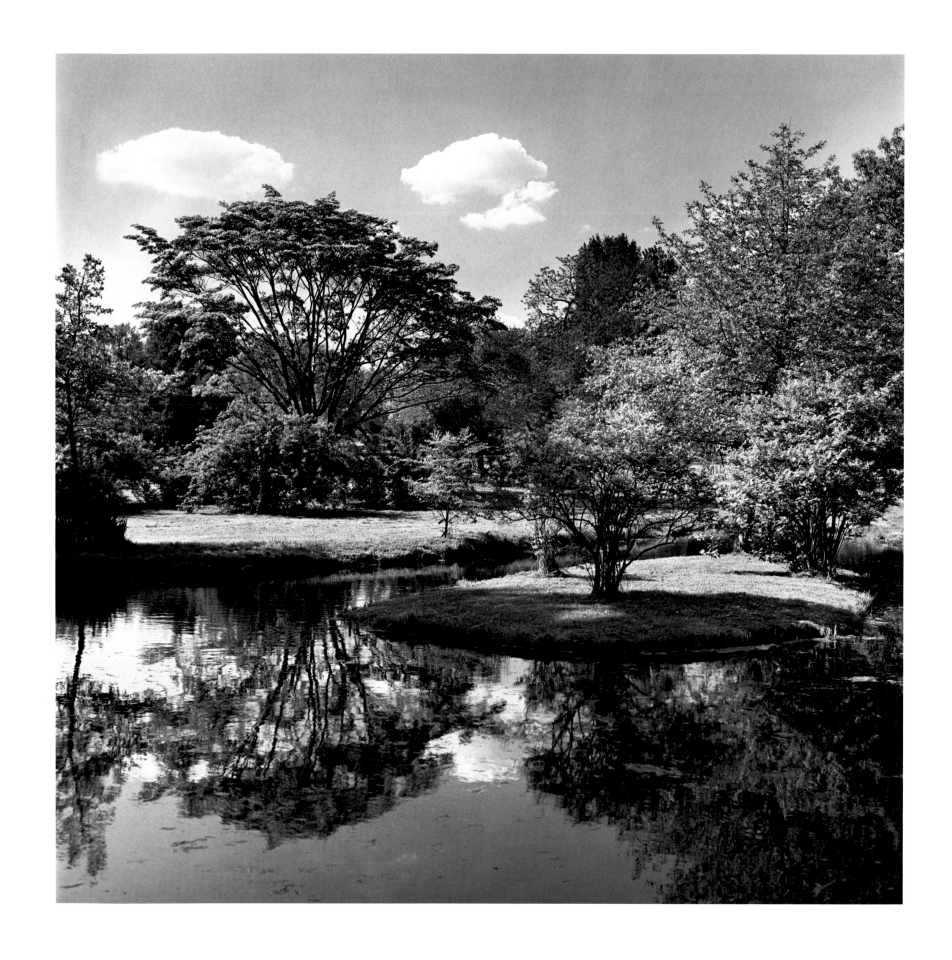

Plate 69. Reflecting Waters, Brooklyn Botanic Garden.

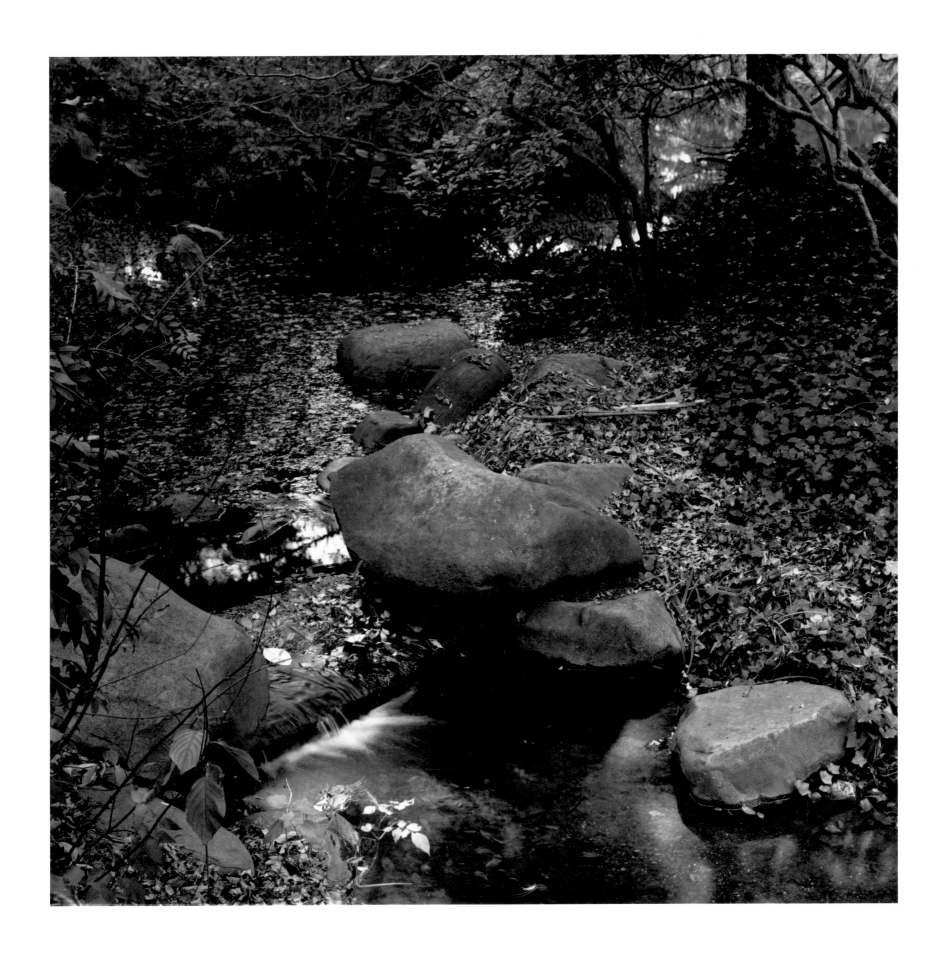

Plate 70. Stream, Brooklyn Botanic Garden.

Plate 71. Magnolia Blossoms, Brooklyn Botanic Garden.

Plate 72. Rose, Brooklyn Botanic Garden.

STATEN ISLAND

❦

"Staten Island affords some of the most beautiful sites . . . to be found in the world," said one observer almost a century and a half ago, "it is so varied, so abounding in fine views, so broken up into hills, valleys, and meadows, so diversified in its scenery that it might serve as an index to the rest of the earth." This description of Staten Island still applies today.

Since the 19th century, many Staten Island inhabitants have been working to sustain the island's varied natural systems. These range from an ancient sand environment at nearly sea level to forests at 410 feet above sea level. Thousands of plant and animal species have structured the island's ecologies. Today, one species—the human—threatens to overwhelm the others through too rapid urbanization.

Faced with this accelerated urban growth, Staten Island's Protectors of Pine Oak Woods, a fifteen-year-old, 1,500 member, community land conservation group, is taking the lead to invent new ways to balance the natural systems of the entire island.

WETLANDS

More than half of Staten Island's nearly 50,000 acres were once marshes, swamps, bogs, wet meadows, or flats. Now only 4,000 acres remain. For thousands of years, these transitional areas between dry land and open water drained the island by absorbing, storing, and slowly releasing melt and rain water. Indiscriminate filling of these wetlands as well as the destroying of island forests that also act as water regulators have hampered the island's natural drainage system. The resulting increase in water runoff, especially in the South Richmond section of the island, floods buildings, lawns, and other human artifacts. One solution has been to bury streams and other remaining natural water systems in storm sewers. Although this does prevent flooding, it also destroys the homes of thousands of species of plants and animals. Such solutions typically protect the home of only one species—the human—at the expense of many others.

The Protectors argue that the feeding and nesting grounds of waterfowl such as herons can become drainage systems that protect the feeding and nesting grounds of humanity, if the reciprocity between herons, humans, and water is understood. Their current efforts to sustain the ecology of the entire island promote another possible solution to the flooding problem. They argue that ecologically functioning ponds can substitute for storm sewers by serving as retention basins for runoff water. If they are enhanced, ponds like Blue Heron Pond can absorb, hold, and slowly release runoff water so that buildings, lawns, and other human artifacts are not flooded. The first step in enhancing wetlands is mapping their watersheds so the entire system can be understood. Then stream banks can be rerouted to create less direct water flow. New ponds can be dug, existing ones deepened, and pond and stream banks stabilized.

The plan to use enhanced wetlands to prevent flooding sustains both herons, humanity, and water by recognizing patterns that connect them. Its use of ponds as storm sewers does not pit one species against many others or one feature of the Staten Island habitat against another; it does not solve human problems in isolation from the biological and physical systems of which humanity is a part. Instead, this proposal sees the needs of many species of plants and animals as interconnected within the patterns of the natural functions of a self-organizing entity—the Staten Island habitat. As a result, a problem within the feeding

and nesting grounds of humans—flooded basements and lawns—can be minimized by improving the feeding and nesting grounds of herons.

THE STATEN ISLAND GREENBELT

Similar efforts to create an equilibrium for the habitat needs of Staten Island have led, over the last twenty years, to the idea of a Greenbelt Park in the center of the island. When fully assembled and mapped, this 2,500-acre nature preserve will protect one of the island's major landforms—hills that attain an elevation of 410 feet. The Greenbelt will also preserve five of Staten Island's seven distinct ecologies—forests with native plants, freshwater and tidal wetlands, open fields, and areas where the presence of the human species has created new ecosystems.

The ecologies found in the Greenbelt at such sites as Bloodroot Valley, Buck's Hollow, Egbertville Ravine, and the Great Swamp at Seaview contain many rare and endangered plants. For instance, according to the Curator of Science at the Staten Island Institute of Arts and Sciences, Bloodroot Valley is remarkable for the richness of its native flora and the wildness and beauty of its scenery. Here, in spring, the rare bloodroot opens snowy eight-petaled blossoms in the morning and closes them at night. Other unusual plants grow on the steep isolated slopes of this valley: Christmas fern, ebony spleenwort, maidenhair fern, silvery spleenwort, fragile fern, hairy Solomon's seal, whorled pogonia, moccasin flower, yellow clintonia, baneberry, blue cohosh, alumroot, yellow violet, spikenard, sweet cicely, partridgeberry, mountain laurel, and Virginia waterleaf.

The Office of the Administrator of the Greenbelt presently has a Master Plan in preparation that considers the natural functions of the ecologies in the Greenbelt as guiding principles for developing its management policy. Because eighty percent of the Greenbelt is relatively untouched natural ecologies, major biological and physical functions of the island's ecosystem occur here. These functions include cleansing and cooling the air, which, among other benefits, helps make Staten Island a comfortable place for the human species to be during the summer. Tree, plants, and forest soils act as a "sink" for airborne pollutants and dust, either filtering them through the leaves of plants as they breathe or providing a surface for them to fall onto. When rainwater that has accumulated on vegetation begins to evaporate, it cools the air. The Greenbelt, just like the Staten Island wetlands, also prevents flooding by absorbing rain and by regulating runoff. The natural lands of this preserve also benefit many other life forms, among them migrating birds, by providing them with resting and feeding grounds during their seasonal migrations from north to south and then back again.

Many of these vital natural functions are in danger of being crippled or destroyed. Staten Islanders are debating easing traffic congestion by putting a highway through the core of the proposed Greenbelt Park. As in the case of flooded basements in South Richmond, the problem of clogged streets in central Staten Island confronts the islanders with difficult choices that affect the future stability of earth, air, water, and life forms on their island. Current efforts to achieve a balance include obtaining protection for the Greenbelt's entire 2,500 acres. This entails demapping the Richmond and Willowbrook Parkways so that the New York State Department of Transportation has no legal claim to the land within the Greenbelt for a transportation corridor.

CLAY PIT PONDS STATE PARK PRESERVE

Another recent attempt to accommodate the needs of the island's biological and physical systems has resulted in a Master Plan for the Clay Pit Ponds State Park Preserve that the New York Region Office of the State Office of Parks, Recreation, and Historic Preservation and community members have developed. In 1980 the State Office of Parks, Recreation, and Historic Preservation designated as parkland 250 acres in one of the island's major landforms, a plain. Located in the southwest corner of the island, the Clay Pit Ponds State Park Preserve forms part of the coastal plain that extends 2,200 miles from Cape Cod to the Mexican border and then for an additional 1,000 miles along the Gulf of Mexico. In the preserve 75-million-year-old beds of sand and multicolored clays provide the conditions for the flora of a pine barren—a sandy environment that fire regenerates. The heat of the fire releases the seeds of pine cones, which in turn produce new plants in the fire's ashes. A

continuation of the famed New Jersey million-acre pitch pine forests, Staten Island's barren creates a striking contrast to the island's northeastern rocky highlands, where parts of the Greenbelt are located.

The Master Plan for the Clay Pit Ponds State Park Preserve provides protection for the park's ponds, which form part of the system of freshwater wetlands that drain South Richmond. In addition, the plan restricts access to the pine barrens. Because its ecology is so fragile, this unique natural area could not survive the trampling of many feet and unrestricted recreational use. Currently, horse trails that predate the creation of the park wind through it. These will be replaced with trails around the perimeter that will be three times as long as the present ones. New and relocated park buildings will accommodate increased numbers of the human species curious to see and learn about this rare 75-million-year-old environment.

INGENIOUS EFFORTS

The New York City Chapter of the Audubon Society is studying accommodations for 600 breeding pairs of herons on two abandoned islands in waterways separating Staten Island from New Jersey—Prall's Island in the Arthur Kill and Shooter's in Kill van Kull. Under a special thirty-year agreement with the New York City Department of Parks and Recreation, this organization is managing both Prall's Island, which was once farmland, and Shooter's Island, the onetime site of a shipbuilding facility. Because the natural systems of both these small islands are functioning so well, the Audubon Society has decided to let them continue with no human intervention. Instead, aided by the Manomet Bird Conservatory in Massachusetts, the Audubon Society is conducting long-term research on why the herons are breeding on these two islands. The arrangement between Audubon and the city's Parks Department provides a model for management of other lands acquired by the city when the city does not have the resources to manage them itself.

About ten miles from Prall's and Shooter's Islands on the northern portion of Great Kills Marsh is Kingfisher Pond, a wood and wetland frequented by birds from Prall's and Shooter's Islands. The Protectors have been able to place this twenty-three and a-half-acre site, so necessary to island birds, onto the

acquisition list of the city's Parks Department and hope soon that it will be protected. They are also promoting a proposal to preserve a site of approximately 150 acres on the south shore of Staten Island that includes the highest point along the New York City bay and ocean coast. The Mount Loretto and Long Pond Area, as it is called, includes lands once used by an orphanage and a sandpaper manufacturer. The woods, meadows, tidal wetlands, and ponds in this area are especially outstanding because they lie on the uneven terrain of the terminal moraine.

These efforts—in pine barrens, in forests, in freshwater and tidal wetlands, in open fields, and in areas where the human presence has created new ecologies—exemplify the inventive ways in which Staten Islanders are balancing what often seem like conflicting habitat needs. Their success could help make that island an index, not just of beautiful sites, but of how urban humanity can live reciprocally with earth, air, water, and other life forms.

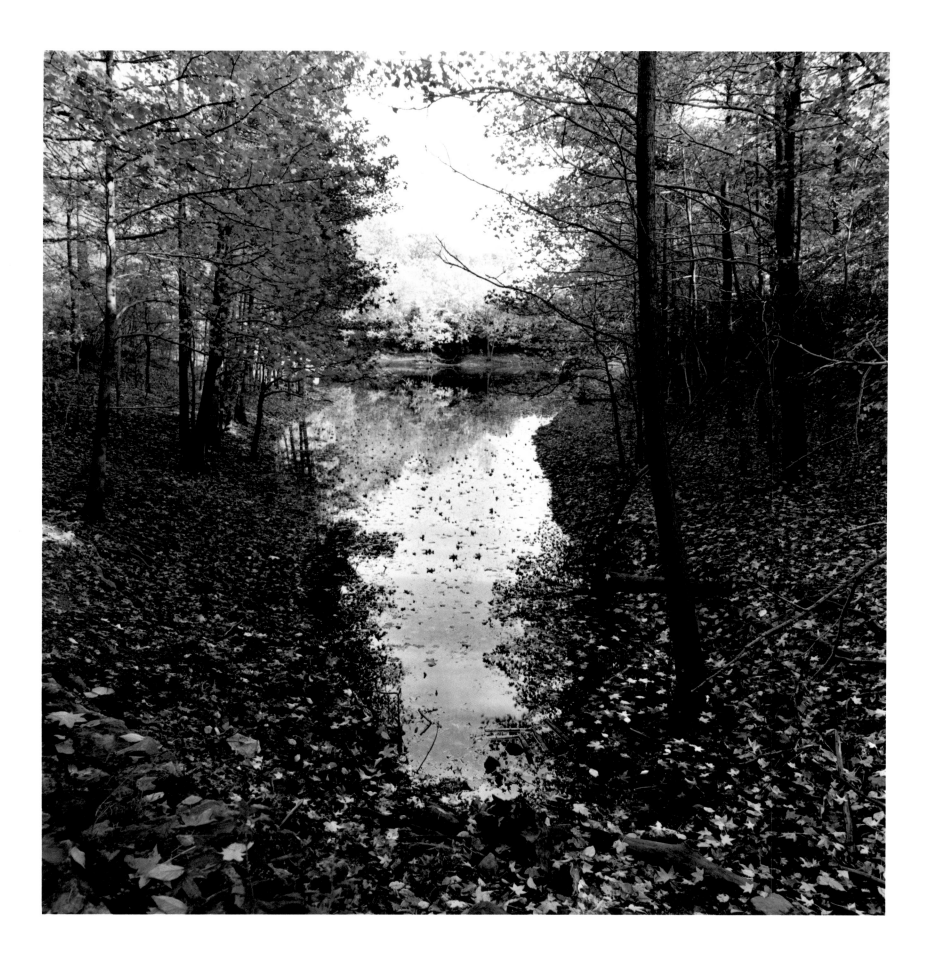

Plate 73. Tadpole Pond, The Greenbelt.

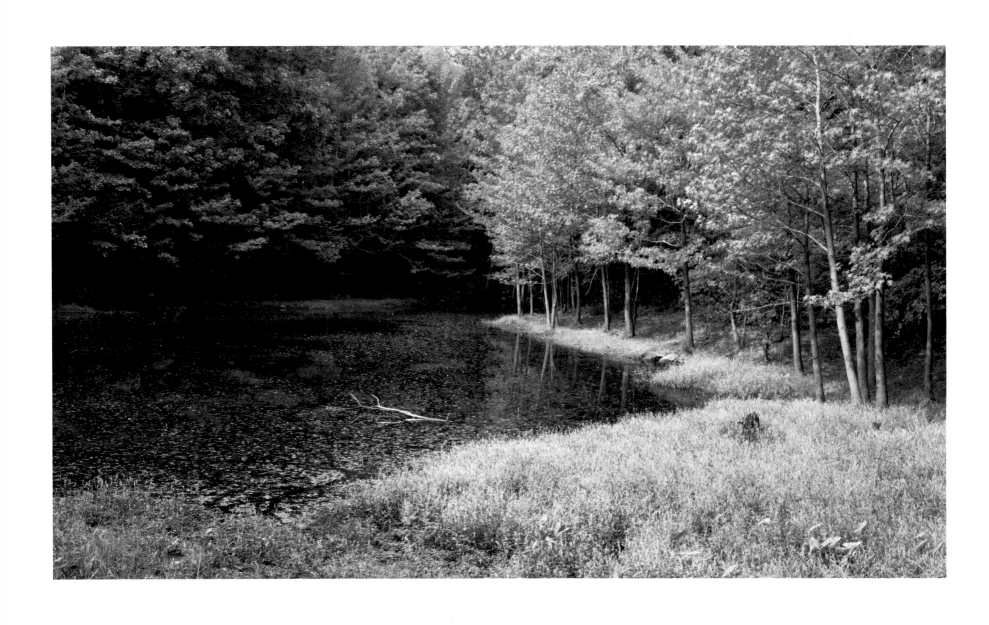

Plate 74. Tadpole Pond, The Greenbelt.

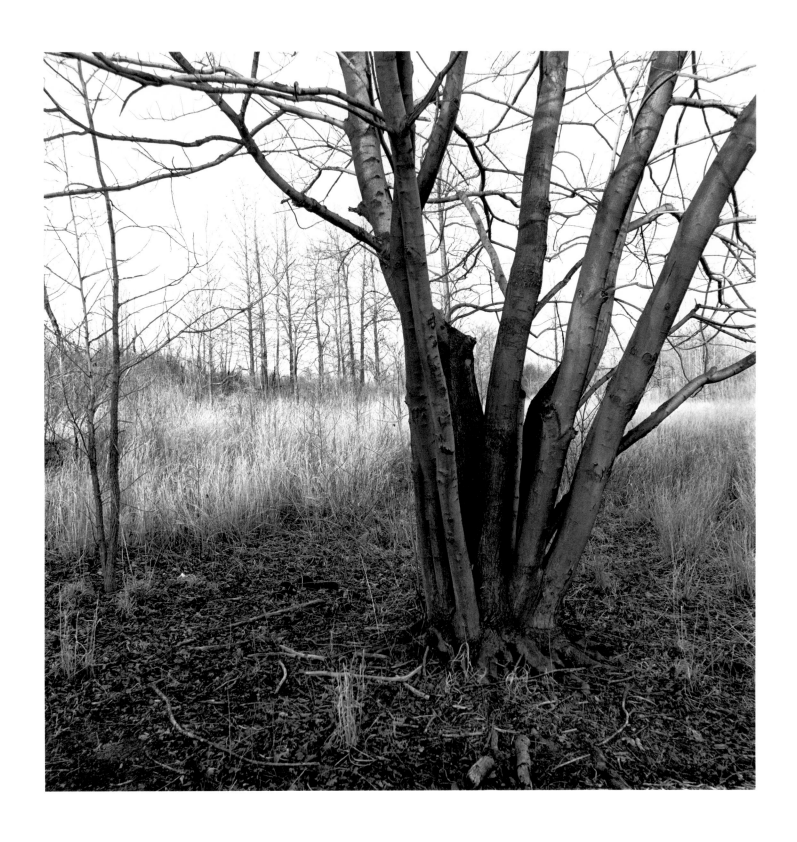

Plate 75. Red Maple, Blue Heron Pond Park.

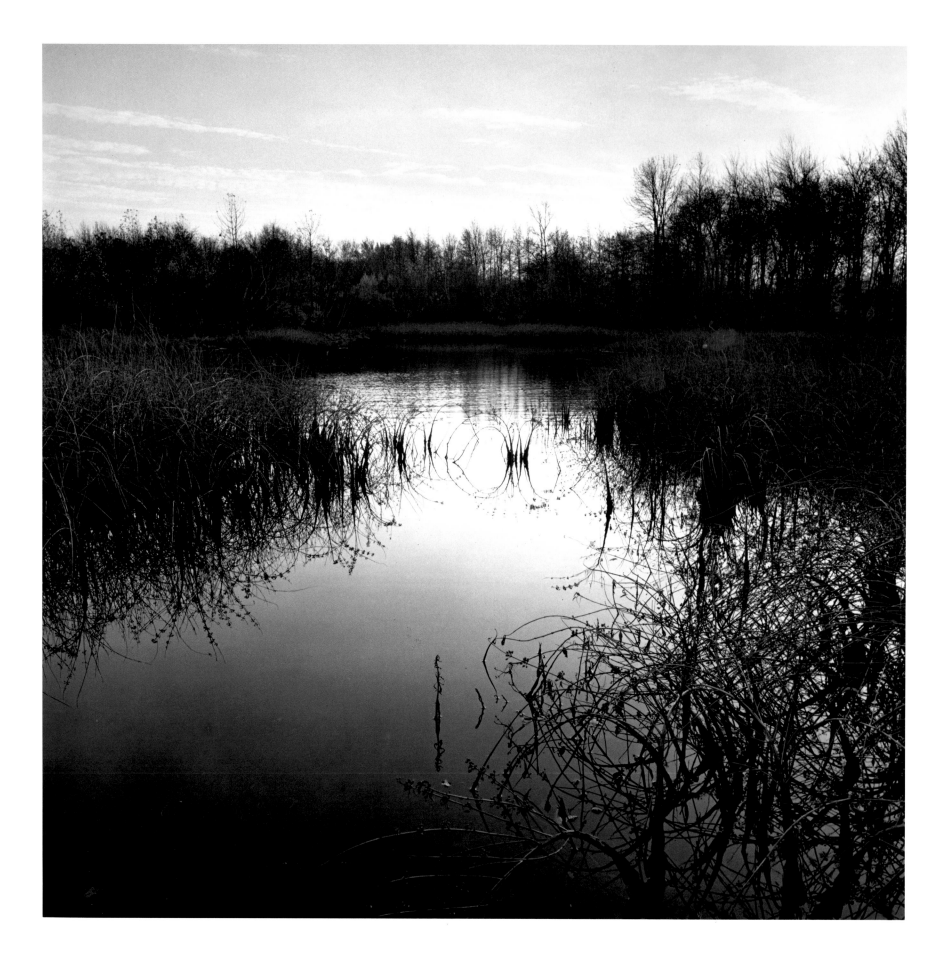

Plate 76. Pond, Blue Heron Pond Park.

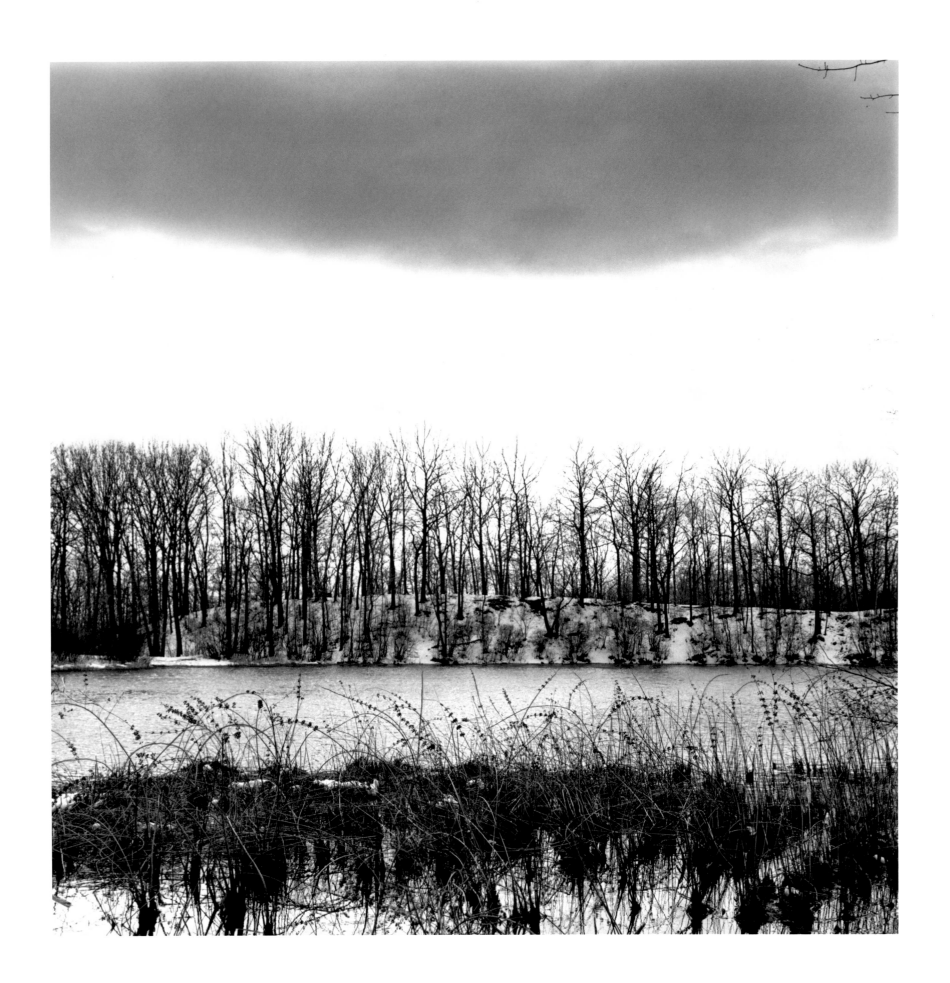

Plate 77. Orabach Lake, The Greenbelt.

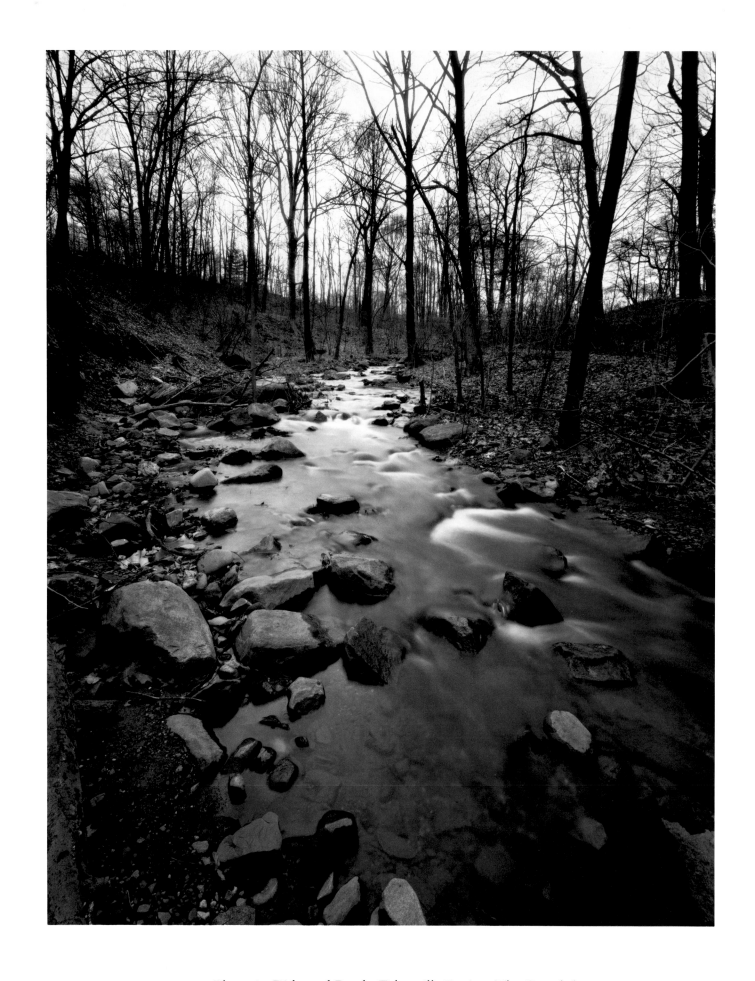

Plate 78. Richmond Brook, Egbertville Ravine, The Greenbelt.

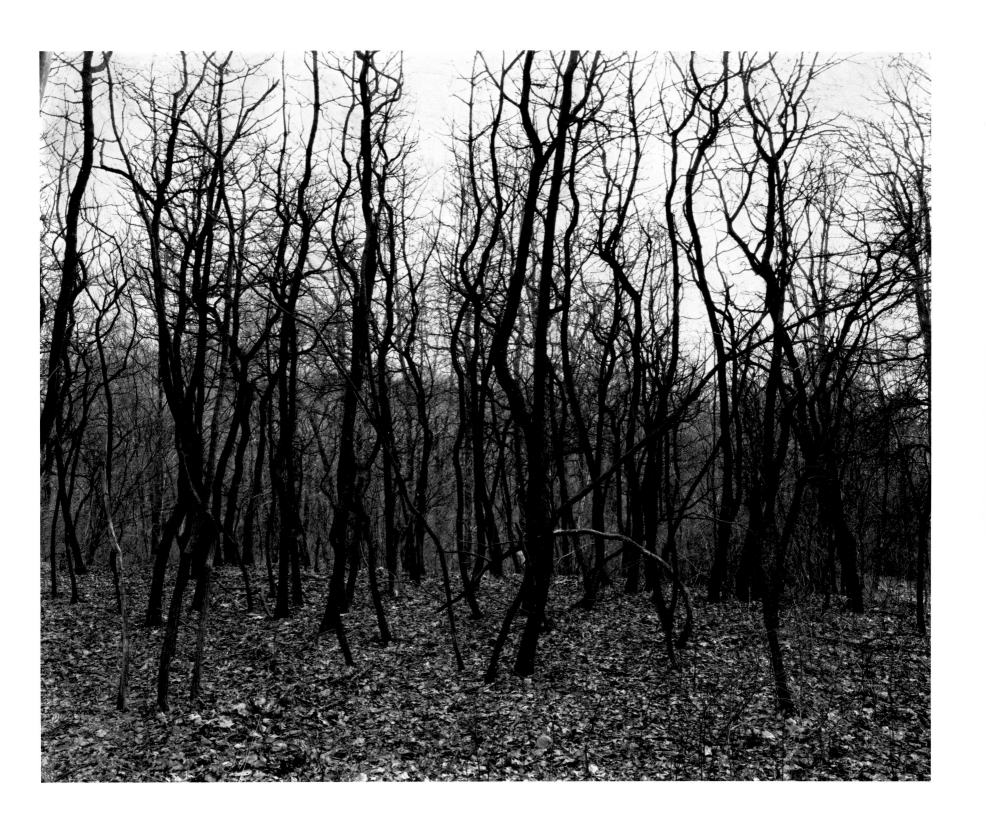

Plate 79. Sassafras, Egbertville Ravine, The Greenbelt.

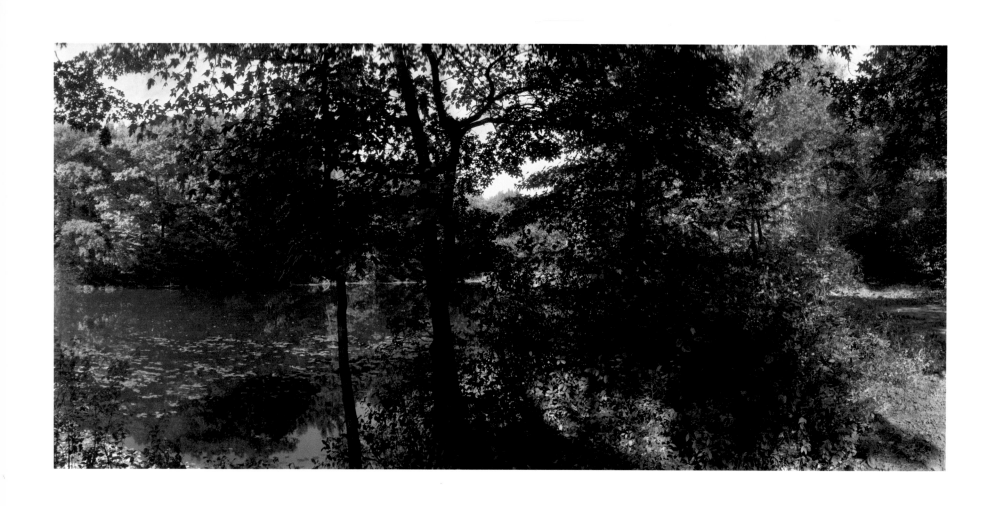

Plate 80. Pond, Wolfe's Pond Park.

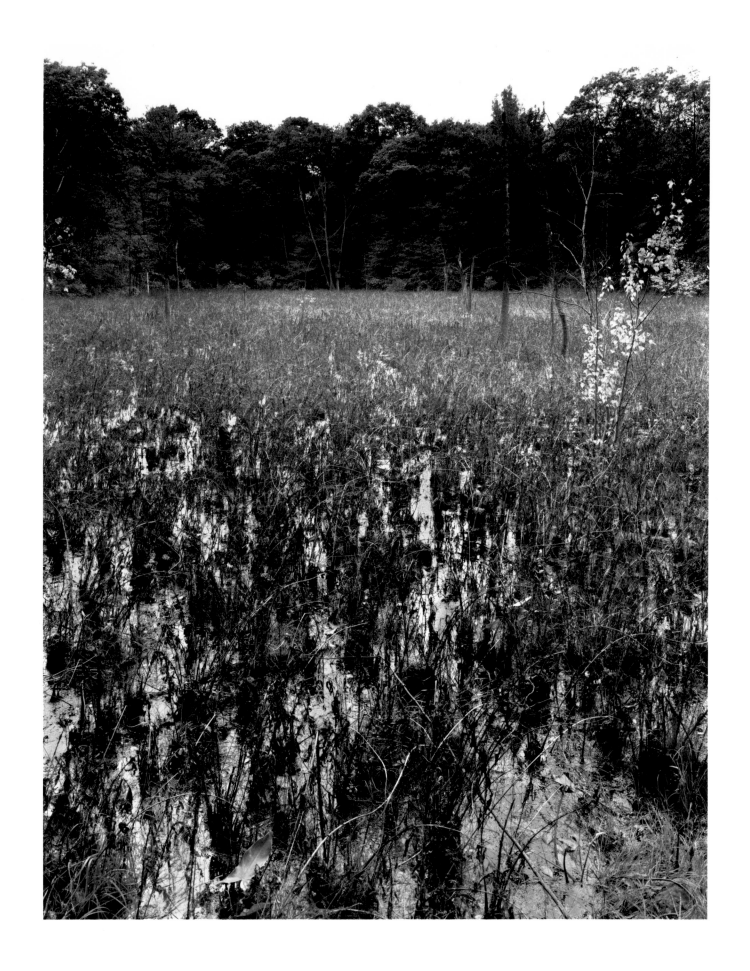

Plate 81. Fall Loosestrife Swamp, High Rock Conservation Center, The Greenbelt.

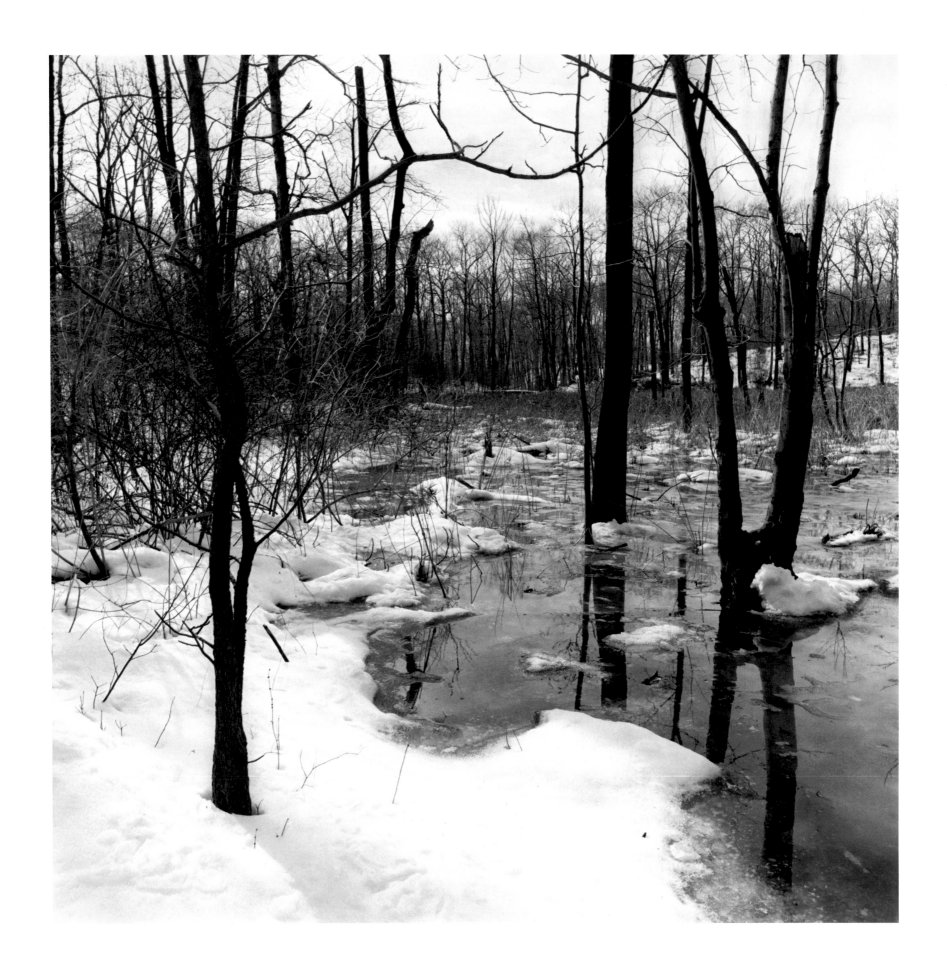

Plate 82. Winter Loosestrife Swamp, High Rock Conservation Center, The Greenbelt.

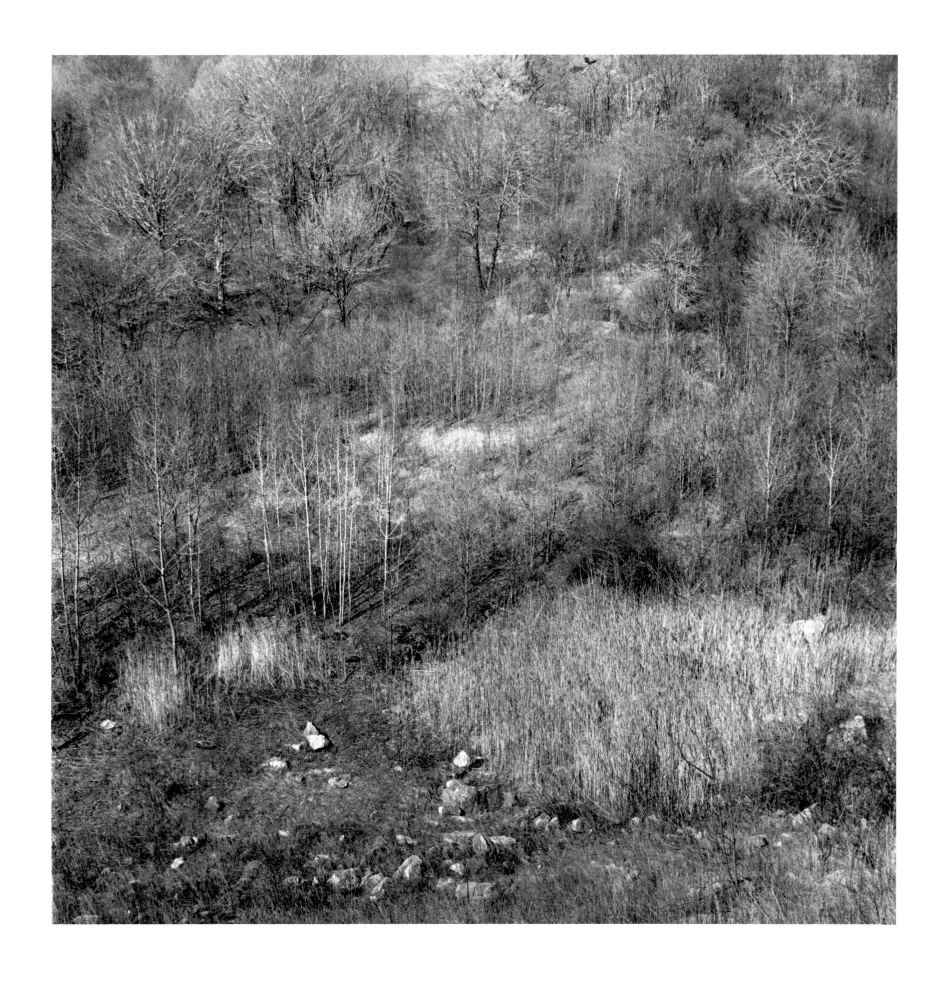

Plate 83. View from Mt. Moses, La Tourette Park, The Greenbelt.

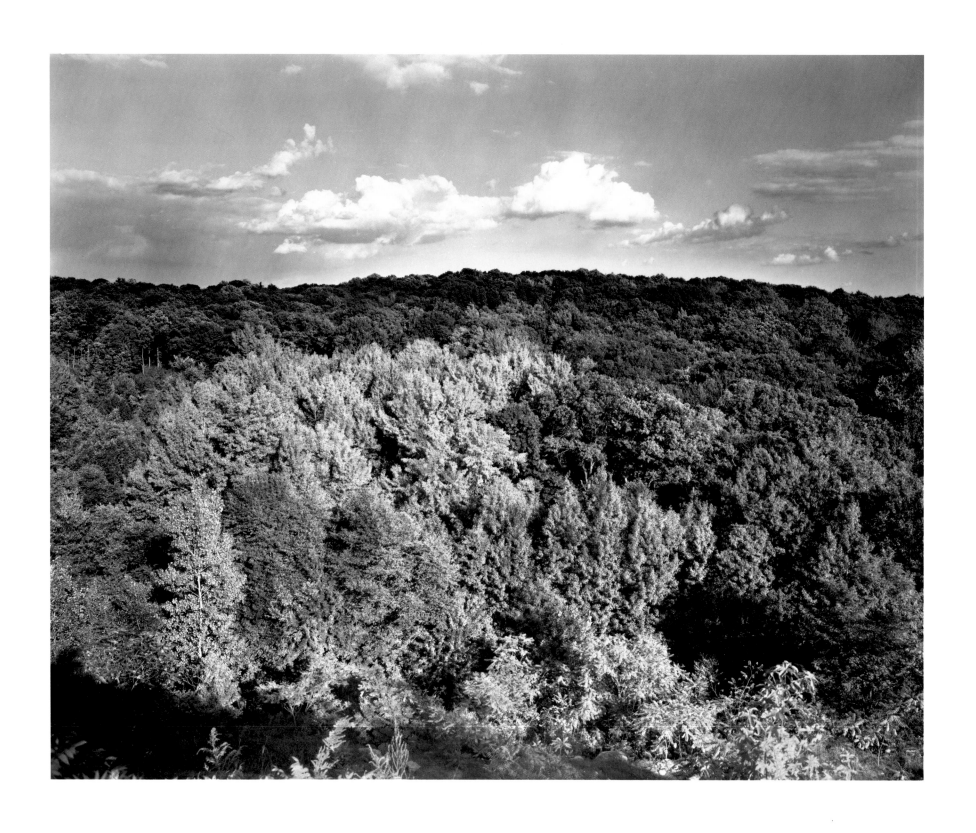

Plate 84. View from Mt. Moses, LaTourette Park, The Greenbelt.

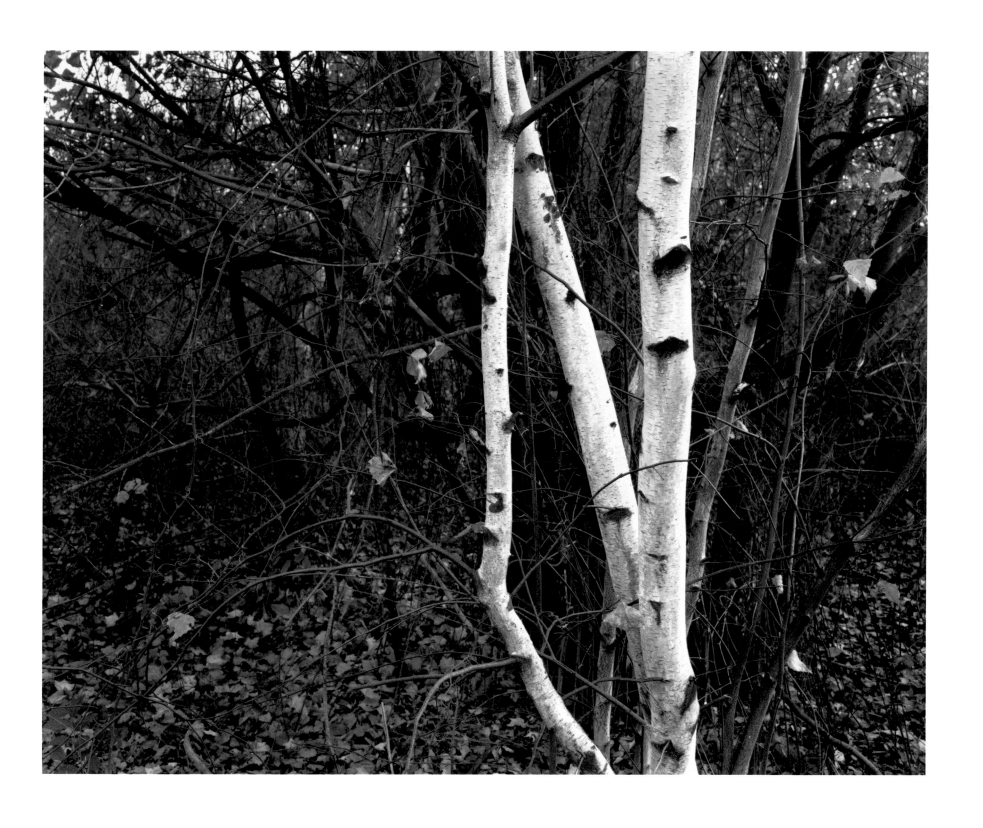

Plate 85. Gray Birch, Clay Pit Ponds State Park Preserve.

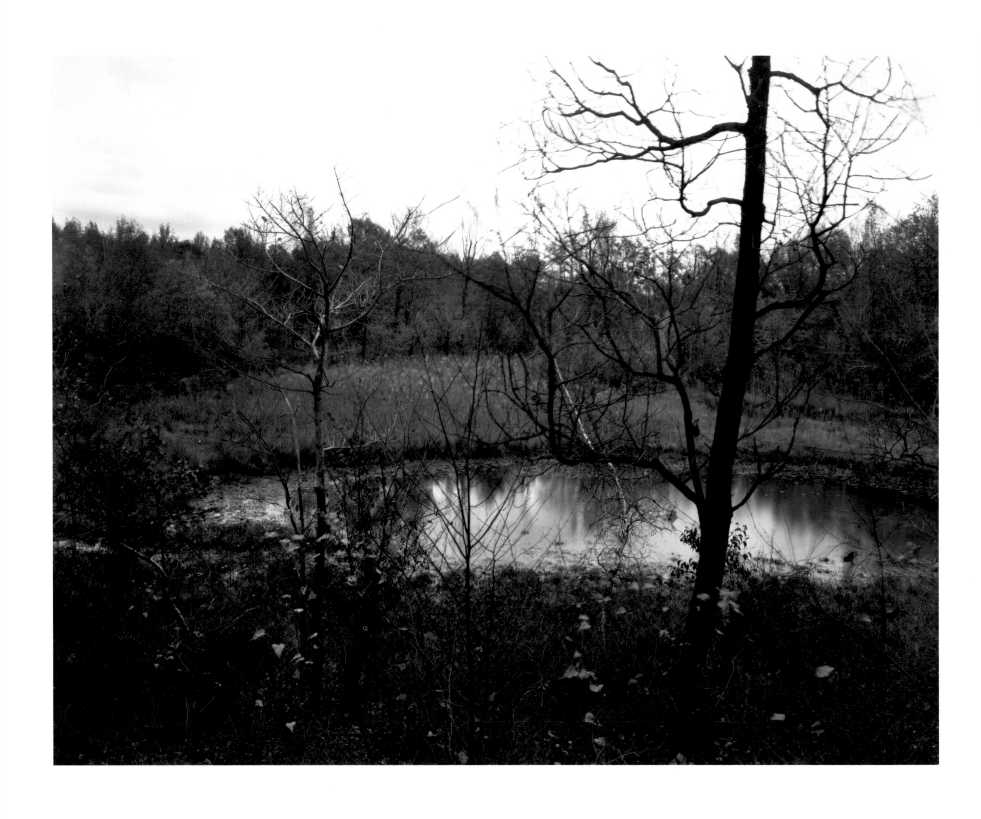

Plate 86. Clay Pit Pond, Clay Pit Ponds State Park Preserve.

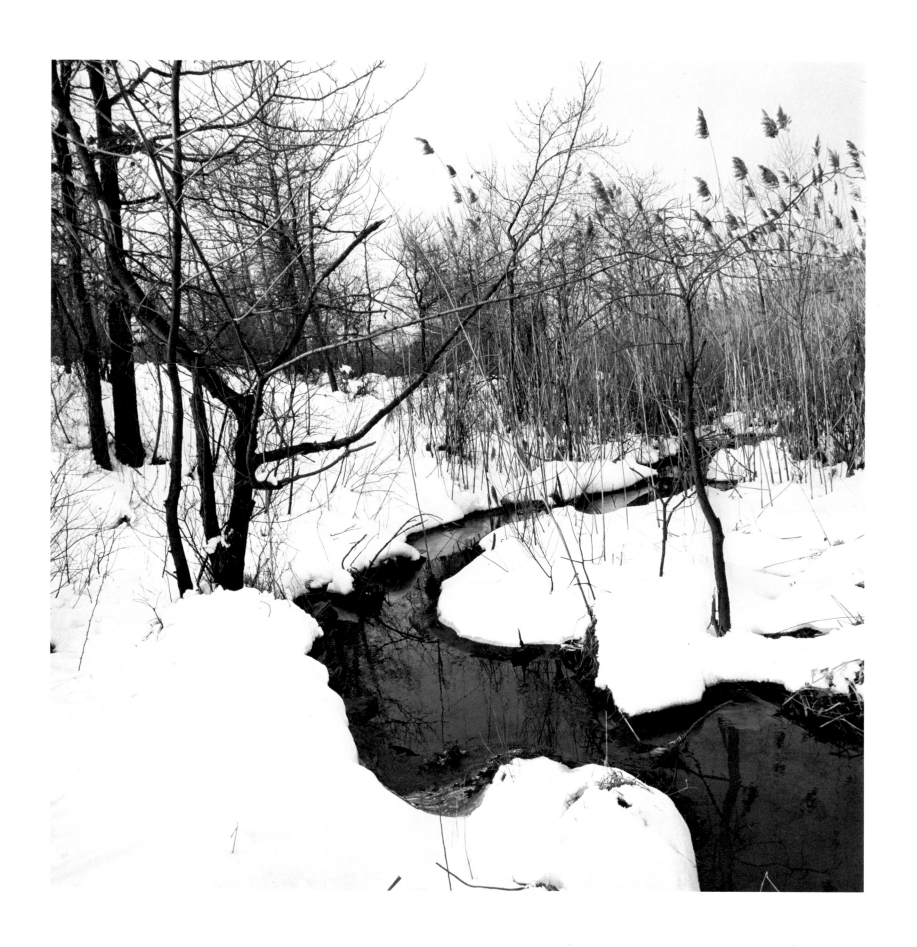

Plate 87. Stream, Clay Pit Ponds State Park Preserve.

THE PLATES

THE BRONX

1. *Lorillard Waterfall, Bronx River, The New York Botanical Garden, Bronx Park.*
2. *Gorge, Bronx River, The New York Botanical Garden, Bronx Park.*
3. *Hunter Island and Pelham Bay, Pelham Bay Park.*
4. *Glacial Erratic Boulder, Hunter Island, Pelham Bay Park.*
5. *Rocky Shoreline, Hunter Island, Pelham Bay Park.*
6. *Bay and Marsh, Hunter Island, Pelham Bay Park.*
7. *Twin Islands, Pelham Bay Park.*
8. *Bronx River, The New York Botanical Garden, Bronx Park.*
9. *Bronx River, The New York Botanical Garden, Bronx Park.*
10. *Marsh, The New York Botanical Garden, Bronx Park.*
11. *The New York Botanical Garden Forest and Bronx River, Bronx Park.*
12. *Tibbett's Brook, Van Cortlandt Park.*
13. *Willow Trees, Van Cortlandt Park.*
14. *Shrub Wetland, Van Cortlandt Park.*
15. *Forested Wetland, Van Cortlandt Park.*

MANHATTAN

16. *Native American Cave, Inwood Hill Park.*
17. *Hudson River and New Jersey Palisades from Inwood Hill Park.*
18. *Forest Walk, Fort Tryon Park.*
19. *Copper Beech, Fort Tryon Park.*
20. *Cliff, Fort Tryon Park.*
21. *The Overlook, Fort Tryon Park.*
22. *Hudson River, Riverside Park.*
23. *Honey Locust Trees, Riverside Park.*
24. *Lawn, Riverside Park.*
25. *Forested Hillside, Riverside Park.*
26. *Snow Storm, Riverside Park.*
27. *Tree and Retaining Wall, Riverside Park.*
28. *Stone Wall, Riverside Park.*

29. *Bow Bridge, Central Park.*
30. *Waterfall, The Ravine, Central Park.*
31. *Bedrock, Central Park.*
32. *The Pool, Central Park.*
33. *The Pool, Central Park.*
34. *Rockwork, The Ramble, Central Park.*
35. *The Gill Stream, The Ramble, Central Park.*
36. *The Arch, The Ramble, Central Park.*
37. *Frozen Pool, Central Park.*
38. *The Loch, The Ravine, Central Park.*
39. *The Pool, Central Park.*
40. *Glacial Boulders, Central Park.*
41. *Sledding, Central Park.*
42. *The Pond, Central Park.*

QUEENS

43. *Udall's Cove, Udall's Cove and Ravine Park.*
44. *Ravine, Udall's Cove and Ravine Park.*
45. *Wetland, Udall's Cove and Ravine Park.*
46. *The Alley, Alley Pond Park.*
47. *Kettle Pond, Alley Pond Park.*
48. *Forest, Alley Pond Park.*
49. *Lady-Fern, Cunningham Park.*
50. *Fire, Cunningham Park.*
51. *Forest, Cunningham Park.*
52. *Water Lilies, Oakland Lake.*
53. *Oak Forest, Forest Park.*
54. *Willow Tree, Willow Lake, Flushing Meadows Corona Park.*
55. *Willow Branch, Willow Lake, Flushing Meadows Corona Park.*
56. *Fort Tilden Beach, Gateway National Recreation Area.*
57. *Fort Tilden Beach, Gateway National Recreation Area.*
58. *Breezy Point, Gateway National Recreation Area.*
59. *Upland Trees, Jamaica Bay Wildlife Refuge, Gateway National Recreation Area.*

BROOKLYN

60. *Fog, Jamaica Bay, Gateway National Recreation Area.*
61. *Dead Horse Bay, Gateway National Recreation Area.*
62. *Plumb Beach, Gateway National Recreation Area.*
63. *Trees, Prospect Park.*
64. *The Long Meadow, Prospect Park.*
65. *American Hornbeam, Breeze Hill, Prospect Park.*
66. *Islands, Prospect Park Lake, Prospect Park.*
67. *Forest, Prospect Park.*
68. *Daffodils, Brooklyn Botanic Garden.*
69. *Reflecting Waters, Brooklyn Botanic Garden.*
70. *Stream, Brooklyn Botanic Garden.*
71. *Magnolia Blossoms, Brooklyn Botanic Garden.*
72. *Rose, Brooklyn Botanic Garden.*

STATEN ISLAND

73. *Tadpole Pond, The Greenbelt.*
74. *Tadpole Pond, The Greenbelt.*
75. *Red Maple, Blue Heron Pond Park.*
76. *Pond, Blue Heron Pond Park.*
77. *Orabach Lake, The Greenbelt.*
78. *Richmond Brook, Egbertville Ravine, The Greenbelt.*
79. *Sassafras, Egbertville Ravine, The Greenbelt.*
80. *Pond, Wolfe's Pond Park.*
81. *Fall Loosestrife Swamp, High Rock Conservation Center, The Greenbelt.*
82. *Winter Loosestrife Swamp, High Rock Conservation Center, The Greenbelt.*
83. *View from Mt. Moses, La Tourette Park, The Greenbelt.*
84. *View from Mt. Moses, La Tourette Park, The Greenbelt.*
85. *Gray Birch, Clay Pit Ponds State Park Preserve.*
86. *Clay Pit Pond, Clay Pit Ponds State Park Preserve.*
87. *Stream, Clay Pit Ponds State Park Preserve.*

NOTES ON THE PLATES

THE BRONX

PLATE 1. Lorillard Waterfall, Bronx River, The New York Botanical Garden, Bronx Park. Pierre Lorillard built a waterfall in the Bronx River during the 1840s to power his nearby Snuff Mill. He kept the postglacial valley (in the background) at a flood-level higher than today's. Park authorities lowered it in the 1880s when they created Bronx Park.

PLATE 2. Gorge, Bronx River, The New York Botanical Garden, Bronx Park. Thousands of years ago, the Bronx River chiseled a deep gorge in what is now the northern part of the park. The Siwanoy people called it the "river of high bluffs." On its slopes grow black birch and wild black cherry trees. Its surrounding forest contains as well hemlocks, beech, oaks, red maples, and tulip trees.

PLATE 3. Hunter Island and Pelham Bay, Pelham Bay Park. The last glacier transported angular and rounded rocks as well as smaller rock fragments to the Pelham Bay area in The Bronx. As this immense ice sheet melted, some 15,000 years ago, it deposited along its path the many different kinds of rocks that it had accumulated during its relentless journey southward. The gravelly bar of glacial debris that is revealed by the receding tides provides an ideal habitat for clams, and yellow plum and other marine worms. The boulders shelter barnacles.

PLATE 4. Glacial Erratic Boulder, Hunter Island, Pelham Bay Park. The dramatic effects of the glacier characterize the landscape of Hunter Island in Pelham Bay Park. A boulder once embedded in ice now perches on bedrock that the glacier polished and scraped thousands of years ago. The ice scooped out bays (in the background)

from what were probably preglacial valleys. When the climate became warmer, their increased depths filled with ocean waters, creating today's seascape.

PLATE 5. Rocky shoreline, Hunter Island, Pelham Bay Park. The exposed bedrock and glacial boulders found along the coast of The East Bronx resemble those of Maine. They extend the New England upland to its southernmost point. Here the intensity of the folding and deformed layering that is evident in the bedrock indicates the colliding impact of the North American and European continents more than 425 million years ago. Resembling the schist and gneiss formations that predominate in The Bronx, the Hartland Formation (seen here) also shows the effects of weathering and exfoliating, which removes the rock surface in thin layers.

PLATE 6. Bay and Marsh, Hunter Island, Pelham Bay Park. High tide inundates coastal salt marshes with sea waters that first reached this level some 4,000 to 6,000 years ago. This intertidal zone abounds with plant and animal life. Here, *Spartina alterniflora*, one of the pioneer plants on mud flats, creates a springy mass of grass. Its strength surpasses human-made bulkheads in holding ground against tidal action. Detritus created by its disintegration helps make salt marshes extremely productive. Three-fourths of the fish in the Atlantic Ocean depend on salt marshes like these for some period of their life cycles, either for food, shelter/protection, or special breeding conditions.

PLATE 7. Twin Islands, Pelham Bay Park. In the foreground is a section of the park's 195-acre saltwater marshes. Part of the park's 782 acres of forest hug the shoreline

in the background. A rich diversity of animal and plant species characterize park forests. Birds migrating in spring and fall need environments such as the one pictured, where forest and marsh vegetation thrive and where food is abundant.

PLATE 8. Bronx River, The New York Botanical Garden, Bronx Park. The Bronx River fluctuates greatly—from a raging torrent in spring to a much shallower waterbody in midwinter. A variety of trees inhabit the almost primeval forest along its banks. The larger ones include northern red oak, black oak, and white oak, with tulip trees reaching the greatest heights of this tree canopy. Nonnative trees, such as the cork and umbrella magnolia, grow here as well. Sweetgum and red maple, which favor sites that are periodically flooded, grow closest to the river.

PLATE 9. Bronx River, The New York Botanical Garden, Bronx Park. The river acts as an erosion tool for the cliff, making the gorge deeper and wider as it cuts into the rock face. Temperature changes also affect the rock, heating it up during the day and cooling it off at night; these changes cause the rock to slowly disintegrate over thousands of years. As the air gets cleaner in New York City, lichen and moss may recover niches in rocks, creating environments fit for ferns, columbines, and other plants associated with this kind of habitat.

PLATE 10. Marsh, The New York Botanical Garden, Bronx Park. The Garden's surface water system forms a stream and then a pond before reaching this seasonally flooded spot. Willow trees overhang the marsh where rushes and sedges thrive. Arrow arum, arrowhead, and iris poke up in the foreground. Near the shelter are

light-barked red maples and sweetgum trees. Behind them grow oaks—red, black, and white. The spring landscape pictured here will soon blossom as warmer weather unfolds buds into leaves and flowers.

PLATE 11. The New York Botanical Garden Forest and Bronx River, Bronx Park. The Garden Forest shelters a grove of Canadian hemlock trees. These graceful evergreens live naturally here among New York City's broadleaved trees. The Hemlock Grove in The New York Botanical Garden Forest is the southernmost stand of these conifers near the Atlantic Ocean.

PLATE 12. Tibbett's Brook, Van Cortlandt Park. A glaciated valley protects one of the most valuable freshwater wetlands in New York City. The natural environment changes from open water (bottom of photograph) to upland forest (background). Stream waters reflect yellow water lilies. Cattails and phragmites (middle ground) thrust their stalks high above the large lily leaves. In the forest, flood plain trees and plants grade into an oak-hickory woodland on higher slopes. Huge snapping turtles, water snakes, and muskrats make this valley their home, and yellow throated warblers, goshawks, merlins, and woodcocks feed and rest here during migration.

PLATE 13. Willow Trees, Van Cortlandt Park. Willow trees control erosion along the banks of Tibbett's Brook in the north-central section of the park. Easily recognized by their long narrow leaves, these willows grow in wetlands whose water quality, vegetation, and extent have been dramatically affected by the construction of the Henry Hudson Parkway and the Major Deegan Expressway. All told, human alteration to the entire Tibbett's Brook watershed has reduced it from 3,253 acres to 2,293 acres.

PLATE 14. Shrub Wetland, Van Cortlandt Park. Shrub wetlands occur along Tibbett's Brook as a transitional zone between open water and solid land. They attract birds, mammals, reptiles, fish, and insects. Waterfowl and shorebirds can be found in them while near-by woodlands provide cover, breeding sites, and food for songbirds and other landfowl. The nourishing of wildlife is a crucial function of an urban natural area such as this wetland.

PLATE 15. Forested Wetland, Van Cortlandt Park. The vegetation of the park falls into six categories: upland falling-leaf forests, successional fields, falling-leaf forested wetlands, shrub wetlands, emergent wetlands, and aquatic bed. The falling-leaf forested wetlands edge Tibbett's Brook in the north-central part of the park. Before the Tibbett's Brook dam was constructed in 1699 to create Van Cortlandt Lake, tidal action influenced this area. Today, red and silver maple, cottonwood, spicebush, skunk cabbage, and sensitive fern grow here.

MANHATTAN

PLATE 16. Native American Cave, Inwood Hill Park. The Delaware people of the Shorakapkok tribe frequented the western side of the Clove, a valley wedged between steep park slopes. The rock enclosures that sheltered them were formed thousands of years ago by dislodged boulders. The surrounding forest contains vegetation typical of regions both to the south and to the north of New York City. The range of the tall straight tulip tree (left) extends to central Massachusetts. On the hilltop grow chestnut oaks that can be found as far south as the Appalachians but become common on the coastal plain from New Jersey and New York northward.

PLATE 17. Hudson River and New Jersey Palisades from Inwood Hill Park. The majestic Palisades loom over the southernmost fjord in the world, the Hudson River. Because the tides penetrate the Hudson Valley as far north as Newburgh and Haverstraw Bay, the river is actually an estuary or arm of the sea. In 1609, Henry Hudson explored this splendid waterway, admiring its valley gouged by glaciers and marveling at sweet smells and a land pleasant with grasses, flowers, and trees.

PLATE 18. Forest Walk, Fort Tryon Park. The secondary-growth park forest contains a mixture of young trees whose opportunistic seeds succeeded in rooting themselves in moist soils. Here white wood aster, sycamore, maple, and tulip trees crowd along the edges of the park walk. The nesting hole in the tree trunk to the left of the path indicates a hollow tree, a vital part of any natural forest. Besides providing homes for animals, decaying trees supply nutrients to the soil, which in turn nourish other forest plants. This is a vital part of the continual cycling/recycling process of a forest.

PLATE 19. Copper Beech, Fort Tryon Park. A princely copper beech spreads its graceful limbs over a sun-dappled lawn. Reflecting the sunlight, the beech's glossy, purple leaves distinguish it from the surrounding green vegetation. The exotic ancestors of this venerable tree were first discovered in Switzerland in the 1660s. During the 19th century, the copper beech became a favorite ornamental tree of estate owners along the Hudson River.

PLATE 20. Cliff, Fort Tryon Park. Dramatic park slopes of Manhattan schist provided landscape architect Frederick Law Olmsted, Jr. with the opportunity to create the illusion of wild nature. He carefully fitted park vegetation, as well as walks and drives, to the craggy terrain. Virginia creeper, Boston ivy, and birdfoot trefoil tolerate the drier, shallower soils of the park slopes.

PLATE 21. The Overlook, Fort Tryon Park. The highest point on Manhattan Island provides a commanding prospect of the Cloisters and the mighty Hudson River with its memorable Palisades. This 270-foot-high Overlook straddles a towering ridge of mica schist rock. Captured by the British during the Revolutionary War, the

Overlook preserves the site on which the British Fort Tryon and the northern sections of the American Fort Washington once stood.

PLATE 22. Hudson River, Riverside Park. The park originally clung to the slopes of the river valley. Today salty waters of the historic Hudson River wash over stone embankments. These boulders edge landfill that was constructed during the 1930s. It stabilizes the river's edge and suggests the rocky Manhattan shoreline that was hidden by the park addition.

PLATE 23. Honey Locust Trees, Riverside Park. Park trees stand silhouetted against rays of the setting sun. Since the 1870s, when it was built, one of Riverside Park's main attractions has been its fine collection of trees and shrubs. Here, locust trees grow on a slope overlooking the Hudson River. Other sections of the park boast such exotics as the spring-blooming cherry and the large-leaved catalpa.

PLATE 24. Lawn, Riverside Park. Almost everyone seems to enjoy open, closely cropped, pastoral lawns. They recall a savannah where food is plentiful and where protective shelter is nearby. The Wisconsin Glacier molded this particular slope, which 19th-century landscape architects Frederick Law Olmsted, Calvert Vaux, Julius Munkowitz, and Samuel Parsons incorporated into their design for the park.

PLATE 25. Forested Hillside, Riverside Park. Riverside Park provides from the promenade along Riverside Drive unique views into tree canopies. Here Norway maples and elm trees have spontaneously grown in what was once probably an open meadow. Areas like this one that were not in the original Olmsted design are now considered legitimate parts of the park. They typify the interplay between human intention and other natural forces that underlies the creation of urban natural sites.

PLATE 26. Snow Storm, Riverside Park. A midwinter blizzard throws a white veil over park trees. Buildings disappear and the city seems far away, creating a feeling more often expected in the wilderness than in the city. When the storm subsides, tracks of the many animals that make Riverside Park their home mark the snow. Because many of them are quite secretive and shrewd, their tracks are rare evidence that they live here.

PLATE 27. Tree and Retaining Wall, Riverside Park. An American elm stands next to a naturalistic park wall that dates from the late 19th century. Despite a persistent blight, these trees are holding their own, especially if dead branches are pruned. American elms have small flowers from March to May and bear fruit from April to May. Several small oaks have also taken root here.

PLATE 28. Stone Wall, Riverside Park. Honey and black locust trees grow close to a retaining wall that separates the upper park drive and walkway from the sloping hillsides. Composed of native rock, except for its imported granite balustrade, the wall is unobtrusive. Its rough-hewn surface provides nooks and crannies for wildflowers and ferns to grow.

PLATE 29. Bow Bridge, Central Park. Central Park's landscape architects, Frederick Law Olmsted and Calvert Vaux, dammed a stream that once flowed through here, creating the lake that Bow Bridge spans. Along its shores they planted vegetation with overall forms that resemble those that would grow here naturally. The missing underbrush indicates a human-designed landscape in contrast to a successional woodland that would have a low-growing story of forest plants.

PLATE 30. Waterfall, The Ravine, Central Park. Park designers Olmsted and Vaux used the rocky and wooded original landscape of Manhattan to create this picturesque scenery. The cascade marks the beginning of The Loch, a shallow waterway that flows through the north end of the park. A largely native forest separates the waterfall, which the landscape architects designed, from the rest of the park.

PLATE 31. Bedrock, Central Park. The bedrock of the Earth protrudes throughout the park. It dramatically introduces the ancient geological history of this area into the midst of a modern city. Without this underlying foundation of Manhattan schist for support, none of Manhattan's celebrated skyscrapers would be possible. Snow rests on shelves created by the joint system of the rocks.

PLATE 32. The Pool, Central Park. Pictured is the northeast corner of the Pool, a two-acre waterbody parallel with West 100th–103rd Streets. This area with its water system, the nonnative willow trees, alder trees that grow naturally in moist ground, and a bridge suggests a Japanese garden.

PLATE 33. The Pool, Central Park. Dips in park terrain resulted from the impact of the last glacier. The landscape architects molded their design to fit its sloping contours, creating the natural looking Pool. They also planted trees along its edges that suggest a forest landscape, though a wild woodland would have an understory of vegetation and fewer species of trees.

PLATE 34. Rockwork, The Ramble, Central Park. The thirty-seven-acre Ramble simulates a forest left to grow on its own. Olmsted and Vaux based the management of this area on the form and character of native vegetation. The existing, exceedingly intricate and interesting plant growth led them to imitate a wilderness, complete with composed rockwork of ruggedly cut local Manhattan schist (foreground).

PLATE 35. The Gill Stream, The Ramble, Central Park. Meandering through The Ramble is The Gill, which simulates a mountain stream although it is actually fed by a pipe and natural runoff water. This "wilderness" area was the first section of the park to be "polished off and made presentable." It was also the most complexly

planned and important feature of the park south of 79th Street. To aid water runoff in The Ramble, Olmsted and Vaux constructed, in addition to The Gill, an underground drainage system. Its restoration is part of current plans to rebuild Central Park.

PLATE 36. The Arch, The Ramble, Central Park. Olmsted and Vaux organized the existing site of The Ramble to form a bold and rugged landscape. They used Manhattan schist to construct an arch that spans both existing bedrock (left) and boulders that they composed (right). Nearby on the northwest arm of The Lake, they created a cave. It once had an entrance next to this arch.

PLATE 37. Frozen Pool, Central Park. An early morning fog shrouds The Pool and park trees. This pastoral landscape was composed by Olmsted and Vaux as a foil to their intricately detailed picuresque scenery. The sense of expansiveness of such places also presents an intentional contrast to city streets.

PLATE 38. The Loch, The Ravine, Central Park. Only one natural stream in Central Park, Montayne's Rivulet, was retained by Olmsted and Vaux. It forms the backbone of the three water areas in the northern park section—The Pool, The Loch, and The Harlem Meer. Glen Span arch (background) carries automobiles over the stream and over an adjacent pedestrian path. Throughout the park, the separation of different kinds of traffic at intersections such as this one makes the park design the first extensive use of what has become a typical feature of modern highway systems.

PLATE 39. The Pool, Central Park. Olmsted and Vaux sculpted The Pool, located parallel with West 100th–103rd Streets, out of a preexisting landscape. They described this landscape as possessing "the highest ideals that can be aimed at for a park under any circumstances." Its horizon lines were "bold and sweeping and . . . (its) slopes have great breadth."

PLATE 40. Glacial Boulders, Central Park. Glacial boulders and a fallen tree typify the more rugged landscape of the northern part of Central Park. In 1863, Olmsted and Vaux convinced the city to extend the park's northern boundary from 106th Street to 110th Street in order to include land features and contours that complemented the original parkland.

PLATE 41. Sledding, Central Park. The slopes and hillsides of Central Park provide seemingly unlimited recreational opportunities. The park designers intended to provide spaces the uses of which could vary seasonally and were not dependent on permanent equipment or limited to one age group or class.

PLATE 42. The Pond, Central Park. Gapstow Bridge spans The Pond in the southeast corner of Central Park. Open water in frozen ponds where food is more readily available attracts abundant wildlife in winter. The natural processes of siltation and infilling here have made The Pond smaller and shallower than it originally was.

QUEENS

PLATE 43. Udall's Cove, Udall's Cove and Ravine Park. High tide inundates *Spartina alterniflora* (foreground) and reed grass behind it. Wetlands like this one result from the mixing of fresh and saltwater along the Middle Atlantic coast, which harbors more salt marshes than any other area in the United States. Here fresh water from the surrounding uplands dilutes seawater from Little Neck Bay and Long Island Sound.

PLATE 44. Ravine, Udall's Cove and Ravine Park. Protected by the 1973 Tidal Wetlands Act, Udall's Cove Ravine runs north from Northern Boulevard to Udall's Cove. This shallow valley includes a winding stream that brings fresh water from nearby hills, which are capped with glacial materials, into the 106-acre tidal marsh and estuary of the cove. Along this swampy

brook grow silver and red maples, willows, and poplars. Here, trapped water has killed the trees (center).

PLATE 45. Wetland, Udall's Cove and Ravine Park. Organic material decomposes in tidal wetlands, where minerals wash down from hills. Tides bring in nutrients and flush out waste products, all of which make this environment very productive of both biomass, which is the amount of living matter in the cove, and a diversity of species. In the oozy muck, fish and crabs spawn. Muskrats, raccoons, opossums, rabbits, squirrels, frogs, toads, turtles, pheasant, waterfowl and a variety of wading and shore birds populate the cove as well. Nearby Little Neck Bay feeds the cove and nurses striped bass, winter and summer flounder, and bluefish. Fishermen have caught up to twenty-one different kinds of fish in the bay. They have even sighted dolphins.

PLATE 46. The Alley, Alley Pond Park. Alley Pond Park safeguards 635 acres of two major interrelated ecologies: a tidal basin and a forested upland. In its northern section, the meeting of Little Neck Bay with Alley Creek creates an estuary or tidal basin. Growing here is the most extensive and healthiest expanse of tall cordgrass and of salt marsh and salt shrub plant communities along the coast of north Queens. The area south of the tidal basin (foreground) hosts a large variety of fresh and saltwater species of plants and animals. Known as the "Alley," this park section boasts the greatest diversity of plant communities in the park. It connects the tidal basin to the second major ecology in Alley Pond Park, the forested upland, which is located on the terminal moraine (background), a deposit of sand and gravel that marks the grinding halt of the last glacier.

PLATE 47. Kettle Pond, Alley Pond Park. The Wisconsin Glacier retreated at an average rate of about one hundred feet per year. Large blocks of ice broke off from it and were buried under glacial debris. When these ice blocks finally melted completely,

the debris settled and steep-sided pits, called kettles, formed. Many of these filled with rainwater and runoff, forming ponds. Alley Pond Park contains several such ponds, each having a slightly different water chemistry and hence a different plant and animal life.

PLATE 48. Forest, Alley Pond Park. The grandeur of the Alley Pond Park forest finds little equal in other urban woodlands. Despite vast changes in the region surrounding the park, its composition still reflects much of the precolonial forests. Artifacts found in this area suggest that people lived here as long as 5,000 years ago. First seen by European settlers in 1637, the composition of precolonial forests suggested that the native peoples, the Mattinecoks, had burned them to improve travel and to aid their hunting. Here, greenbrier surrounds a black cherry tree, up which a poison ivy vine has climbed.

PLATE 49. Lady-Fern, Cunningham Park. The plants and the wildlife that depend on them in Cunningham Park represent a historic preserve of precolonial life. Here the feathery fronds of the lady-fern surround a sweetgum tree.

PLATE 50. Fire, Cunningham Park. Although lightning often starts woodland fires, people cause most of the fires that occur in city parks. Fires can be an important natural phenomenon because they return nutrients to the soil. But in cities where urban woodland is at a premium, their damage is disproportionately great. Here a fire has been started in the wound of a red oak that the callous growth around the wound indicates the tree was trying to heal.

PLATE 51. Forest, Cunningham Park. Seasonal flooding creates a reflecting pool for forest trees, such as the sweetgum and red maple, which can withstand submersion for short periods. Red oak, sweetgum, and dogwood thrive in upland park woods. Blackberry thickets surround small ponds and low-lying depressions left by the melting of glacial ice. Hemlocks live here

as well. Nesting and migratory birds fill the 356-acre park with their furtive activities, range of colors, and remarkable singing.

PLATE 52. Water Lilies, Oakland Lake. White water lilies float on the surface of Oakland Lake. The system of veins visible on their undersides is similar to other water lily leaves. The 19th-century English landscape gardener Joseph Paxton was inspired by his study of water lilies to develop a structural system that made possible his glass greenhouses—one of the origins of the modern glass skyscraper.

PLATE 53. Oak Forest, Forest Park. One of the last densely forested areas of mature oak in New York City survives in Forest Park. Its biotic community has reached an equilibrium that took hundreds of years to achieve. The contortions of wild black cherry trees result from allowing the forest to grow without human intervention. This tree propagates easily because birds carry its seeds from one part of the woods to another.

PLATE 54. Willow Tree, Willow Lake, Flushing Meadows Corona Park. A very old willow tree has grown in the open for years, allowing its branches to spread out. Its twigs, buds, leaves, and fruit provide food for many birds and other forms of wildlife. Willows, like this one, control waterside erosion by stabilizing lakesides. Here the tree protects the shoreline of Willow Lake, which Park Commissioner Robert Moses created when he transformed 1,346 acres of Flushing Meadows into a park.

PLATE 55. Willow Branch, Willow Lake, Flushing Meadows Corona Park. For centuries Flushing Creek flowed into Flushing Bay through salt marshes. Robert Moses's plan for Flushing Meadows Corona Park included the present boat basin where the creek meets the bay at the northern end of the park. At the southern end he formed two lakes from existing tidal pools. One of these, Willow Lake, qualifies as a wetland.

Limited access to this area has helped to preserve it so that the lake remains a much-treasured remnant of Long Island's natural history.

PLATE 56. Fort Tilden Beach, Gateway National Recreation Area. Constantly moving and shifting sands of a beach environment shape sand dunes, which have characterized this area for 4,000 to 6,000 years. The beach grass, whose roots keep the sand from blowing away, needs the nutrients found in fresh sand and in salt spray to grow. Because it is so brittle, people trampling on the grass easily kill it. Seaside goldenrod (foreground) sprouts here during the spring.

PLATE 57. Fort Tilden Beach, Gateway National Recreation Area. Sandy beaches characterize the southern shoreline of New York City in Queens, Brooklyn, and Staten Island. Beaches like this one at Fort Tilden began to develop some 12,000 years ago. By that time, the last glacier had melted and retreated northward. Earth and stone carried and deposited by the glacier at its southernmost extension, known as a terminal moraine, produced outwash materials that formed embryonic shores. Materials washed westward by currents from Montauk Point on the eastern tip of Long Island also contributed to the buildup of bars and sandspits. Rockaway Peninsula, where Fort Tilden is located, is one of these sandbars.

PLATE 58. Breezy Point, Gateway National Recreation Area. Breezy Point is part of one of four units of the Gateway National Recreation Area, a 26,000-acre federal waterfront park. Three of the units totaling almost 24,000 acres are in New York City and the fourth in New Jersey. The Breezy Point Unit covers more than 1,000 acres of land and 4.5 miles of beach. Located at the western tip of Rockaway Peninsula, Breezy Point itself fronts on the Atlantic Ocean. Boulders have been placed at intervals along the beachfront to stop sands from drifting westward. Geologically interesting in themselves, the boulders often

protect animals and plants that usually live along rocky shores.

PLATE 59. Upland trees, Jamaica Bay Wildlife Refuge, Gateway National Recreation Area. In 1951 Parks Commissioner Robert Moses directed the New York Transit Authority to construct sand dikes in Jamaica Bay for the two ponds that became the basis of the Wildlife Refuge. To stabilize the dikes, Herbert Johnson, a Parks Department employee, planted beach grass—enough to reach from here to Boston. In the ponds, he put widgeon grass and sago pondweed, favorites of waterfowl. To attract landbirds on the upland, Johnson grew shrubs and trees preferred by local and migratory birds. Less than forty years later, the Wildlife Refuge supports a rich variety of food chains, the result of Johnson's work, the recent efforts of the National Park Service, and the regenerative powers of nature.

BROOKLYN

PLATE 60. Fog, Jamaica Bay, Gateway National Recreation Area. Autumn fog rolls over the salt marsh and tidal waters of Jamaica Bay in the Brooklyn section of the Gateway National Recreation Area. The bay formed about 12,000 years ago when the Wisconsin Glacier melted. Today its more than 9,000 acres, about half of which are in Brooklyn and half in Queens, make it one of New York City's largest open spaces. Located under a major bird migration route, the bay and its countless islands attract over 300 species of land and water birds year round.

PLATE 61. Dead Horse Bay, Gateway National Recreation Area. The origin of Dead Horse Bay's unique name has been lost. Its tide laps against decayed wooden pilings to which mussels, sea squirts, and wood borers or shipworms attach themselves in great numbers. Once the tide turned millstones that ground grains on Barren Island. Today that island (background) forms part of a federal park.

PLATE 62. Plumb Beach, Gateway National Recreation Area. Once an island, Plumb Beach today preserves a historic wetland as well as an environment of continual activity. The mud flat or intertidal area (foreground) serves as a refuge for marine life, such as hard-shell and razor clams. A salt marsh (middle ground) contains plants, like salt marsh cordgrass and *Spartina alterniflora*, which can withstand flooding by ocean tides twice a day. Wind and water constantly destroy and rebuild the fragile beach and dune environment (background).

PLATE 63. Trees, Prospect Park. The design of Prospect Park features both native and exotic trees, shrubs, and other vegetation. Landscape architects Olmsted and Vaux created, in the area pictured, a protected niche, using evergreens like the Black Austrian Pine (right). During winter such groves provide much-needed shelter for wildlife: the trees block the wind, which enables animals to retain greater body heat.

PLATE 64. The Long Meadow, Prospect Park. Landscape architects Olmsted and Vaux shaped the undulating expanse of the Long Meadow from the glacial debris of the terminal moraine or southernmost extension of the last glacier. The grandeur of the sky above and seemingly endless meadow below create, as Olmsted indicated, "a sense of enlarged freedom" for the city dweller. The park designers believed that the pleasure such a view brings is one of the most important reasons for a "scenic" urban park such as Prospect Park.

PLATE 65. American Hornbeam, Breeze Hill, Prospect Park. The branches of an American hornbeam create the kind of seemingly random patterns that continue to make picturesque scenery so popular with park visitors. In April and May this tree displays its flowers; in August, September, and October, its fruits. Olmsted and Vaux planted picturesque groves of evergreens and deciduous trees and shrubs throughout the lower third of Prospect Park.

PLATE 66. Islands, Prospect Park Lake, Prospect Park. Trees on small artificial islands create an intricate shadow play on Prospect Park Lake. This sixty-acre lake was carved by park designers Olmsted and Vaux from a plain formed by the meltwaters of the last great glacier. Reflecting waterbodies such as this one are major features in Olmsted's and Vaux's "scenic" urban parks. The park designers believed that city people should experience lake views for the tranquilizing effects they have on the human spirit.

PLATE 67. Forest, Prospect Park. A forest of twenty acres grows on the eastern slope of the wooded hills that extend through the park center from Valley Grove Pass to the Nethermead Arches. These woods remain relatively undisturbed as a memorial to the Battle of Long Island, which was fought here on 27 August 1776. A glacial erratic boulder (center) commemorates the melting of the Wisconsin Glacier some 15,000 years ago.

PLATE 68. Daffodils, Brooklyn Botanic Garden. The stark shadow of a tree falls over daffodils on Boulder Hill in the Botanic Garden. Like the tulip and the narcissus, the daffodil puts forth its flowers in early spring, leaving few traces of its presence during the rest of the year. In contrast, evergreens (background) keep their needles year round.

PLATE 69. Reflecting Waters, Brooklyn Botanic Garden. A human-designed stream meanders through the Brooklyn Botanic Garden. At its southern tip, this waterway encircles a small island where the quiet brook's shimmering waters reflect vegetation that includes forsythia and dogwood. In 1911, landscape architect Harold A. Caparn transformed what was then a nondescript rubbish dump into this bountiful oasis for flowers, shrubs, trees, and New Yorkers.

PLATE 70. Stream, Brooklyn Botanic Garden. In 1911 landscape architect Caparn

extended the waters of an existing kettle-hole pond to form a stream in the fifty-acre Brooklyn Botanic Garden. Along its edges he placed rocks that the last glacier had left strewn around the site. This stream creates a naturalistic setting for the Garden's Systematic Collection, which Caparn organized as an evolutionary walk.

PLATE 71. Magnolia Blossoms, Brooklyn Botanic Garden. One of the most memorable of the "many gardens within a garden" for which the Botanic Garden is known is Magnolia Plaza. Here the snowy white flowers of more than eighty magnolia trees herald the arrival of spring, attracting thousands of visitors every April.

PLATE 72. Rose, Brooklyn Botanic Garden. The delicate petals of a rose shimmer under the rays of the setting sun. This rose grows in the Cranford Memorial Rose Garden, one of the largest rose collections in the United States. The Garden's lattice-enclosed acre features over 5,000 bushes and 900 species and varieties of roses. The much-loved rose, which dates back 32 million years, is the first flower ever to have been cultivated.

STATEN ISLAND

PLATE 73. Tadpole Pond, The Greenbelt. In central Staten Island's 2,500-acre Greenbelt are preserved kettle-holes, which formed when blocks of ice broke off from the melting Wisconsin Glacier and created depressions in glacial debris. Now rainwater fills the depressions, producing a series of small lakes and ponds within the park. The brilliantly colored leaves of the red maple and sweetgum woodland that surround this wetland have blanketed the forest floor.

PLATE 74. Tadpole Pond, The Greenbelt. The northern sections of the Greenbelt's thirty-five miles of trails wind along a ridge of serpentine rock. In this area glacial ponds, like this one, can be found as well as one of the last undisturbed forests in the

city. As early as 1870, Frederick Law Olmsted had recommended "the establishment of a park system" in Staten Island's hills. One hundred and fourteen years later, in 1984, The Greenbelt was designated. Its creation is the dream of local preservationists who have been working since 1966 to stop construction of the Richmond Highway.

PLATE 75. Red Maple, Blue Heron Pond Park. Hardwood forests in the Hudson-Mohawk Valley have been cut often, causing tree stumps, like this red maple's, to produce many sprouts. As the tree matures, only one or two sprouts will survive. The switch grass growing behind the tree indicates that secondary succession is taking over what was once an open field.

PLATE 76. Pond, Blue Heron Pond Park. Dedicated in 1984, Blue Heron Pond Park lies to the north of Raritan Bay. Its 155 acres contain ponds, swamps, streams, woodlands, and grasslands in a natural drainage basin. Bird watchers have spotted seventy-five species of birds in the park's grass, wood, and wetlands.

PLATE 77. Orabach Lake, The Greenbelt. An extensive mat of swamp loosestrife or water-willow slowly encroaches on open pond waters. Low-growing spice and blueberry bushes along with taller red maple, swamp white oak, and sweetgum trees ring the fifteen-acre Orabach Lake. This bottomland forest contrasts with trees growing in the upland part of The Greenbelt. There white, red, and black oak thrive, as do beech, tulip, and hickory trees. Sugar maple, white ash, and black walnut trees characterize the rarer third type of Greenbelt wooded area, which is found on sloped hillsides with good drainage in Bloodroot Valley.

PLATE 78. Richmond Brook, Egbertville Ravine, The Greenbelt. Richmond Creek flows over glacial debris from far north of Staten Island. Nearby magnificent one hundred-year-old oaks, beech trees, and tulip magnolia have reclaimed the slopes of

a ravine cut by waters pouring out of the last glacier. This second-growth woodland typifies the developing forests of New York City, which in another fifty years will be extraordinary. They are a very uncommon urban feature, making New York City's park system unique.

PLATE 79. Sassafras. Egbertville Ravine, The Greenbelt. Sassafras sprouts from roots that spread horizontally. Groves of sassafras are thus clones, consisting actually of just one root system or genetic system. The three different leaf patterns of the sassafras also distinguish it: a three "finger" shape, a "thumb-and-mitten" outline, and smooth egg-shaped leaves.

PLATE 80. Pond, Wolfe's Pond Park. Wolfe's Pond forms part of a 318-acre park on Raritan Bay. Here sweetgum, red maple, and greenbrier surround a section of a wetland system that is protected under the Freshwater Wetlands Act by the Department of Environmental Conservation. Urban wetlands are valuable because they provide flood, storm water, and erosion control, recharge groundwater supplies, create habitats for feeding, nesting, and spawning of fish and wildlife, and add natural beauty to the city.

PLATE 81. Fall Loosestrife Swamp, High Rock Conservation Center, The Greenbelt. The water level and amount of land covered by a swamp varies seasonally. Here water inundates deciduous, hardwood trees within the ninety-five acres of High Rock Conservation Center. Freshwater wetlands, such as Loosestrife Swamp, encourage the return of animals, like reptiles, that human bias once drove from the city.

PLATE 82. Winter Loosestrife Swamp, High Rock Conservation Center, The Greenbelt. The winter condition of loosestrife, a swamp plant, belies its more colorful summer state. From July to September pinkish-purple flowers capture attention. They cluster where the upper lance-shaped leaves, which form in pairs or threes, meet the plant stem. The tips of these stems,

which can reach eight feet high, often bend over and take root, accelerating their rate of incursion into open, shallow waters. This swamp was open water only ten to fifteen years ago.

PLATE 83. View from Mt. Moses, La-Tourette Park, The Greenbelt. The most outstanding site for watching and studying migrating birds of prey, such as osprey, hawks, and eagles, in the New York metropolitan area is atop Mt. Moses. Begun as a road construction dumping site by Park Commissioner Robert Moses, who was also a prolific road builder, the "mountain" now offers views of woodland in every direction, an unquestionably rare urban experience.

PLATE 84. View from Mt. Moses, La-Tourette Park, The Greenbelt. Hardwood forest stretches from the bottom of the over one hundred-foot-high Mt. Moses as far as the eye can see. The treetop view encompasses a secondary succession woodland that includes white, red, and black oaks, exotic-flowered tulip trees, coarse compound leaf hickories, smooth gray-barked beeches, shrubby sumacs, and opportunistic cottonwoods that take advantage of any chance to increase their numbers.

PLATE 85. Gray Birch, Clay Pit Ponds State Park Preserve. The sharp thorns and tendrils of greenbrier grow over a gray birch tree. A native tree, the gray birch appears white because its air-filled cells reflect light. Its presence indicates that not long ago this area was an open field. Due to the natural processes of succession, gray birches never get very old or very big. These sun-loving shrubby trees disappear after about fifty years because they are replaced by other, more competitive trees that shade them out.

PLATE 86. Clay Pit Pond, Clay Pit Ponds State Park Preserve. In New York City's southwest corner within the Clay Pit Ponds State Park Preserve lies a unique blend of habitats—scrub, boggy lowland, transitional and upland woods, a pine barren, a sandy upland, bogs and ponds, disturbed and cultivated areas, and fields returning to nature. These natural ecologies contain a wide variety of vegetation, including coastal plain flora, northern hardwoods, and vegetation similar to that found in the celebrated New Jersey Pine Barrens. Clay Pit Pond itself is a cold spring-fed pond with a clay bottom in the midst of the only pine barren in New York City. Bricks manufactured in the 19th century from clay

mined in this area can be found in many New York City buildings.

PLATE 87. Stream, Clay Pit Ponds State Park Preserve. In 1980 the New York Region Office of the State Office of Parks and Recreation designated 250 acres of Staten Island as a state park. The Clay Pit Ponds State Park Preserve protects some of the most geologically diverse land in the city. Approximately 15,000 years ago, the southern edge of the Wisconsin Glacier reached into this region. Near its terminal moraine and within the park lie exposed on the Earth's surface 75-million-year-old deposits of multicolored clays and the only indigenous fossils in the greater New York City area.

EPILOGUE

In the city's natural sites New Yorkers find oaks and owls, bloodroot and bladderwort, turtles and toads, muskrats and monarch butterflies, humanity and herons, streams and rivers, pebbles and boulders. They can hear the shrill call of spring peepers, the quick, light patter of rain on vegetation, the crunch of twigs breaking underfoot, tides lapping on stone and sand, and blue jays quarreling. They can smell earth thawing in spring, summer grasses, and salt-sprayed breezes. They can feel rough tree bark, furry leaves, and prickly stems. They can taste bitter acorns and sweet wild strawberries. They can see the cyclical display of seasonal colors: the purples, yellows, grays, blacks, browns, and whites of spring trees and bushes; the countless greens of summer vegetation; the dry browns, crackly reds, and brittle yellows of autumnal leaves; and the cold white of winter.

In city forests and marshes, urban dwellers experience their mutuality with the Earth. They are encountering what Olmsted described a hundred years ago as "the life and movement of nature," which is "rooted in . . . (the same) intelligence which embodies and upholds . . . man." These experiences are possible because hundreds of their fellow residents are creating in urban natural sites a new ecosystem. By creating such an ecosystem these sustainers of urban nature are aligning themselves with ancient practices that recognize the need for humanity's reciprocity with nature. Time and again, humanity has developed techniques to experience its give-and-take with the Earth by ordering its most life-dependent activities in correspondence with planetary patterns. The Pythagorean geometry of ancient Greek temples is based on cosmic patterns. Hopi planting rituals are congruent with nature's cycles. In New York City, residents are developing new techniques to remember their relationship to the planet. They are creating a unique, life-supporting, urban ecosystem.

The form each human culture develops to harmonize its activities with nature's illuminates the precariousness of its way-of-being on the Earth. Our dilemma is that the nature that we once saw as an unlimited resource has limits. To make our predicament even more perplexing, we are now aware that humanity's survival is inextricably linked to nature's survival. We are understanding that present ecological systems have become extremely vulnerable through our very efforts to survive without them. We are recognizing that for nature to continue to support human life, we must revitalize it. Urban nature, in particular, has become a human artifact.

New Yorkers are beginning to create a new ecosystem as their habitat. Like the Greek temple or Hopi ritual, this human artifact formalizes the exchange between humanity and nature. My hope is that the increasing strains on the biological and physical systems of New York City will be lessened by the city's emerging new ecosystem. If this ecosystem thrives, it can help engender much more than the health of earth, air, water, and life forms within New York City. It can aid in creating a sense of well-being for the people who live here — a sense of dwelling in place that creates the feeling that this is where one belongs — that this is home.

Jean Gardner
Summer 1988

*The plates are printed in 300-line screen duotone lithography by
the Meriden-Stinehour Press, Meriden, Connecticut.
The text was set in Bembo by the Meriden-Stinehour Press, Lunenburg, Vermont.
The paper is Lustro Offset Enamel Dull, 100 lb text, made by S. D. Warren, Massachusetts.
The book was designed by Wendy Stewart and Joel Greenberg.*